LESSONS IN
REALISTIC WATERCOLOR

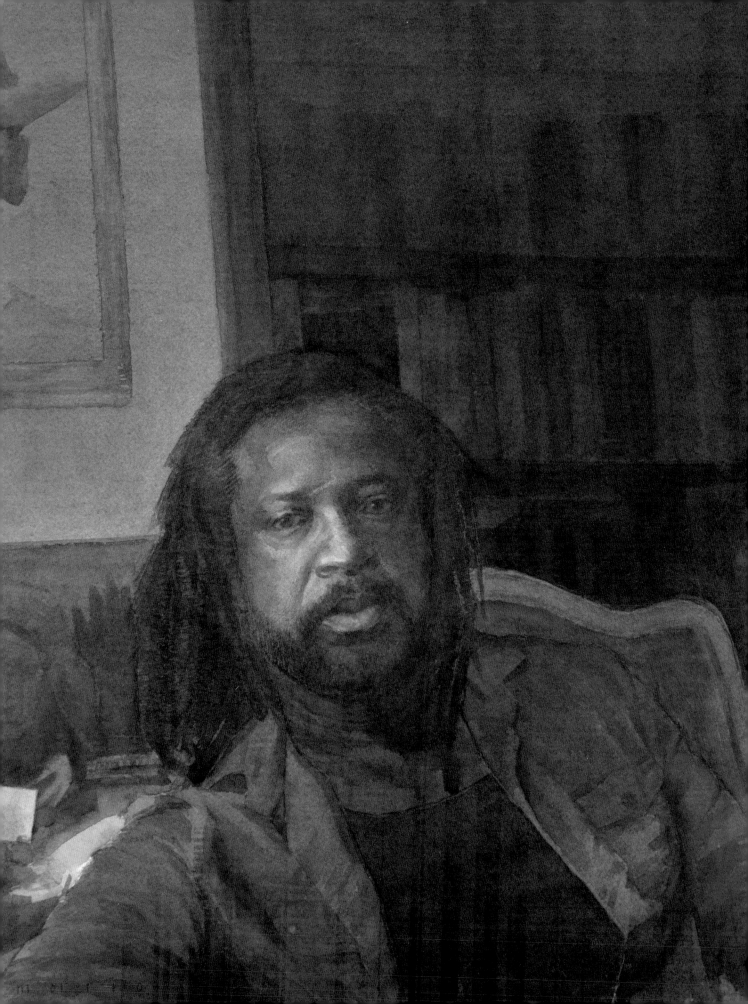

LESSONS IN
REALISTIC WATERCOLOR

A CONTEMPORARY APPROACH TO PAINTING
PEOPLE AND PLACES IN THE CLASSICAL TRADITION

MARIO ANDRES ROBINSON

MONACELLI STUDIO

"Be true to your work and your work will be true to you."

—Pratt Institute motto

Copyright © 2016 Mario Andres Robinson and The Monacelli Press

Illustrations copyright © 2016 Mario Andres Robinson unless otherwise noted
Text copyright © 2016 Mario Andres Robinson

Contributing artists: John James Audubon; Henry Casselli; Thomas Eakins; Winslow Homer; Michael Lowery; John Singer Sargent; and Stephen Scott Young.

Published in the United States by Monacelli Studio,
an imprint of The Monacelli Press

Library of Congress Cataloging-in-Publication Data

Names: Robinson, Mario Andres, 1967- author.
Title: Lessons in realistic watercolor : a contemporary approach to painting
people and places in the classical tradition / Mario Andres Robinson.
Description: First American edition. | New York : The Monacelli Press, 2016.
Identifiers: LCCN 2015038871
Subjects: LCSH: Watercolor painting--Technique. | Realism in art.
Classification: LCC ND2130 .R625 2016 | DDC 751.42/2--dc23
LC record available at http://lccn.loc.gov/2015038871

ISBN 978-1-58093-445-9

Printed in China

Design by Jennifer K. Beal Davis
Cover design by Jennifer K. Beal Davis
Cover illustrations by Mario Andres Robinson

10 9 8 7 6 5 4 3 2

First Edition

MONACELLI STUDIO
The Monacelli Press
236 West 27th Street
New York, New York 10001

www.monacellipress.com

PAGE 1: TICKET BOOTH (DETAIL), 2012
WATERCOLOR ON PAPER, 40 X 27 INCHES (101.5 X 68.5 CM)

PAGE 2: MARLON JAMES, 2015
DRYBRUSH WATERCOLOR ON PAPER, 20 X 16 INCHES (51 X 40.5 CM)
COURTESY OF *MAN OF THE WORLD* MAGAZINE

PAGE 6: BRADSHAW BEACH (POINT PLEASANT BEACH, NJ), 2015
WATERCOLOR ON PAPER, 20 X 15 INCHES (51 X 38 CM)

DEDICATED TO THE MEMORY OF MRS. BEAULAH KING

I would like to thank my loving wife, Diana Robinson, for all the support you've provided over the past fifteen years. My mother, Reta Moye, for the tough love you gave me when I needed it. My family and friends who have excused my regular absences at important engagements and social gatherings, due to my hectic work schedule. Thank you for understanding! To the executives of Winsor & Newton, your unwavering support of my career means the world to me. I'm honored to serve as a Brand Ambassador for your products. Special thanks to Carla Friday and Jimmy Leslie for logistic support, friendship, and a good laugh at the perfect moment. To the executive editor, Victoria Craven, thank you for bestowing your trust in me; your guidance throughout this project was invaluable. My editor, Alison Hagge, you were a joy to work with! I am in awe of your ability to process information. To my painting heroes Stephen Scott Young and Henry Casselli for granting my request to include your amazing works, without hesitation. You both have been a source of inspiration throughout my career. I would like to thank Michael Lowery for allowing me to use his beautiful painting to demonstrate the expressive power of watercolor. Sincere thanks to the Metropolitan Museum of Art for the use of paintings by Thomas Eakins, Winslow Homer, and John Singer Sargent. Maureen Bloomfield, editor of the *Artist's Magazine* for your kind and generous spirit. I value our relationship. The *Artist's Magazine* gave me my first feature article in February 2001 and we're still going strong! The editors and writers of *Watercolor Artist* and *Pastel Journal* are among the best in the business. Lastly, to all my models who have taken time from their busy lives to pose for me, I am forever grateful. My work would be a shell of itself without your presence. Thank you from the bottom of my heart!

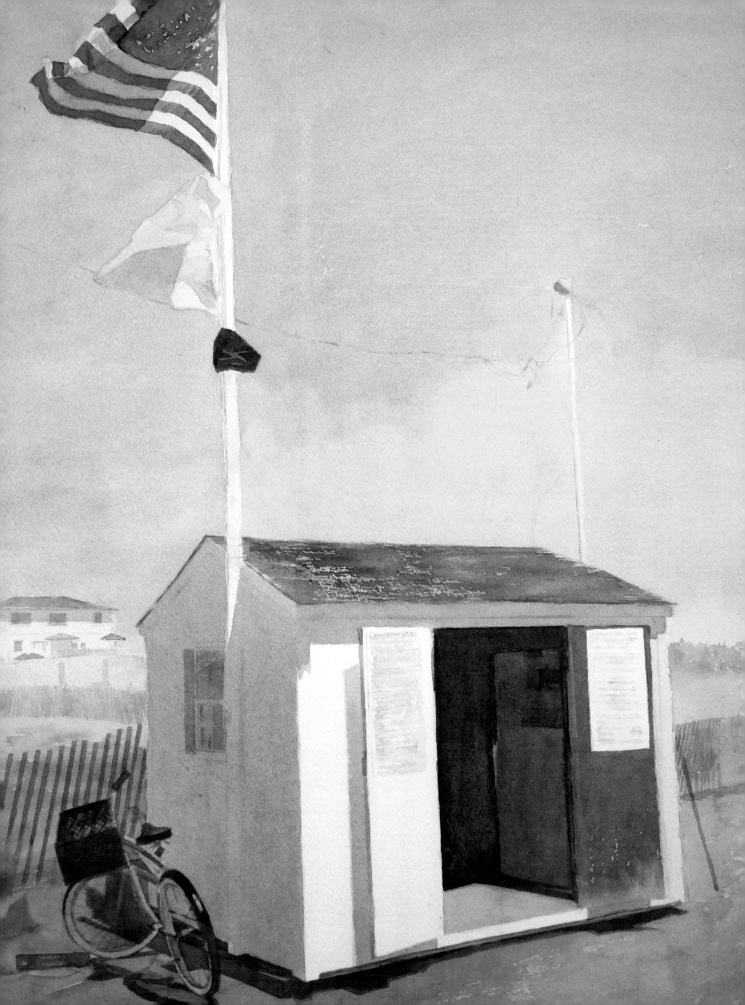

CONTENTS

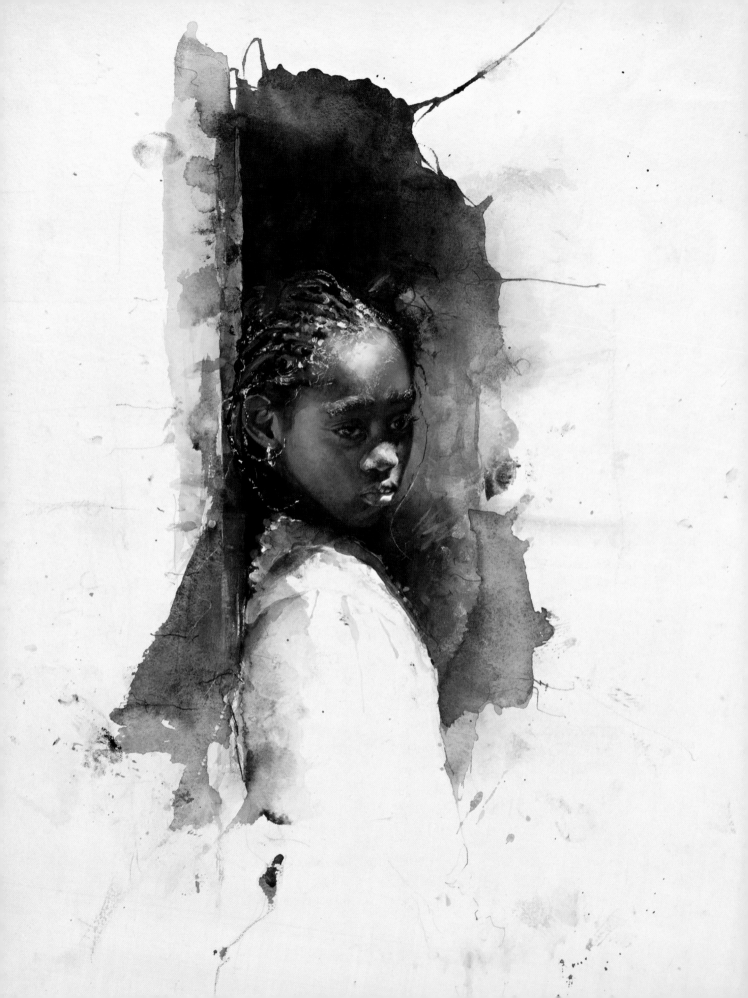

THE LEGACY OF AMERICAN WATERCOLOR

"You will see, in the future I will live by my watercolors."

—Winslow Homer

The British dominated watercolor during the eighteenth and early nineteenth centuries. Their landscapes were particularly notable. Paul Sandby (1731–1809) was described in his obituary as "the father of modern landscape painting in watercolors." As a Foundation Member of the Royal Academy, he did much to elevate the medium's primary association with amateurs and established it as a medium that could compete with oil painting.

The most recognizable of the British watercolorists was J.M.W. Turner (1775–1851) who, by 1796, was equally proficient in oil paint and watercolor. His unique approach to painting landscapes was innovative in terms of technique and composition. He is quoted as saying: "It is necessary to mark the greater from the lesser truth: namely the larger and more liberal idea of nature from the comparatively narrow and confined; namely that which addresses itself to the imagination from that which is solely addressed to the eye." Turner's willingness to freely omit or alter anything in a particular scene distinguished him from his peers, who copied nature as it truly appeared to the eye.

Turner was the first watercolorist to extensively utilize the wet-in-wet technique to float and mix large areas of color. The development of this technique allowed him to extend the size of his paintings to three feet or more. In the 1790s, Turner spent hours tinting and coloring architectural elevations and views. These provided him with a sense of the precise tonal values of objects, as well as control over broad tonal washes. His paintings were moody and bursting with color and energy. Artists working in the medium of watercolor have benefitted greatly from Turner's innovative prowess.

STEPHEN SCOTT YOUNG, ZARIA, 2000
WATERCOLOR ON PAPER, 22 X 14 INCHES (56 X 35.5 CM)
COPYRIGHT © STEPHEN SCOTT YOUNG

Young is adept at melding loose, frenetic washes of color with tight, measured brushstrokes in places of emphasis. The white of the paper is also a key component, as the subject seems to be bathed in sunlight.

A BRIEF SURVEY OF AMERICAN MASTERS

In America, watercolor began to take shape as an art form in the early 1800s. The American naturalist, John James Audubon (1785–1851) set out to illustrate every bird in North America, using the medium of watercolor. His life-sized, dramatic portraits of birds, along with his depiction of the wilderness struck a chord during the continent's Romantic Period. Audubon was not the first person to attempt to paint and describe all the birds of America (Alexander Wilson has that distinction), but for a half a century he was the young country's dominant wildlife artist. Critics of Audubon's work have pointed to certain inaccurate details; however, few argue with its excellence as art. His *Birds of America* collection is still a standard by which twentieth- and twenty-first-century bird artists are measured.

The rising popularity of watercolor in America prompted Winslow Homer (1836–1910) to work less in oil paint and begin making watercolors professionally.

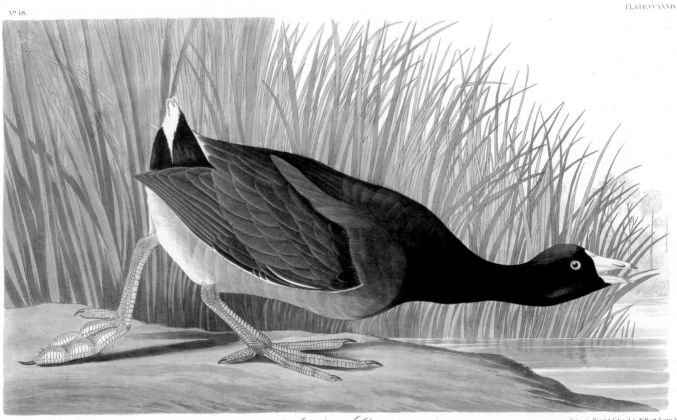

JOHN JAMES AUDUBON, AMERICAN COOT, 1831
WATERCOLOR ON PAPER, 12½ X 19¾ INCHES (32 X 50.5 CM)
COURTESY OF JOHN JAMES AUDUBON CENTER (AUDUBON, PA)

The amount of attention Audubon paid to minute details in each feather of the birds he painted is remarkable. It's a demonstration of his mastery of the medium of watercolor.

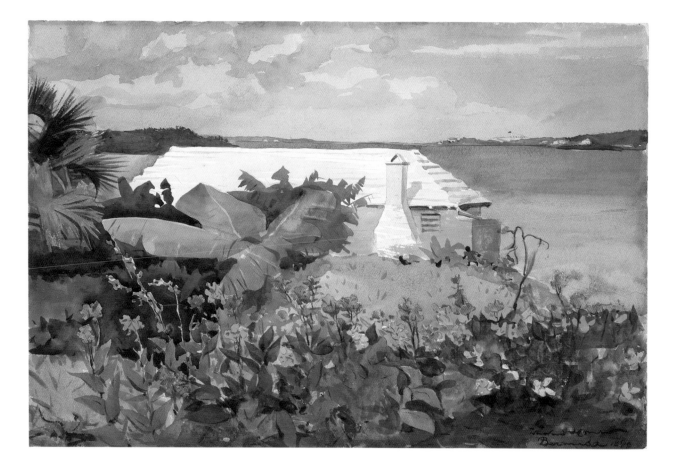

WINSLOW HOMER, FLOWER GARDEN AND
BUNGALOW, BERMUDA, 1899
WATERCOLOR AND GRAPHITE ON OFF-WHITE WOVE PAPER,
13⁵⁄₁₆ X 16⁵⁄₁₆ INCHES (34 X 41.5 CM)
COURTESY OF THE METROPOLITAN MUSEUM OF ART
(NEW YORK, NY)

The transparent quality of watercolor allowed Winslow Homer to
show the captivating effect of light on the colorful architecture of
Bermuda.

Between 1873 and 1905 Homer created nearly seven hundred watercolors. He is regarded by many as the greatest American painter of the nineteenth century. The art historian Hereward Lester Cooke once said, "almost singlehanded[ly Homer] raised the status of watercolors in America from a secondary art, which had degenerated into a poor and imitative cousin of oil painting, into a new and vital mode of expression." Born in Boston and raised in rural Cambridge, Homer began his career as a commercial printmaker and settled in New York in 1859. He began to expand his mastery of oil paint during the 1870s; however, ultimately, it was the success of his watercolors that allowed him to step away from his work as a freelance illustrator.

In the summer of 1883, Homer moved from New York to Prouts Neck, Maine, in search of solitude. There he captured the lives of fisherman and the supportive role of the women and children in the village. The often-tumultuous sea was a dominant factor for the local fisherman, as they relied upon the bounty of the sea and risked their lives to attain it. In his highly regarded watercolor *The Ship's Boat* (1883), a group of fishermen are seen grasping for a capsized boat. Homer's rapid brushwork mimics the explosive energy of the rolling waves. The muted tones of the painting exaggerate the cold, damp atmosphere.

In direct contrast to the subdued palette of Homer's New England works are the luminous, sun-drenched watercolors he painted in the Tropics. Homer once said, "I think Bahamas the best place I have ever found." His

blues are saturated, the skies are cerulean, and the white of the paper is unabashedly exposed to create highlights. In the watercolor *Flower Garden and Bungalow, Bermuda*, shown on the previous page, Homer's mastery of watercolor is on full display. His confidence is apparent, as the white of the paper is used to enhance the appearance of sunlight in the scene. The muted blues of the sky and water are effectively utilized to bolster the colorful chroma of the flowers in the foreground. Homer's watercolors offer a glimpse into daily life on the island.

In the medium of watercolor, there are many ways to decipher one artist's technique from another. For instance, Winslow Homer's watercolors rely upon the white passages of the paper for bright highlights, which capture the effects of sunlight; whereas Andrew Wyeth used a more layered approach, applying muted tones, that resulted in a somber moodiness. Brushwork also plays a key role in the look and feel of a watercolor painting. Because water is the vehicle that carries the color, the artist's reaction to the flow of water is reflected in each painting.

Thomas Eakins (1844–1916) painted portraits of friends, family members, and prominent people in his hometown of Philadelphia. His body of work can be viewed as an overview of intellectual life in the late nineteenth and early twentieth centuries. He studied drawing and anatomy at the Pennsylvania Academy of the Fine Arts in 1861, as well as at the École des Beaux-Arts in Paris with Jean-Léon Gérôme. Upon returning from Europe, Eakins's first works included both oils and watercolors, which demonstrates his interest in oil and watercolor early in his career. In January 1874, he exhibited four sporting scenes (three of them sculling) at the American Society of Painters in Water Colors. One of the more ambitious watercolors Eakins exhibited was *John Biglin in a Single Scull* (1873–1874), which features a rower on the open water of Schuylkill River in Philadelphia. Biglin's muscular forearms and pensive facial expression describe the tenacity of a champion.

Eakins revered watercolor. Therefore, he created studies in oil, lest he ruin the watercolor during execution. This point demonstrates the difficulty of watercolor and the unpredictable nature of the medium, as opposed to the control he was able able to exert over oil paint. In 1875, Eakins turned his attention to America's pastime with his watercolor *Baseball Players Practicing* (1875). One critic compared the achievement to American master Winslow Homer: "Mr. Eakins enters the lists with Mr. Homer, in his 'Ball Players,' with its vigorous contrasts of bright green grass, and the illuminated white and blue of the players' costumes, against a well-devised background." The burgeoning sport of baseball served as the perfect vehicle by which Eakins could explore the anatomical prowess of the athletes, while utilizing the unique qualities of watercolor. The artist's superb drawing skills, combined with the deft handling of watercolor elevated the medium to lofty heights. Thomas Eakins is highly regarded for his portraits in oil paint; however, the watercolors he produced during his lifetime were pivotal and further shifted the paradigm for American watercolor.

Similarly, Andrew Wyeth (1917–2009) is one of the most influential and well known painters in the history of American art. His status is especially exceptional, however, due to the fact that his success is based largely on his work in watercolor. Unlike the majority of historic figures in American painting, Wyeth avoided using traditional oil paint. His detailed works in egg tempera were the only deviation from watercolor.

Andrew Wyeth's approach to watercolor ran the gamut—from loose, abstract splashes to measured glazes. The artist was trained under the strict guidance of his father, celebrated illustrator N. C. Wyeth (1882–1945). He was introduced to egg tempera by his brother-in-law Peter

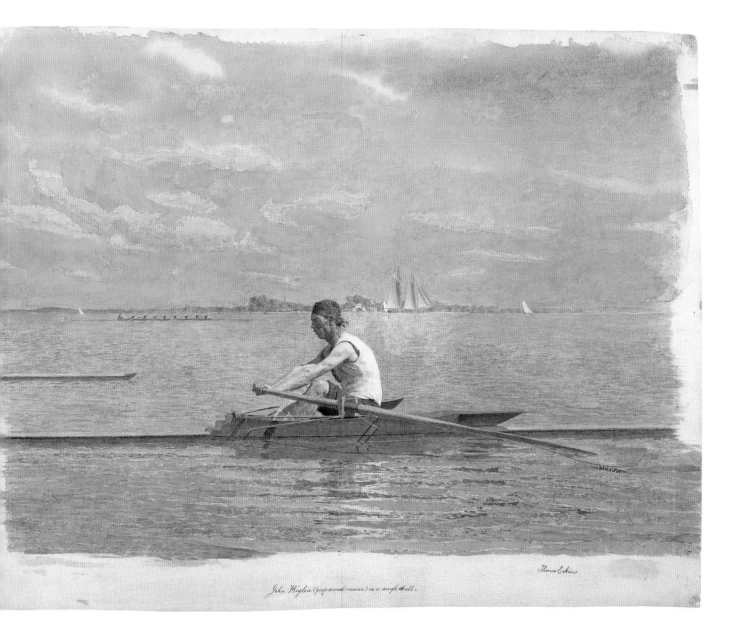

John Biglin (professional oarsman) in a single scull.

Thomas Eakins

THOMAS EAKINS, JOHN BIGLIN IN A SINGLE SCULL, 1873–1874
WATERCOLOR ON OFF-WHITE WOVE PAPER, 19⁵⁄₁₆ X 24⁷⁄₈ INCHES (49 X 63 CM)
COURTESY OF THE METROPOLITAN MUSEUM OF ART (NEW YORK, NY)

The hand of Thomas Eakins is more visible in his watercolors. His deft handling of the medium gives the impression of movement throughout the scene. Eakins's glazes of color are fresh and immediate, enhancing the effect of sunlight bouncing off the rippling waves.

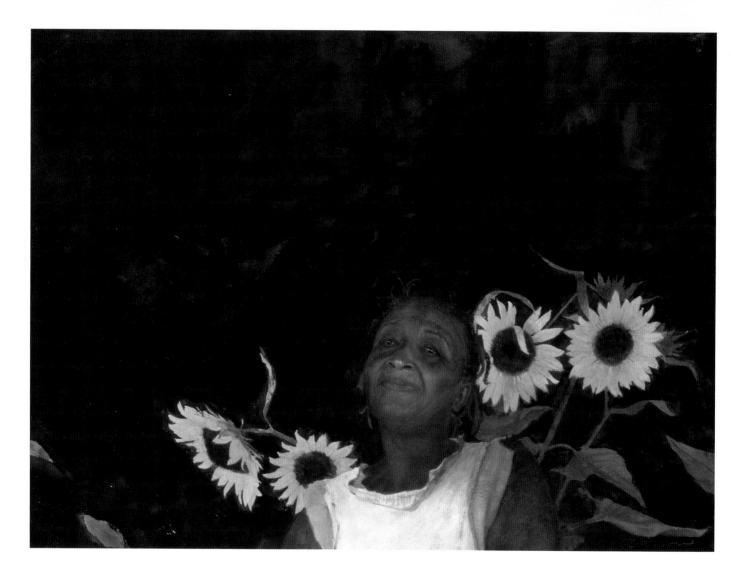

HENRY CASSELLI, SUNFLOWERS, 1993
WATERCOLOR AND DRYBRUSH ON PAPER, 21 X 29 INCHES
(53.5 X 74 CM)
COPYRIGHT © HENRY CASSELLI

The composition in enhanced by the way the sunflowers sweep through the painting and are highlighted by the subject's face in the center. The negative space at the top also directs the viewer's attention toward her smiling face.

Hurd in 1932. The younger Wyeth found a counterbalance between the instantaneous nature of watercolor and the layering effects of tempera.

In October 1945, his father and his three-year-old nephew, Newell Convers Wyeth II (b. 1941), were killed when their car stalled on railroad tracks near their home and was struck by a train. Wyeth referred to his father's death as a formative emotional event in his artistic career. His paintings became more personal and imbued with mystery. The muted tones of his palette appeared somber and emblematic of loss. In 1948, the young artist painted *Christina's World*, featuring a severely crippled woman pulling herself up a grassy hill toward her house. Her face turns away from the viewer and there are no clues as to why she's in the field. The muted tones of the tempera are simply a backdrop, while the pop of pink on Christina's dress dazzles in the midday sun.

It's important to note that Andrew Wyeth began painting bucolic American scenes during the explosion of Abstract Expressionism. His work has long been controversial. As a representational artist, Wyeth created work in sharp contrast to abstraction, which gained currency in American art and critical thinking in the middle of the

twentieth century. Nevertheless, Wyeth was dogged in his beliefs and undeterred by popular consensus.

Wyeth's work vacillates between subjects from his hometown of Chadds Ford, Pennsylvania, and the family's summer home in Cushing, Maine. Between the years of 1971 and 1985, Wyeth drew and painted Helga Testorf, a neighbor in Chadds Ford. He worked with her in secrecy and the result is a study in artistic growth and biological change. The *Helga Series*, as it is called, consists of 63 watercolors, 164 pencil sketches and drawings, 9 highly finished drybrush paintings, and 4 tempera works. The drybrush watercolor *Lovers* (1981) is a moody scene, with a barrage of shadows whipping across Helga's flesh. Her face is obscured in shadow, while a shadowy figure looms in the background. Wyeth's handling of the medium of watercolor is at its highest in this painting.

The contemporary watercolor scene is burgeoning, largely due to the advent of the Internet, which offers artists the ability to search for like-minded individuals. In addition, watercolor organizations such as the American Watercolor Society and the International Watercolor Society have been instrumental in promoting the medium. The societies regularly host competitions, which offer cash prizes, purchase awards, and provide exhibition opportunities to qualified artists. Publications are sources of information that showcase watercolor paintings alongside works in various mediums. This demonstrates the fact that watercolor is taken seriously and not relegated to simply a sketching tool. Major galleries around the country have taken notice and begun to represent watercolorists, based solely upon the merit of their work. This is a sea change, as the default medium had, until recently, been largely oil paintings with rare exceptions.

Just as the twentieth century featured the likes of Andrew Wyeth, Edward Hopper, and a selected few who spearheaded the advancement of American watercolor,

the twenty-first century also has its giants. Henry Casselli (b. 1946) was from the ninth ward of New Orleans, Louisiana. He received a scholarship to study at the John McCrady School of Fine Arts in the French Quarter. In 1966, he enlisted in the United States Marine Corps and was assigned the position of combat artist, where he feverishly recorded the horrific scenes of Vietnam. Casselli had a front-row seat, as he was thrust onto the battlefield within three days of his arrival. His drawings have a frenetic, gestural energy. During Casselli's fourteen months in Vietnam, he produced hundreds of works, which are part of the National Museum of the Marine Corps in Triangle, Virginia.

Following his discharge from the Marine Corps, Casselli returned to New Orleans and focused more intently on watercolor. His depictions of African-American subjects are not stereotypical, rather they represent intimate moments between neighbors with shared experiences. In 1980, Casselli was invited by the National Aeronautics and Space Administration (NASA), in an official capacity, to record the preparations for America's first Space Shuttle launch. His drawings of the astronauts are sensitive and reflect the weight of the impending mission. The watercolor *Sunflowers* (1993) is an arresting image of sunflowers framing the face of his subject, as she looks out into the distance. The slight backward tilt of her head and transcendent gaze connote a moment of repose.

As I became serious about watercolor, I searched for artists who were working in a traditional manner. I was pleasantly surprised to find a few mid-career watercolorists who were exhibiting at museums, galleries, and teaching workshops. I was immediately drawn to the work of Dean Mitchell (b. 1957). His style is evocative of Winslow Homer in terms of the simple and elegant manner in which he applies the paint to his works. The light, airy quality of Mitchell's watercolors distinguishes him from artists who

work in multiple glazes. I am moved by the humanity his portraits exude; however, the manner in which he is able to render architecture is astounding. He is widely known for his depictions of the French Quarter façades, as well as Quincy, Florida, where he was born. Mitchell's work represents working-class Americans and the conditions in which they live.

Mary Whyte (b. 1953) is a watercolorist who garners much of her inspiration from the Gullah descendants of coastal Carolina slaves. Her sensitive depictions of young girls are powerful displays of her love for the people in the region. Her painting style is largely loose, yet highly detailed in selected areas. Storytelling is the hallmark of Whyte's work. The subjects she chooses to paint are generally captured in their everyday surroundings, devoid of decoration or embellishment. It is refreshing to view works of art that reflect people in our society who are not celebrated in the mainstream.

Stephen Scott Young (b. 1957) began his life in Honolulu, Hawaii. He attended Flagler College and studied printmaking for three years at the Ringling College of Art and Design in Sarasota, Florida. Young experimented with oil paints early in his career, however, he was drawn to etching. Young's etchings are comprised of loose, delicate lines and the detailed areas are crosshatched with the precision of a surgeon. The emotive powers of his etchings are reminiscent of Rembrandt van Rijn (1606–1669).

In the mid-1980s, Young began making trips to Harbour Island, in the Bahamas, where he sketched and painted local architecture. Curious children would invariably stop and watch him. Eventually, Scott began to incorporate the children into his watercolors and capture the beauty of the island. In 1994, the overcrowding of Harbour Island led him to move his home and studio to the nearby island of Eleuthera. Posing young children with dark skin against whitewashed or colorful backgrounds became the hallmark of Young's work. The contrast between the children (mostly girls) and the grittiness of the architecture in the scenes creates a fascinating tension.

The watercolor *Zaria*, shown on page 8, demonstrates Young's ability to apply transparent washes of watercolor in a loose, yet confident, manner. The highlighted areas of the child's face lend to its form, while the sun-splashed dress emphasizes the pervasive quality of the Bahamian sunlight. In 1997, Linda Marc wrote: "He has been compared to both Winslow Homer and Thomas Eakins. . . . Young's subject matter is similar to Homer's, who also visited the Bahamas and painted the island's people. Young's sense of drama and his luminous colors seem more like Homer, while his careful execution is similar to Eakins."

The perception that watercolor is a marginalized medium has largely been eradicated. Each medium possesses distinct qualities that allow artists to express their thoughts and ideas. The concept of hierarchy in mediums gives an unfair advantage to one artist over another. It is important to note that every one of the aforementioned contemporary artists has had exhibitions at major American museums in the past few years.

MY OWN JOURNEY

I remember the day I sat down and told my mother I had aspirations to attend an art school. I could see a level of disappointment on her face as she responded, "You know there's a lot of competition out there." It may have been naïveté on my part; however, I was unfazed by her admonition. Rather than saying "no," she was kind enough to use veiled language to deter me. As I grew older, I began to hear murmurings that were similar to my experience and

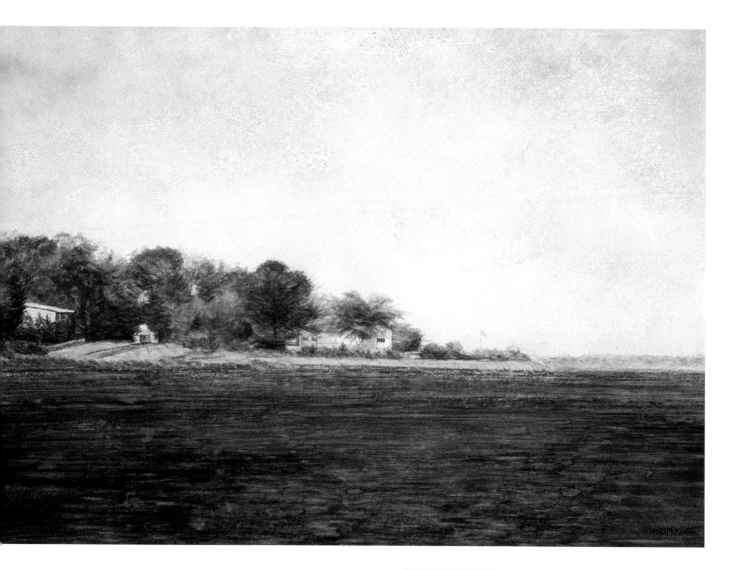

KEYPORT, 2002
WATERCOLOR ON PAPER, 16 X 20 INCHES (40.5 X 51 CM)

Creating a sense of depth in watercolor painting is simply a matter of how much water you mix with the pigment. The foreground was painted using a thicker application of color, which pushes the background back into the composition.

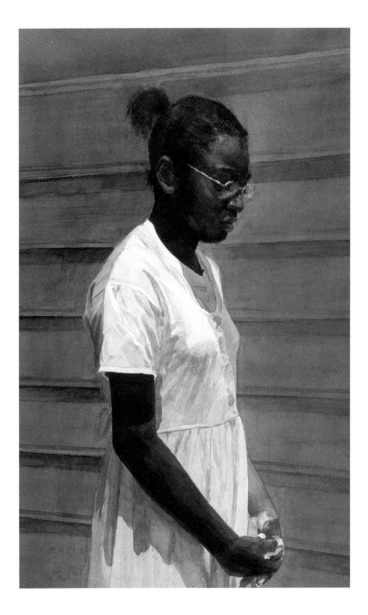

realized my story wasn't unique at all. The truth is a career in art is a mystery to those who live and work in the "real" world—even to creative individuals who aspire to make their living selling art as a commodity.

My mother's statement stuck with me during my time as a student at Pratt Institute in New York. I had a difficult time focusing on assignments that were seemingly irrelevant to the potential of supporting myself as an artist upon graduating. The most valuable lesson I learned at Pratt was the discipline to complete tasks in a timely manner.

I am often asked, "With whom did you study?" The truth is, I was not formally trained in watercolor, as the curriculum didn't offer it during my time as a student. I studied drawing and techniques in oil painting, which gave me a solid understanding of color. The methods I employ in watercolor are a combination of my natural response to the medium, as well as those featured by the artists I've admired throughout the years.

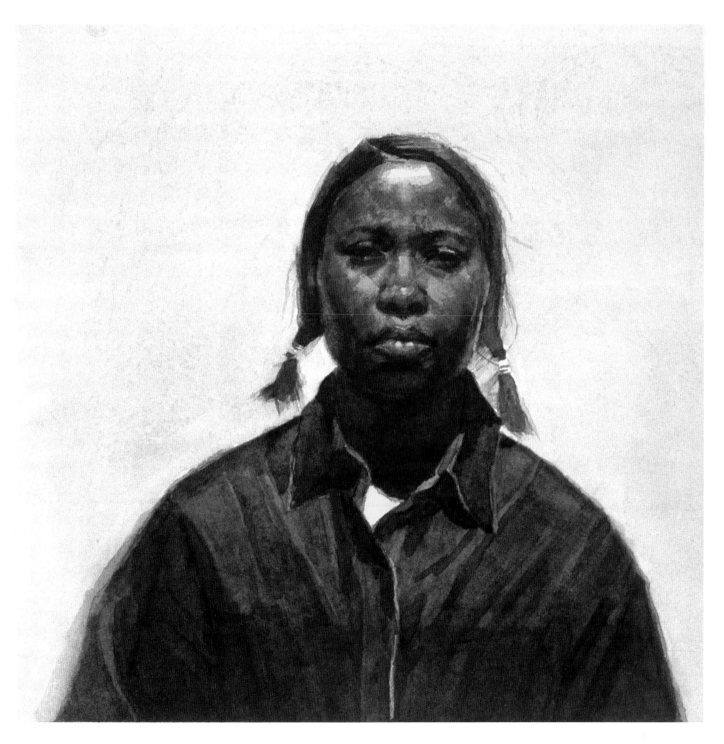

SEA BREEZE, 2003
WATERCOLOR ON PAPER, 10 X 10 INCHES (25.5 X 25.5 CM)

Working in a miniature format allows the artist to exert a great amount of control over the manipulation of the watercolor. The risk of incurring unwanted water marks and other such hazards, which occur during the execution of larger works, is reduced when working on smaller paintings.

Prior to experimenting with watercolor, I studied the work of American masters such as Andrew Wyeth, Thomas Eakins, and Winslow Homer. There were aspects of each artist that I admired. As I began to look deeper into their work, my fear of the medium began to dissipate. The common refrain was that watercolor was a difficult medium that could not be controlled. It was likened unto a wild beast with deadly intentions. The great artists of the past proved, however, that the negative myths regarding watercolor were not true—although a specific mind-set is required when working with watercolor.

The imagery in my work reflects the multifaceted experiences that have shaped my life. I was born in the southwestern region of Oklahoma, and by the time I was eleven, my family had relocated to a coastal town in New Jersey. The horses, cattle, and farmland of the Midwest are familiar subjects for me. I am equally inspired by the sandy beaches, boats, and the frenetic energy of the Atlantic Ocean. The painting *Keyport* shown on page 17, reflects the beauty of the Raritan Bay just a few blocks from the home in which I was raised. The people who populate my paintings are family members, close friends, and a few interesting characters I've been fortunate to spend time with throughout my travels.

My imagination often takes me back to my early days, spent in Oklahoma. I am fortunate to have models in New Jersey who are willing to facilitate the roles of certain characters, reminiscent of my rural memories. In the watercolor *Sea Breeze*, shown on the previous page, I asked my friend to dress up as a "farm girl," despite the fact she had never been on a farm or traveled to the Midwest. There are also instances where a model embodies a particular idea, as in the case of *Safety Pin*, shown on page 18. While visiting my mother in Alabama, I reconnected with a model I paint frequently. As she posed, a button fell off her dress. I could vividly remember moments in my childhood when pins of all sorts were utilized to temporarily mend my garments. That wardrobe malfunction changed the tone and tenor of my entire session with Kenyata.

MY TEACHING METHOD

My knowledge of watercolor has increased throughout the years, largely due to countless hits and misses. I have learned more from making critical mistakes than I have from the more triumphant moments. For example, when I began using watercolor, I wasn't fully aware of the water on a fully loaded brush as I focused intently on areas of my paintings. The result was drops of water running wildly down the surface of the painting, leaving white streaks behind. After ruining a few paintings, however, I became more cognizant of the water's presence. The fact is, moments such as this will occur; however, it's your response to them that determines your growth as an artist.

The technique I presently employ has been refined over time. In the beginning, I worked more directly with color and deepened the values with darker colors in the same range. The result was an oversaturation of chroma. In essence, the warm colors were too warm and the cool colors were too cool. I needed a better balance between the two. In an effort to spend more time identifying the proper values of the subject in the early stages, I decided to begin with a monochromatic underpainting. This allowed me to glaze thin veils of color over established values, placing a high value on the initial groundwork of the painting. As you'll see in the demonstrations on the pages

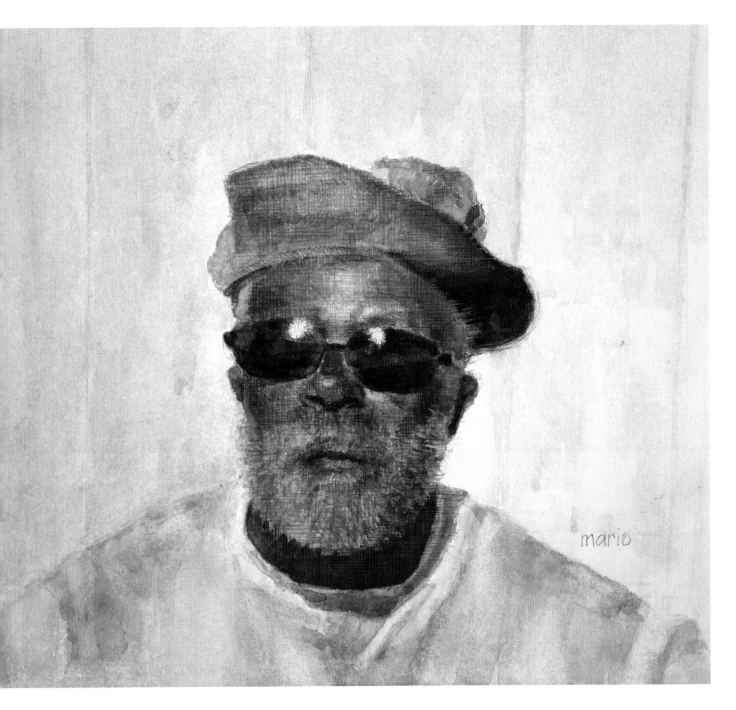

CLEMSON, 2002
WATERCOLOR ON PAPER, 10 X 10 INCHES (25.5 X 25.5 CM)

After painting with the medium of pastel for ten years I began to paint watercolors, as well. The linear crosshatching pattern in this painting is a result of my working habits in pastel. As I grew comfortable with the working properties of watercolor, I was able to loosen up and paint with more confidence.

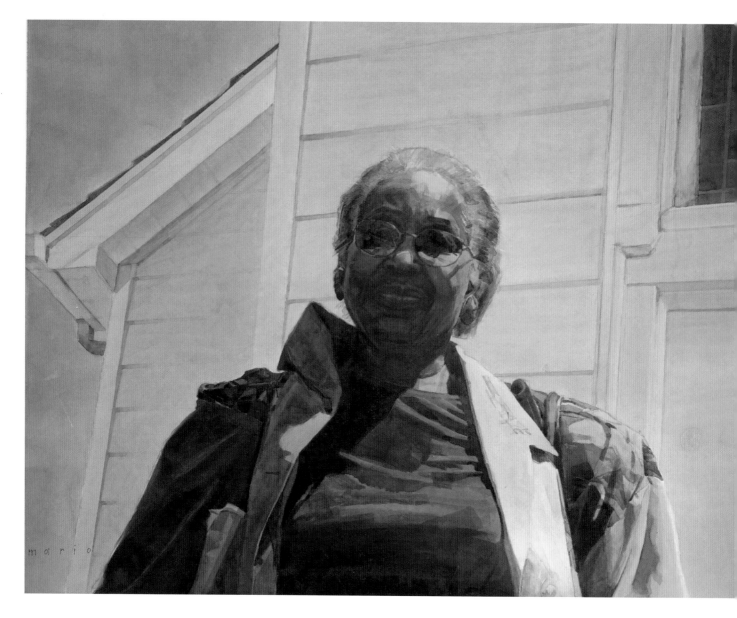

THE KEYPORT NATIVE, 2010
WATERCOLOR ON PAPER, 20 X 25 INCHES (51 X 63.5 CM)

Mrs. Ball was the first person to commission me for a painting, following my college years. It was a pleasure to paint her portrait twenty years later. I posed her on the stairs of the church and positioned myself a few stairs below her. This vantage point was reminiscent of my view of Mrs. Ball in my youth. It's important to personalize your work, whether it's an interesting composition, color choices, or technique.

that follow, this is the technique that I continue to employ to the present day.

My affinity for watercolor has grown in recent years, as I've become less tolerant of the toxins of oil paint and the dust particles of pastel. In most cases, oil paint requires a medium, such as Liquin or turpentine in order to thin it. This allows an artist to spread the paint freely onto the canvas. Even cleaning oil paint from brushes requires solvents. Soft pastels leave residue on the paper's surface, once applied. Removing the pastel "dust" requires the artist to blow onto the painting and release these particles into the air. The spray fixatives associated with pastels are toxic, as well.

These various toxins can generate surprising reactions. In fact, I recently taught a watercolor workshop at an art school where a multitude of mediums were being taught simultaneously. During a break, I wandered into a fellow artist's class to view an oil painting demonstration he was giving. Within a couple of minutes, I had to leave the classroom to get fresh air due to the effect the chemicals had on my system. Watercolor, by contrast, doesn't have any negative effects. Plus, I love how, at the end of a painting session, I can use a wet sponge to wipe down my palette and simply wash my brushes with soap and water.

I have been teaching workshops throughout the United States for ten years. I also receive questions from students all over the world who are enrolled in my online Craftsy watercolor class. Teaching watercolor workshops has given me insight into the mind-set of artists on a beginner and intermediate level. Common mistakes include using the wrong brush for a particular task or loading a brush with either too much or not enough paint. Working too slowly can also be a hazard, causing the water on the surface to dry and form hard watermarks on the painting. The pages that follow are filled with the technical and practical advice that I've given my students over the years. But that's only part of what it takes to be a successful artist.

When I'm in the classroom, prior to addressing issues pertaining to the medium of watercolor, I begin by managing the students' expectations. Painting with watercolor requires tenacity and a willingness to accept mistakes. The learning curve is steep, and the journey will be full of disappointments and setbacks. The good news is that the smallest breakthroughs in watercolor will magnify the quality of your end result. And these moments are great confidence boosters!

Along the journey to becoming the artist you desire to be, there will be highs and lows. Applying unnecessary pressure upon yourself is counterproductive. You should enjoy your creative process, as you relieve your mind of the stress of daily life. My aim is to simplify the process of watercolor, in order for you to enhance your creative adventure.

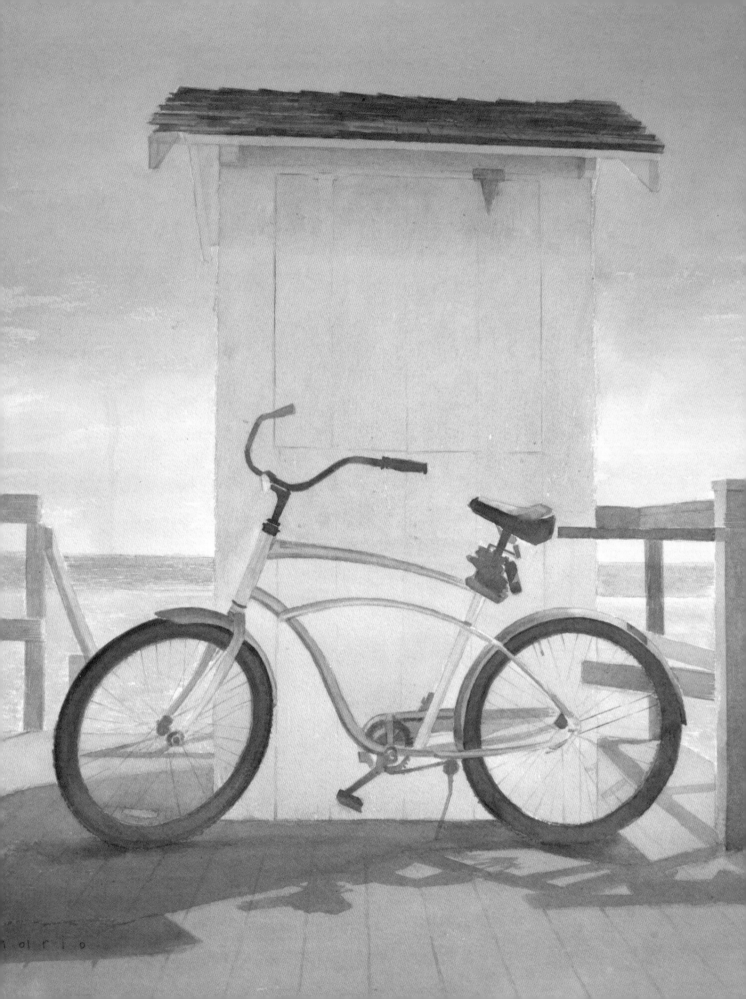

ESSENTIAL STUDIO PRACTICES

"Keep thy shop, and thy shop will keep thee."

—*Benjamin Franklin*

It's important to have proper studio practices—no matter your current skill level. Watercolor is unforgiving, and one mistake can ruin all your hard work. Fortunately, there are a few simple measures you can take to improve your painting experience. Making time to properly prepare your materials can minimize the potential for an unpleasant surprise during the process of painting.

The space you carve out for yourself should reflect your personality and allow you to be comfortable. A studio can be a refuge as well as a source of inspiration from which fresh ideas can flow. There is no industry standard by which a studio is measured. Its functionality is based solely upon the needs of the artist. My creativity soars in an organized atmosphere; therefore, my studio is set up to facilitate my need for order. This concept may not appeal to you. Whatever your preferences, it's vital to listen to your own voice and operate in your comfort zone.

I like to compare my work area to the cockpit of an airplane. Prior to departure, a pilot completes a before-takeoff checklist; likewise, a before-landing checklist prior to arrival. Both lists are tailored for specific tasks. Each item must be carefully considered prior to being checked off the list.

CRUISER, 2015

WATERCOLOR ON PAPER, 22 X 18 INCHES (56 X 45.5 CM)

I enjoy spending time riding my bicycle around town in search of scenic locations to paint. On this particular day, I was intrigued by the interplay of the shadows on the boardwalk. It's important to take advantage of unexpected moments that occur during your pursuit of inspiration.

ORGANIZING YOUR WORK SPACE

Nothing is more personal to an artist than his or her work space and tools. Your work space should be set up to achieve specific goals. For example, making sure you didn't use the last sheet of paper towel during your previous work session will ensure that when a random drop of water drips off your brush and meanders slowly onto a wet area of your painting, you will be prepared—and not find yourself scrambling. We've all experienced such moments. Your work area should also accommodate the occasional splash of water onto a wall or floor.

Some professional artists maintain studios outside of their primary residences; however, the majority of artists have studios in their homes. Working in a pristine area of your home can inhibit your creativity; if you're concerned about ruining a valuable possession, you will not work freely. If possible, choose an area of your home with a low amount of traffic. There's nothing worse than experiencing a burst of creative energy only to have it extinguished by someone asking you "What's for dinner?"

One of the most popular refrains I hear from students concerns the issue of creating art at home. They view the classroom as a sanctuary, far removed from the family members who just happen to have an emergency as they're immersed in the act of painting. I tend to have a lot of mothers in my classes, and the constant notifications from their cell phones prove they are telling the truth. While it may be difficult to garner respect from those who fail to see your "greatness," you can take certain steps to maximize the potential of a home studio. I believe it's the most cost-effective and convenient option for an artist on any level.

I converted our spare room, which is located in a quiet area of the house, into my work area. The room is modest

Working in an intimate space can be a challenge, in terms of space. I use my taboret as an active support for my palette, as well as storage.

in size, and the bare essentials are strategically placed in my space. I mix the colors on my palette with my left hand; therefore, my taboret, which holds my supplies, is located on my left side. My drafting table can be adjusted from a 0 to 45 degree angle, based on the desired flow of the water. Working on a flat surface causes the water to settle immediately and the watercolor stains the fibers of the paper. This stifles the free-flowing nature of the water and offers less spontaneity than a wash.

Having clean water readily available is essential when painting in watercolor. Working with unclean water can taint the color mixtures on your palette. I keep three mason jars filled with clean water next to my palette. The clear glass allows me to see when the water becomes dirty and needs to be replaced. After rinsing the color off my brush, I use my fingers to squeeze out the excess water from the brush. This protects the hairs of the brush. During my painting session, I lay my brushes on an absorbent paper towel to keep them as dry as possible, while resting them. If you're working on a flat surface with all your materials next to your painting, it's good to keep your water jars as far away from your painting as possible. In the frenzy of painting, it's easy to forget that the water jars are there and spill water on your painting.

Your "preflight checklist" may differ from mine; however, in the effort to gain control over the flow of water, as it hits the surface, I take two sheets of paper towel and fold them twice for extra absorbency. Using artist tape, I tape all four sides down next to my painting. Also, I've learned that it's better to be safe when applying color to my work, so I always set up a testing area. This helps to insure, when I'm painting, that my brush is ready to meet the surface of the paper; it also helps prevent random buildup of deposited pigment on my brush. I've learned the hard way that one stroke of undissolved color can ruin a painting.

SETTING UP YOUR PALETTE

As the Brand Ambassador of Winsor & Newton, I have had many opportunities to learn about the artist materials they manufacture. Once, while I was working at a company-sponsored event, the resident artist noticed I had squeezed a large amount of tube watercolor onto each section of my palette. He suggested that I squeeze a small, "pea-sized" amount onto my palette and replenish it, as needed, throughout the day. This turned out to be an excellent tip. Moist paint left to dry on the palette is susceptible to mold as well as dust, and certain colors become brittle. Furthermore, the color becomes less brilliant when it's re-wet and old paint takes longer to dig out than fresh paint. When painting with others in a group, it may appear to be miserly to put such small quantities of paint on your palette; however, the colors will appear more vibrant and alive.

The order in which each individual artist's palette is arranged is a matter of personal preference. I organize my palette into sections, as shown on the following page. The first two colors (left to right), burnt umber and French ultramarine, are the ones that I mix together to achieve my initial block-in. Next, are my most frequently used blues, then my cool and warm reds. I separated the cadmium yellow and raw sienna, in order to keep the raw sienna with my darker colors. The last section contains my dark and warm colors. I keep an additional palette available for colors I use periodically. A well-established palette takes the guesswork out of locating a particular color while painting.

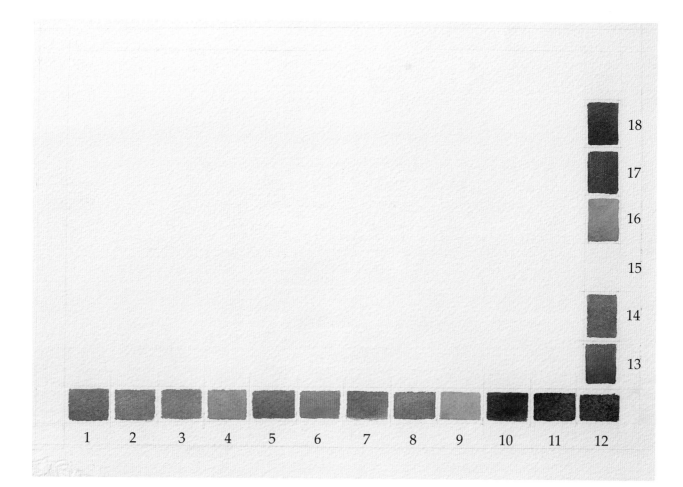

Specifically, these are the colors on my palette:

1. burnt umber
2. French ultramarine
3. Prussian blue
4. cobalt blue
5. cerulean blue
6. opera rose
7. permanent rose
8. cadmium red
9. cadmium yellow
10. sepia
11. Payne's gray
12. neutral tint
13. burnt sienna
14. dark brown
15. Chinese white
16. raw sienna
17. alizarin crimson
18. indanthrene blue

The colors on my palette are professional grade, manufactured by Winsor & Newton. I use these colors for portraits, landscapes, and other genres.

All of the colors that I've listed are manufactured by Winsor & Newton. (Note: The dark brown is a limited-edition color, and may not be readily available any longer.) While I prefer Winsor & Newton paint, several manufacturers produce high-quality pigments. It's important to find the brand that facilitates your creative needs.

STRETCHING YOUR PAPER

If you plan to use a lot of water during your painting process, then it's important that you stretch the watercolor paper to avoid buckling. Heavier papers, such as 300-lb. cold-pressed watercolor paper, may seem sturdy, thereby capable of withstanding multiple washes without warping; however, they are also susceptible. And the painting process is much more enjoyable when you are working on a crisp, flat sheet of paper.

When stretching watercolor paper, time is of the essence. Once the paper begins to dry, it will change shape, so it's important to have the necessary materials handy. I begin by filling a bathtub or sink with cold water and then submerging the paper for 15 to 20 minutes. The paper should be fully submerged and rotated to assure that both sides are equally stretched. While the paper is soaking I prepare my board by layering several sheets of paper towel on it. Personally, I prefer to use a Helix metal edge drawing board when I stretch my paper, but any flat, water-resistant surface will suffice. In the case that I need to stretch multiple sheets of paper, I use my drafting table. Be

As watercolor paper dries, its fibers constrict; therefore, it is necessary to tape or staple it to a sturdy board, such as the Helix board shown here, that won't warp under the pressure.

sure that the support on which you're taping the paper is sturdy. This will help avoid warping once the paper begins to dry.

When removing the paper from the water, pull it out vertically. This will prevent minor damage. Lay your paper on the board, and remove the excess water from the surface by gently patting both sides dry with a paper towel. Then, using artist tape, quickly affix the edges of the paper to the board, and allow the paper to dry in a flat position, prior to working on it. A common mistake is to prop the board up vertically while the paper is drying. This causes the water to flow to the bottom of the paper and pulls the top of the paper away from the board, causing it to warp.

Note: If you plan to work on a large-scale watercolor, an alternative working method is advised. Simply, mount your watercolor paper on a board. There is no need to stretch the paper ahead of time. It will not buckle when it's flooded with large washes, since it will be mounted to a sturdy support.

TIPS

- Gently pat the paper until all excess water is removed from the surface. Wiping the paper will damage the surface of the paper.

- Avoid using a hair dryer to dry the paper. The natural drying process is less harsh on the paper.

- Keep in mind, paper dries more quickly in warmer climates.

CLOTHESLINE, 2010
WATERCOLOR ON PAPER, 9 X 12 INCHES (23 X 30.5 CM)

I painted this watercolor on a 140-lb. piece of Arches paper that was in a block. I generally keep a few blocks, of varying sizes, in my studio. This allows me to work on a new idea without going through the process of stretching a loose sheet of paper.

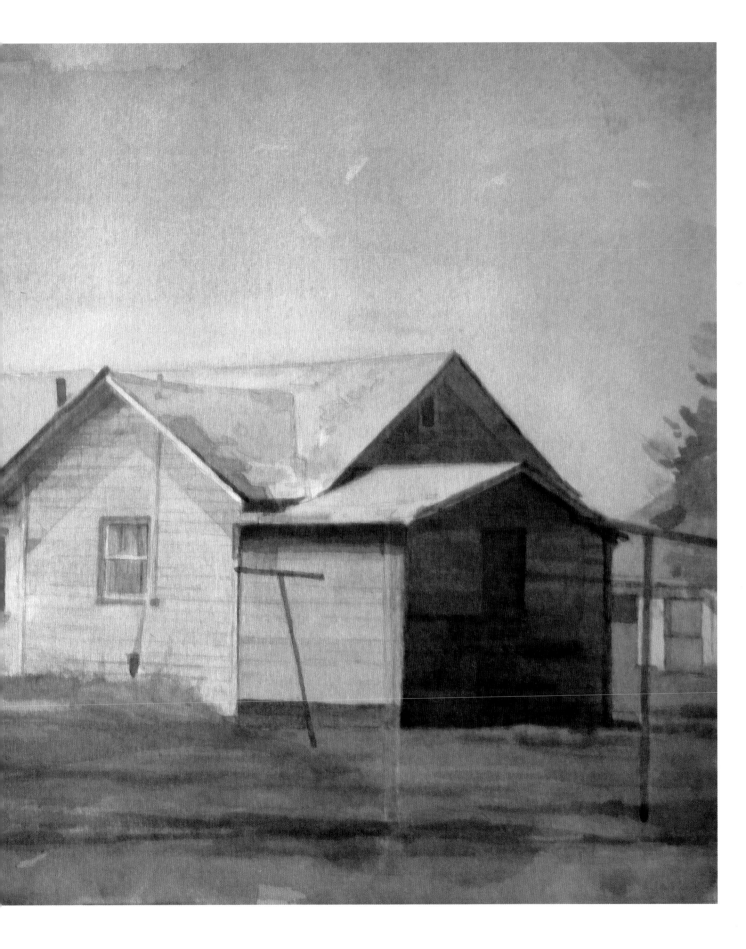

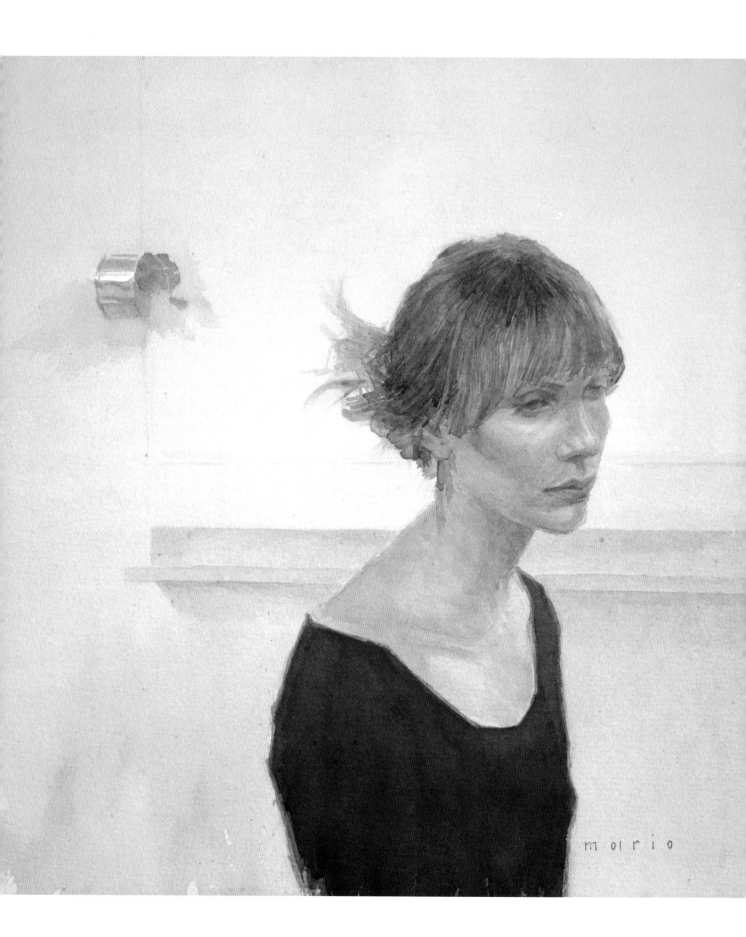

morio

MATERIALS AND TOOLS

"You must try to match your colors as nearly as you can to those you see before you, and you must study the effects of light and shade on nature's own hues and tints."
—William Merritt Chase

If you want to see an artist light up, simply strike up a conversation about art materials. It may sound absurd to a non-artist; however, the length a conversation can last when a single brush is the topic is astonishing. I was recently filmed in my studio for a promotional video featuring Winsor & Newton products. I used a series 7, size 14 brush, which is rarely seen on the market, in the video. The reaction to the video was favorable; however, the comments regarding the brush were overwhelming. Apparently, the "size 14" is beloved all over the world!

Brushes seem to be on the top of the "food chain" in terms of importance to artists, mostly due to the fact that the turnover rate for paint and paper is higher, whereas a good brush will last for decades. My recommendation is to invest in the best brushes you can afford, even if you have to build your inventory incrementally. If your desire is to remain animal friendly, due to your stance on their treatment, seek out a manufacturer that produces the best synthetic brushes.

Shopping for art supplies can be an exciting pursuit, as your mind conjures the new works of art you can produce with your newly found treasures. Your shopping spree must be met with practicality, however, as you counter what you need versus what you want. Consider the time frame in which you'll actually use a particular product you purchase. Some materials do not fare as well as others if they're collecting dust in a closet for long periods of time.

This chapter covers practical approaches to choosing proper art supply materials that best suit your needs. Along the way, I'll make recommendations, based on my observations regarding tools that have improved my painting experience.

JILLIAN, 2015
WATERCOLOR ON PAPER, 14 X 14 INCHES (35.5 X 35.5 CM)
One of the most important factors to consider when painting is determining which materials to use and when. A proper assessment of the area you're painting will determine what you'll need.

PAINT

When I first got started painting with watercolor my primary concern was the cost. I had heard myths concerning the difficulty of the medium and cautionary tales by fellow artists who had tried and failed to meet their goals. It reminded me of bull riding where the rider attempts to stay mounted, while the bull jumps around wildly to buck him or her off. I was on a limited budget; therefore, I needed to be sure that I liked the experience of using watercolor prior to investing a lot of money. With that in mind, I purchased an economical set of Winsor & Newton Cotman tube watercolors.

My first few attempts were not great; however, I didn't have any major disasters either. Once I began to feel comfortable with the medium, I invested in professional-grade paint. I immediately noticed the pigments were stronger and the colors were more vibrant. When choosing paint, there are a few factors to consider. The price of a tube of watercolor is basically determined by the amount of pigment (as opposed to the amount of binders and other artificial fillers) it contains. Simply put, student-grade paint contains less pigment; therefore, it is a more economical option. I recommend that you invest in the best paint you can afford. You can save money by scrimping on other supplies, for sure; however, paint shouldn't be one of them.

I will be the first to admit that when I'm shopping at an art store or online, reading a watercolor tube isn't as exciting as looking at all the pretty colors. However, the label on the tube holds a wealth of information concerning the characteristics of the paint. The location and amount of information on a paint tube varies, based on the manufacturer, however quality paints generally list the following, as shown in the photo opposite (clockwise, from top right):

The use of high-quality art materials can provide a greater possibility of success in your work. This is especially true in terms of the paint you choose.

- manufacturer's lightfastness
- pigment number
- opacity
- the range of the watercolor
- permanence rating
- series number
- swatch of the color
- volume of paint in the tube
- manufacturer's name for the color
- price group (the higher the letter or number, the more expensive the paint); not shown here

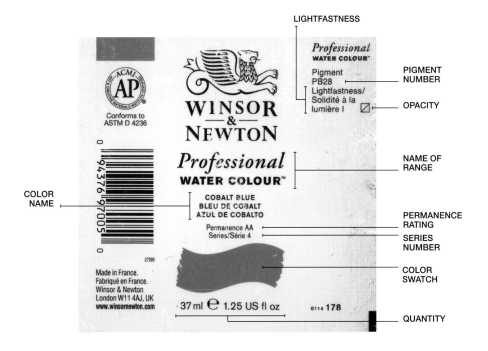

LIGHTFASTNESS

PIGMENT NUMBER

OPACITY

NAME OF RANGE

COLOR NAME

PERMANENCE RATING

SERIES NUMBER

COLOR SWATCH

QUANTITY

Professional
WATER COLOUR™

Pigment
PB28
Lightfastness/
Solidité à la
lumière I

WINSOR & NEWTON

Professional
WATER COLOUR™

COBALT BLUE
BLEU DE COBALT
AZUL DE COBALTO

Permanence AA
Series/Série 4

Conforms to
ASTM D 4236

Made in France.
Fabriqué en France.
Winsor & Newton
London W11 4AJ, UK
www.winsornewton.com

37 ml ℮ 1.25 US fl oz 0114 178

I understand the financial aspect of purchasing materials—the reality of leaving the art store with what you need versus the items you can afford. My advice is to buy the best paint you can, without "breaking the bank."

As you become more experienced with watercolor, you'll develop an acute awareness of your materials and their effect on your work. The manufacturer's labels will help you discern each color's properties.

MANAGING YOUR STUDIO INVENTORY

Keep an inventory of the materials you use regularly, and be sure to make a note when a particular material needs to be replaced. Prior to shopping at an art supply store or online, make a list of the essential supplies you intend to purchase. It's the same principle as why it is a good idea to avoid grocery shopping without a list; if you have a plan, you will be less inclined to purchase items on impulse. And finally, rather than setting out to impress others with costly items that are not functional, I recommend being prudent when you purchase your supplies. Your focus must be on the process of making art.

By allocating an area of my closet for my art supplies, I can keep a tally of what I have used. This removes the element of surprise when searching for a depleted item during the painting process.

PAPER

Watercolor paper is offered in a variety of surfaces, weights, and sizes. The most common surfaces are cold-pressed and hot-pressed. Cold-pressed paper is slightly textured and, therefore, is the kind most frequently used by watercolorists. The bumpy surface is helpful for textural effects, as it soaks up large amounts of water and pigment. Hot-pressed paper is thinner, featuring a slick surface with a minimal tooth. Washes dry quickly on hot-pressed paper, and glazes tend to be more transparent and flat.

Another factor to consider when choosing watercolor paper is weight. I've received an enormous number of questions from artists concerning the measuring system regarding paper. Paper is measured in pounds (in the United States) and grams (elsewhere). This means that you may see a paper that is listed as "300-lb. watercolor paper." But, of course, when you pick up a sheet of that paper, it doesn't weigh three hundred pounds. Manufacturers commonly weigh five hundred sheets (a ream), and use this quantity to identify the weight of each sheet. For example, five hundred sheets of paper, measuring 22 x 30 inches, that is placed on a scale and determined to weigh 140 pounds is offered as 140-lb. sheets of watercolor paper.

Personally, I prefer 300-lb. Arches cold-pressed watercolor paper, which is sturdy and holds large amounts of water. It should be noted that, although the paper is durable, it should be stretched prior to painting on it (as discussed on page 29). Failing to do so will result in warping. There are times when I have a burst of creative energy and want to forego the stretching process. Arches also offers paper in watercolor blocks, which is pre-stretched and glued on all four sides, eliminating the need to wet and stretch the paper before painting.

Throughout your painting session, you may want to use a scrap piece of paper to test a particular color you've mixed, prior to applying it directly to your painting. I keep the discarded scraps of paper from larger sheets I've previously cut down and label them, based on their weight. It's important to test a color on a scrap of paper that is identical to the paper on which you're painting, since the appearance of watercolor is largely determined by the weight and texture of the paper.

BRUSHES

A brush that is good for one artist will not necessarily be suitable for another. There are an abundance of brushes on the market, ranging in price from a few dollars to several hundreds. Finding the right brushes to create your paintings is of great importance, as they will largely determine the appearance of your work. I recommend shopping at a brick and mortar art supply store and asking permission to wet a few brushes so that you can feel their response on a scrap piece of watercolor paper. You don't need color in the wash to check for responsiveness, spring, or the ability to cover a large area.

I have tried a few different brushes throughout my career and have settled on two different hair types: sable and squirrel. Sable hair is soft and absorbs water like a sponge. A good sable brush should have a fine point, which allows for detailed effects. Brushes comprised of

THE INVENTOR, 2009
WATERCOLOR ON PAPER, 18 X 24 INCHES (45.5 X 61 CM)

It can be tempting to try to paint every singular strand of hair, especially when it has a repeated pattern. In this painting, I massed in the shadows, working wet-in-wet using a series 7, size 8 brush. A few areas, such as the curls on the top, received details with drybrush. It's best to maintain simplicity with larger shapes, in order to avoid overworking them.

squirrel hair are typically mop brushes, which are used to cover larger areas of the paper. The strokes are smooth and flat, without the appearance of texture. Brushes are basically divided into two distinct categories: flat and round. There are variations of these types of brushes and we'll discuss this further in this chapter.

FLATS

For a straight edge, such as the clapboards on a house or wires running from an electrical pole, the ideal brush would be a flat. Flats possess chiseled straight edges, which can be utilized for capturing more accurate lines than could be created by using the tip of a round brush. I use flats when painting the façades of buildings, windows, poles, and so forth. Larger flats, such as the ones pictured below, can also be used for painting large areas, such as an open sky. The application of color using the side of a flat brush is primarily for coverage of an area, rather than textural effects.

It's important to explore the full potential of your brushes. Employing various techniques can vastly improve your work. The marks displayed in the image below were created using a ¾-inch, series 295 flat brush. The top row shows a basic stroke. This is a good way to lay down a flat wash of color, while maintaining a straight line. The next three rows show how the straight edge of the brush can be used to make a wide variety of straight lines. This technique requires a flick of the wrist, just as you would place a dot on the letter *i*. If the brush rests on the paper for an extended period of time, the lines will not appear as clean. The fifth line is slightly textured, as it was worked wet-in-wet, and the last three lines display varying degrees of thickness, based upon the angle the brush was held.

ROUNDS

Rounds are the most commonly used brush among watercolor artists. I use series 7 round brushes, which are

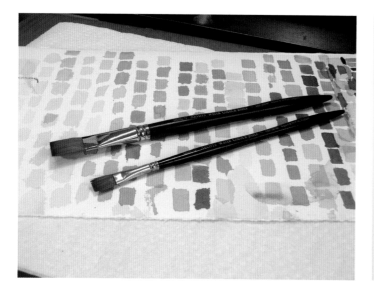

I prefer natural hair when using a flat brush, due to the fine, chiseled edge it makes.

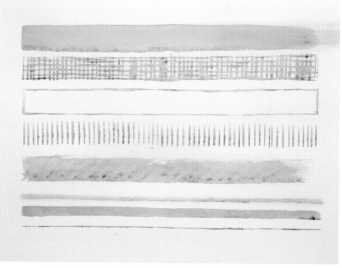

A Winsor & Newton ¾-inch, series 295 flat brush can be used to create a wide range of marks.

comprised of sable hair. From the largest (size 14) to the smallest (size 1), they all perform the same task. The only distinction from brush to brush is the amount of color each holds. I would compare my set of round brushes to a set of flat-head screwdrivers. They are all designed to turn slotted screws; however, they are used for different sizes.

The side of a round brush, when saturated with large amounts of color, can be used to lay in smooth washes and glazes. I also like to create texture in my paintings by removing excess water from the brush and applying drybrush effects. It is important to use the proper size brush when contemplating an area in which to work. Larger brushes are designed to hold more water, and it's easy to lose control when filling in small areas. A good rule of thumb is to think of your brush as a sponge. After assessing the area in which you're working, decide how much water you would squeeze from the sponge to fill in the desired area.

A quality mop brush that possesses a fine point can be a time-saver, allowing you to focus on painting rather than constantly switching brushes. I primarily use mop brushes to lay in flat washes of my underpainting. These brushes hold large amounts of water, and due to their soft hairs, they distribute the paint evenly. The top row on the image above right shows how the side of the mop brush pushes a flat wash across the paper. The next two rows demonstrate how the mop brush performs when held at different angles. The fourth row is a drybrush application, demonstrating broken brushstrokes that can achieve textural areas. The soft appearance of the bottom row is a result of water being brushed onto the surface of the paper, followed by color being applied wet-in-wet. This is my basic approach to painting skies. I always moisten the paper with water prior to laying in transparent washes of blue, which prevents hard edges.

The Winsor & Newton series 7, size 9 round brush is the most versatile brush that I use in my paintings. It holds

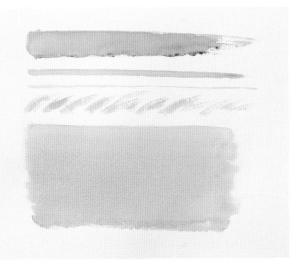

A Winsor & Newton size 5 squirrel mop brush can serve many needs.

CARING FOR YOUR BRUSHES

Never leave your brushes soaking in a container of water. This will weaken the hairs of the brush and eventually cause them to become misshapen. During your work session, I recommend you dip the used brush into a clean container of water, squeeze out the excess water, and rest it on a paper towel.

When cleaning your brushes (for instance, at the end of a painting session), gather them into your hand and place them under cold running water. Swirl them around on a brush cleaner and work the soap through the bristles and into the ferrule. Work the soap downward toward the tip of the brush and rinse them under cold water until all color is no longer evident. The brushes should be reshaped and allowed to dry vertically (with the hairs pointing down) or on a flat surface.

When storing your brushes for any length of time, be sure they are clean and dry before placing them in a sealed container. Mothballs can be added as a moth deterrent, but these shouldn't be solely relied upon as a sure preventive.

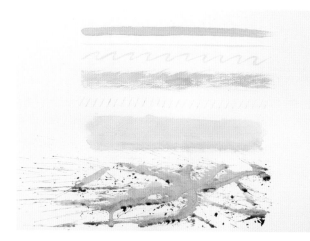

A Winsor & Newton series 7, size 9 brush can be used to create an extraordinary range of strokes.

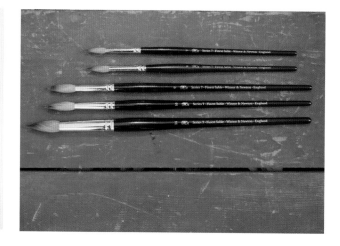

Kolinsky Sable series 7 round brushes are extremely versatile and are widely regarded as the finest watercolor brushes on the market.

loads of water for broad washes, as well as has a reliably fine tip. The top row in the top left image is a standard stroke, using the tip of the brush, while applying pressure. The second row shows a stroke with less pressure on the tip. The third row is a good example of how much water this brush holds, as I only reloaded the brush once to achieve the squiggly line. The fourth row is a drybrush technique, executed with the side of the brush. The fifth row demonstrates various effects created with the tip of the brush to show the brush's versatility, which is rare for its size. The sixth row is a wash into clean water, and the bottom row is a basic splattering technique.

Kolinsky sable hair brushes have a large color-carrying capacity, which simply means each stroke is consistent. You can use the side of the brush to deposit a larger area of color or paint with the fine point to create a precise line. Kolinsky sable can be expensive; therefore, a less costly option could be the way to go. For instance, the Sceptre Gold II is made from a mix of sable and synthetic fibers.

Winsor & Newton's pure squirrel brushes are excellent for laying in large washes. The squirrel hair is relatively

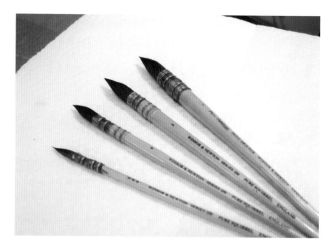

Squirrel brushes are an excellent choice for creating smooth, flat washes for building façades or skies.

thin and conical in shape, which allows the brush to hold large amounts of color. These hairs come to a very fine point and are responsive. I generally use them to lay the groundwork in the initial layers of color. Their action is fluid and useful for large, flat areas.

DRAFTING TABLE OR EASEL

Whether you work at an easel, tabletop easel, or drafting table, your primary goal should be comfort. Each has its advantages, and you may find that your needs change, depending upon the circumstance. When painting from life, for instance, I use an easel for greater access to the model rather than the drafting table, which can get in the way. The upright position makes it easier to translate the information from the model to the paper.

By contrast, when working in my studio, I prefer to work at a drafting table (such as the one shown on page 26). The main advantage of both a drafting table and a table-top easel is that they can be adjusted to the desired incline, and this can be changed as your skills develop.

There is absolutely no need to work vertically if you're anxious about the water's movement. At first, you may even find the rapid pace at which the water flows when your easel is set at a 45-degree angle to be daunting. However, as your confidence grows, you'll become more comfortable with the pace. In time, I recommend you try working at a more vertical angle, as you'll notice the difference in the appearance of your work once you allow the water to flow more freely. The pigments don't settle into the tooth of the paper as aggressively and the water can be moved around with a brush easier while it's on the move.

OTHER STUDIO SUPPLIES

Artists are generally creatures of habit, and I am no exception. My watercolor setup has been the same since I began painting watercolors more than a decade ago. Knowledge about how the materials will perform during the painting process generates a certain level of confidence.

PALETTE

Watercolor palettes are made of either plastic or porcelain. The most common palettes have small sections around the outside and a few sections in the middle for mixing colors. Other palettes have one flat section for mixing colors, which makes it conducive to working wet-in-wet. I prefer to mix my colors in a plastic palette that resembles a muffin pan. I use the six-well, four-well, and two-well versions. Each well is 1 inch (2.5 cm) deep and enables me to mix large amounts of color without the risk of running

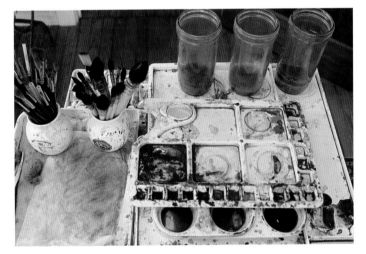

I use three jars in order to insure that the water I have accessible remains clean during my painting session. I clean my brushes in one jar at a time and once they're all dirty, I refill them with clean water. This also serves as an opportune time to walk away from the painting and return with fresh eyes.

out of a particular color. It's important to note that mixing colors can be tough on brushes; therefore, it's best to use an inexpensive brush that can easily be replaced.

SPRAY BOTTLE

A good spray bottle is an invaluable tool. You may find small, travel-sized bottles at the art supply stores; however, they hold small amounts of water and are only useful for spritzing. I use a large, 32-ounce professional sprayer, commonly used for pesticides and cleaners. My painting technique involves using thin washes of color, containing a lot of water. I mix the colors for my paintings in a muffin pan, prior to applying them. If the colors need to be adjusted, I use the large spray bottle to dilute the mixture. A large spray bottle is also instrumental to wet larger areas of the paper for wet-in-wet techniques.

PAPER TOWELS

This may be stating the obvious, but during a painting session it's a good idea to have a sheet of paper towels readily available. As I begin my work day, I tear off a sheet of paper towel, fold it, and place it in my back pocket. I don't want to struggle with the roll of paper towels when a potential accident is occurring. Paper towels are also useful for lifting damp areas that are light in value, such as white pickets of a wooden fence.

PENCILS

There may be areas of your painting where you would prefer a loose appearance to offset the more rendered ones elsewhere. I recommend settling these and other issues in preliminary sketches and value studies, prior to beginning a painting. The spontaneous nature of watercolor can be alluring, but in practice the act of painting with watercolor works best within the framework of a solid drawing. Think of watercolor as jazz. Although the common perception is that jazz musicians play their instruments with reckless abandon, it's not true. They conform to a musical language of chords and syncopation, while riffing on those expressions.

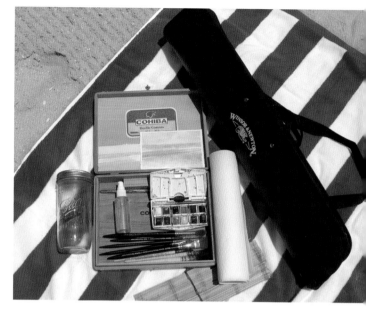

I like to make a checklist prior to painting outdoors. It can be a setback to your painting experience, depending on what you forget to bring to your painting location.

To execute a detailed drawing I use a lead holder, which holds graphite lead. I have found that softer graphite, such as B, 2B, 3B, and so forth, tends to bleed into the watercolor when wet. Using a 6H, I lightly apply a line drawing. The point of the lead is extremely sharp; therefore, an excessive amount of pressure will score the paper, resulting in trapped color in the grooves. Whether or not to erase pencil lines from the final painting is a matter of taste. I leave the lines in my paintings, unless they're in a distracting area. If you choose to remove them, once the painting is completely dry, use a kneaded eraser to remove the unwanted pencil lines.

ARTIST TAPE

Using artist tape protects the surface of the paper, and the tape possesses a low adhesive. I prefer the white tape, as colored tape can be distracting to the eye. I use artist tape to maintain a clean edge on the borders of my watercolors. I also utilize it when stretching loose sheets of watercolor

paper. More affordable tapes are available on the market; however, they are more destructive to the paper.

PLEIN AIR SUPPLIES

En plein air is a French expression that means "in the open air." While it is a challenge to capture the essence, movement, and atmospheric changes that arise in outdoor painting, it is well worth the time spent. This activity is extremely rewarding and enjoyable; however, it does require its own set of supplies. A few of the more common ones are listed here.

EASEL

I use the Winsor & Newton Bristol watercolor easel, which is made of lightweight aluminum and, therefore, is easy to transport. If you are planning to paint outdoors, you'll need to bring something to anchor the easel. I generally use my tote bag to secure the easel.

COMPACT PALETTE

I use a Cotman Field Box, which contains twelve half pans of color and three removable trays for mixing color, and is airtight. I replaced the Cotman pans of color with Winsor & Newton professional-grade artist pans.

BRUSHES

When painting *en plein air*, it's best to use brushes that can be readily replaced. Painting outdoors is not a controlled activity, and you always run the risk of losing items or destroying them.

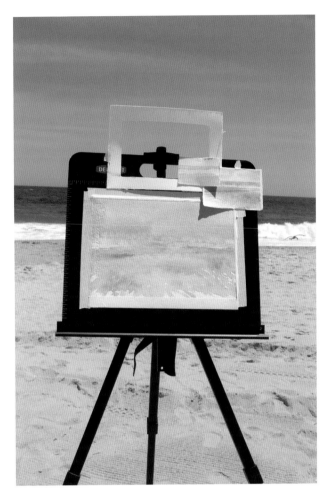

Painting outdoors requires patience and a willingness to "go with the flow." When I paint *en plein air*, my painting style is looser, as I negotiate the constant changes in the atmosphere. Here is my easel set up, with my thumbnail sketches close for reference. Also notice my viewfinder, which is taped to the board.

TIPS

- Be sure to drink plenty of water, in order to remain hydrated during long periods of sun exposure.

- Wear sunscreen, even in the fall and winter months.

VIEWFINDER

When surrounded by the vastness of nature, I find decid-ing what to include in a scene can be a daunting process. I always bring a viewfinder and attach it to my easel. This helps distill the amount of information upon which my eyes can focus. I also find it helpful when composing a scene, as it narrows the area of focus and allows me to focus on the specific, rather than the general.

ADDITIONAL SUPPLIES

Be sure to bring pencils, a container for water, a spray bottle, paper towels, and whatever personal effects you

A hat with a sizable brim will protect your head and face from dam-aging UV rays of the sun. If you plan on painting in intense sunlight for an extended amount of time, consider attaching an umbrella to your easel for shade.

might need to protect yourself from the elements (such as sunblock, a broad-rimmed hat, and an umbrella). I prefer to keep my load light when transporting materials in the field, just in case I have to walk a long distance. I stretch a few sheets of paper in advance and tape them to a light-weight board.

PLEIN AIR DEMONSTRATION

In this exercise, I spent the day painting at the beach. The ocean is a place of solace for me, and I thoroughly enjoy the atmosphere. I have artist friends who live in various parts of the country, and they are all inspired by the scenes surrounding them. The most familiar scenes for me are near my home along the Atlantic Ocean.

STEP 1

ONCE I CHOSE MY PAINTING SPOT on the beach, I painted two small thumbnail sketches, in order to identify the color relationships and study the scene in the most basic manner. The first sketch is almost abstract, as I wanted to refer to this sketch while painting the larger watercolor. In the second sketch, I wanted to insure that I had mixed the correct colors and, therefore, my brushwork is more active. I also wanted to prepare myself for the water application and which areas would be worked wet-in-wet.

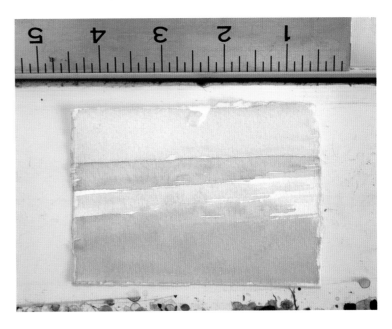

THUMBNAIL SKETCH, VARIATION #1
WATERCOLOR ON PAPER, 3 X 4 INCHES (7.5 X 10 CM)

In an effort to highlight the most important aspects of the scene, I began with the basic shapes in a small sketch.

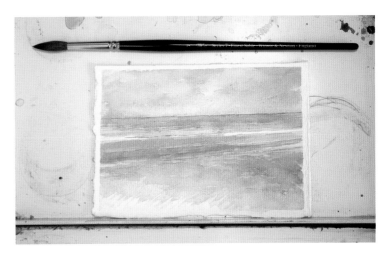

THUMBNAIL SKETCH, VARIATION #2
WATERCOLOR ON PAPER, 3 X 4 INCHES (7.5 X 10 CM)

In preparation for the final painting, I laid in brushstrokes to mimic the ones I would use later.

STEP 2

WITH THE KNOWLEDGE of the second thumbnail sketch fresh on my mind, I quickly drew three horizontal lines with a vanishing point that is outside the composition. The simplicity of the drawing allows me the flexibility to edit elements of my painting as the weather conditions change.

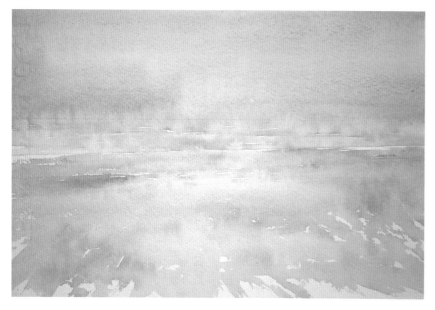

STEP 3

I BEGAN AT THE TOP of the composition, applying water to the paper and brushing small amounts of cerulean blue. I worked each section wet-in-wet, moving downward. The light changed sporadically during the day, therefore I forwent the monochromatic block-in stage, which I typically do when painting outdoors, in order to save time. The ocean and sand colors here were variations of Payne's gray, dark brown, raw sienna, and burnt sienna.

STEP 4

AS THE LIGHT BEGAN TO CHANGE, I decided to stop painting and pack up my supplies. The experience of painting on location is rewarding in a plethora of ways. My expectations are measured, as I am solely interested in observing nature in its entire splendor. I always enjoy the experience, regardless of the outcome of my efforts.

SKETCH OF THE ATLANTIC, 2015
WATERCOLOR ON PAPER, 12 X 16 INCHES (30.5 X 40.5 CM)

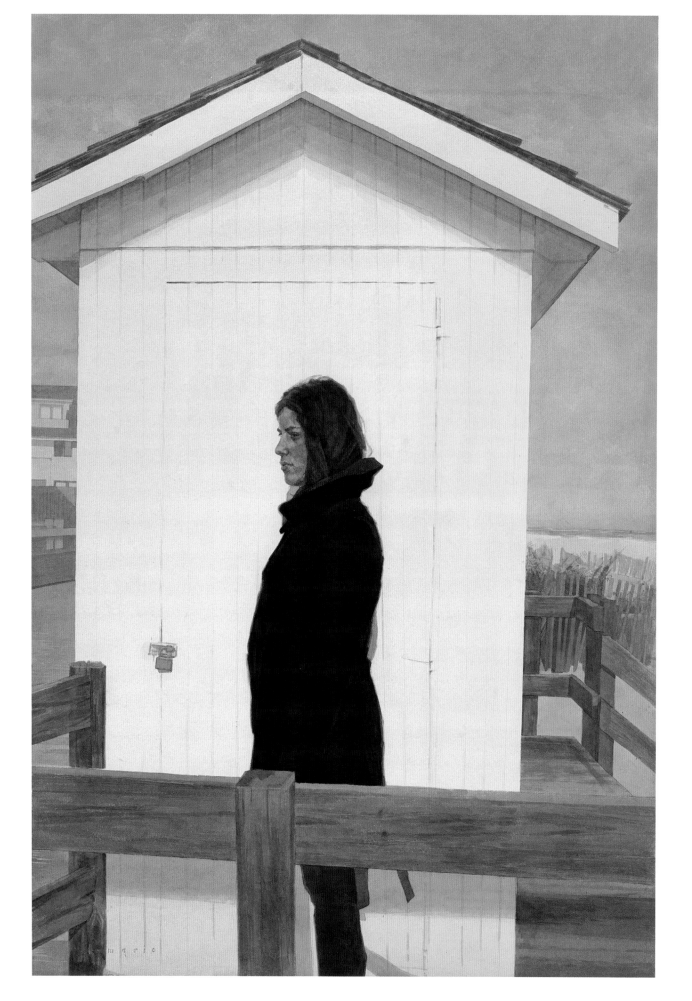

EXPLORING YOUR SUBJECT

"The aim of art is to represent not the outward appearance of things, but their inward significance."

—*Aristotle*

I am often asked, "Why do you paint people?" The simple answer is: my fascination with the human condition and our emotional response to it. I'm drawn to people and places with a complex story that evoke an emotional response from the viewer.

One of my favorite activities is visiting the Metropolitan Museum of Art in New York. The museum's permanent collection offers an intriguing walk through history, as the imagery reflects cultures from around the world. The artists recorded the architecture, fashion, local customs, and important historical events that predate photography. Our connection to history would be significantly minimized without documentation of these aspects of earlier cultures.

I live in Point Pleasant, New Jersey, which is well known for its commercial fishing industry. The appearances of the modern-day fishermen who populate the docks differ drastically from the men in Thomas Eakins's depiction in his watercolor *Taking up the Net*, shown on the following page. Eakins painted this scene of Gloucester, New Jersey, more than one hundred years ago. While the fashion and technology have changed, the backdrop of nature in which the subjects are working is similar to the New Jersey vistas I capture today.

Telling a compelling story doesn't have to be as complicated as it may seem. Subtle changes in a subject's facial expressions or body language can convey a range of emotions. The setting in which your subject is placed provides context and broadens the viewer's understanding of your overall vision. In *Ticket Booth*, shown opposite, I wanted to crystallize the ideas I had concerning the end of a long summer at the Jersey Shore. The woman's position is paramount, as she turns her back to the ocean, which is the main attraction for tourists. Her expression of melancholy is antithetical to the typical behavior exhibited by beachgoers during the high season.

TICKET BOOTH, 2011
WATERCOLOR ON PAPER, 40 X 27 INCHES (101.5 X 68.5 CM)
The contrast between the whitewashed ticket booth and the dark silhouette of the subject places the emphasis squarely upon the model. The muted tones in the background quiet her surroundings, as the warm tones in her face are the only hints of color, therefore attracting the attention of the viewer.

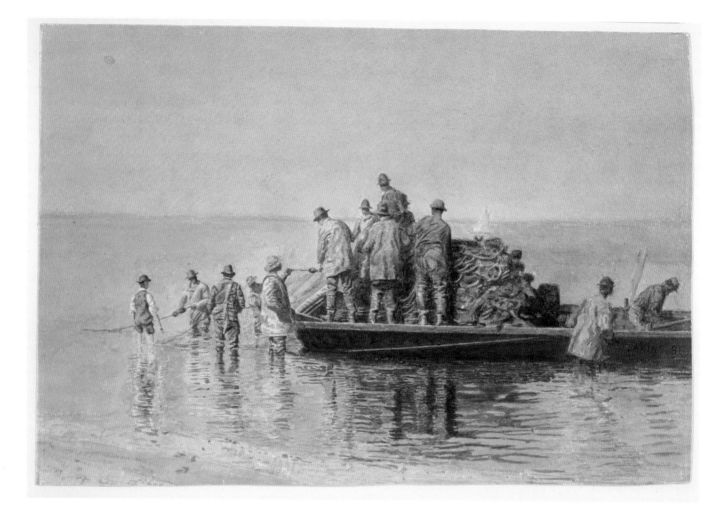

If you want to distinguish yourself from artists who solely possess technical prowess, it is essential for you to personalize your work. The art market is flooded with images pointing toward the creator of the work and his or her technical prowess, but many of these paintings are devoid of a meaningful dialogue with the viewer. While there are no hard and fast rules governing the content of an artist's work, it is cathartic to share your feelings—and rewarding, as well.

The depth of my work depends largely upon the subjects I choose to depict. I find the beauty of everyday people, such as the gentleman depicted in *Today We Count*, to be a bountiful source of inspiration. My desire is to give a voice to the voiceless members of our society. I respect

THOMAS EAKINS, TAKING UP THE NET, 1884
WATERCOLOR ON PAPER, 9⁹⁄₁₆ X 14⅛ INCHES
(24.5 X 36 CM)
COURTESY OF THE METROPOLITAN MUSEUM OF ART
(NEW YORK, NY)

Thomas Eakins created a sense of depth by applying a minimal amount of light washes to the background, while using heavier glazes in the foreground. The level of realism is raised with his handling of the reflections in the ripples of the water.

the vision of contemporary artists; however, I seek to bring balance to the art world. At times, it resembles a beauty contest, rather than a reflection of the broader world in which we reside. It's important for me to challenge the status quo with images that offer the viewer more than beauty that appears on the surface.

IDENTIFYING KEY DETAILS

It is fascinating to consider the degree to which apparel and jewelry affect our personas. A new pair of shiny gold earrings can boost one's self-confidence and enrich an otherwise mundane experience. I rely heavily upon clothing and accessories to communicate my ideas, while providing a glimpse of my subject's everyday life.

CLOTHING

The clothes we choose to wear represent our personal style. People have a tendency to make judgments based upon their perception of what a particular person is wearing. The majority of people who comment on the painting of Charles Jones, on the following page, believe

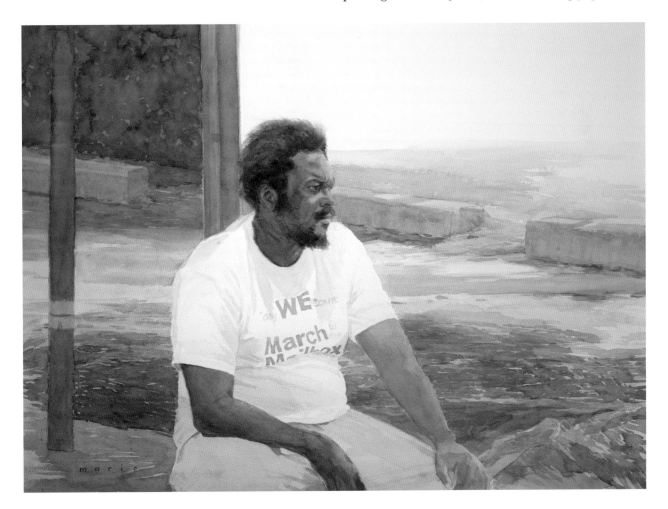

TODAY WE COUNT, 2013
WATERCOLOR ON PAPER, 18 X 24 INCHES (45.5 X 61 CM)

I rarely include written text in my work; however, the statement on this homeless man's T-shirt, referencing voting rights, was difficult to omit.

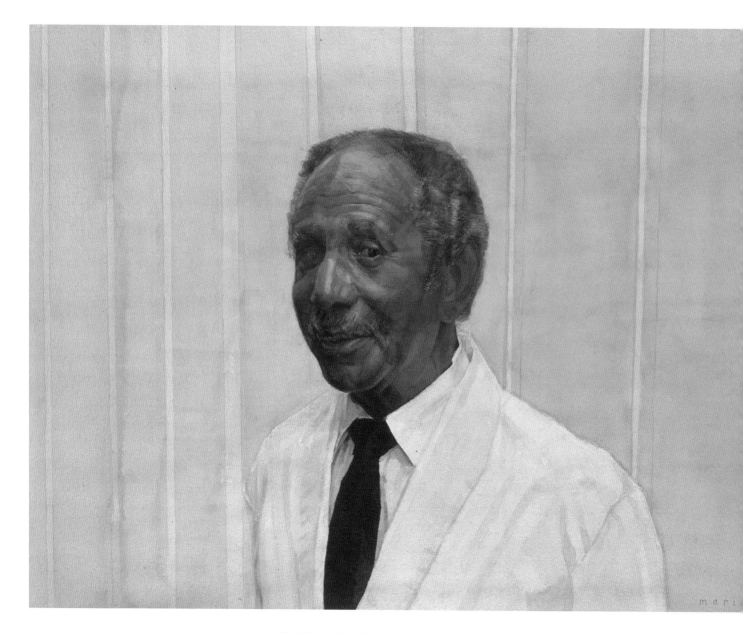

CHARLES, 2008
WATERCOLOR ON PAPER, 22 X 30 INCHES (56 X 76 CM)

Mr. Jones's face had so much character in it. I used multiple glazes, as well as a considerable amount of drybrush, to capture the intricacies of his skin. I decided early in the process to apply the glaze layers and embellish the highlights, using Chinese white. This allowed me to work in a holistic manner.

he is wearing a lab coat and, therefore, assume he is a physician. The simple reality is that he's a bartender in Charleston, South Carolina, and a deacon at his church.

Clothing can be a powerful tool when you're communicating with viewers of your work. The painting of Mr. Jones demonstrates the ingrained stereotypes we apply to individuals on a daily basis. The esteem in which many observers hold Charles, prior to finding out he's not a doctor, is high. The mood they express after I tell them his modest backstory is generally melancholy. I am not an artist who paints commissions for clients; therefore, I don't portray a person in a stereotypical fashion upon request. For instance, when painting *Dr. Hallett*, shown above, I found it important to allow his humanity to shine through without the baggage of status. I avoided the trappings of his profession and simply displayed the man. My work

DR. HALLETT, 2005
WATERCOLOR ON PAPER, 9 X 12 INCHES (23 X 30.5 CM)

The light in this painting is a combination of thin washes of color in light areas and glazes of Chinese white, heightened with drybrushed strokes of white paint. The reflected light underneath the subject's chin was achieved by mixing Chinese white and neutral tint. Chinese white is an opaque pigment and should be applied in thin layers.

celebrates the humanity of all people in our society in equal fashion, regardless of social status.

I am fascinated by the personal style of the individual. Whether it's the uniform on a soldier, the formal attire of a churchgoer, or the casual outfit of a teenager. We all make statements to the world through our clothing. The job of an artist is to speak clearly to the viewer when expressing a particular point of view. It's important to decide what you seek to communicate through your model. In my work, I am seeking to reconcile the America of my childhood and

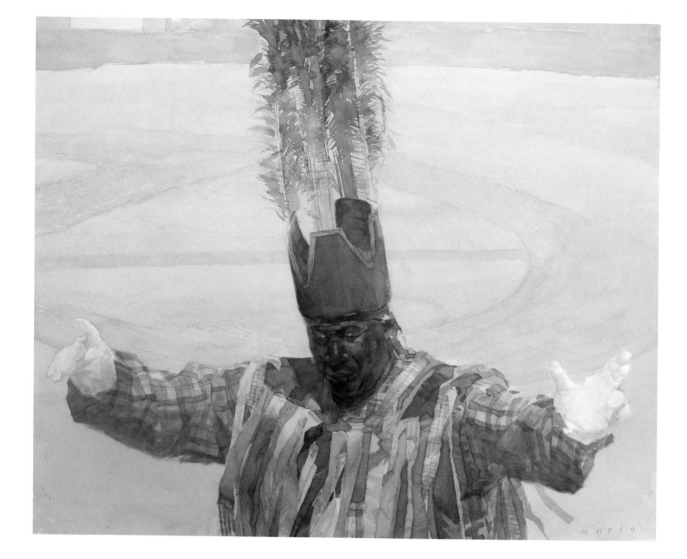

ST. KITTS MASQUERADE DANCER, 2014
WATERCOLOR ON PAPER, 20 X 22 INCHES (51 X 56 CM)

I thoroughly enjoy painting patterns. For me, it's akin to placing the pieces of a puzzle in their proper place in order to create an image. I used a combination of the wet-in-wet technique and a series of glaze layers to prevent the plaid from appearing too stiff and regimented.

the one in which I find myself as an adult. In the effort to present a timeless quality in my work, I take a step back to the time when young girls would wear dresses to school and even play in them afterward. I enjoy shopping in the Salvation Army and vintage stores to find clothing that conjures those shared memories we hold dear, as Americans.

Sometimes I find a person's personal style interesting and decide to paint that individual in his or her own clothing or uniform, especially when it strikes me in a profound manner. During a cruise to the Caribbean a few years ago, the ship docked in St. Kitts. I stumbled upon a large group of men dressed in colorful costumes. They were dancing to drums and chanting for the entertainment of tourists. One of the dancers was more enigmatic than the rest, as he was the leader of the group. I was compelled to single him out and paint his portrait, shown above.

When choosing the apparel for your model, keep in mind that you will be painting it. I have had students begin the drawing for a portrait from a photograph, only to confront a laborious amount of detail in the clothing. Their response to the issue was to eradicate the pattern on the subject's clothing, which left the painting flat. Small repetitive patterns or thin meandering lines present a set of challenges for which you will need to be prepared. I prefer plaids and stripes, as they exemplify a sense of Americana. These kinds of patterns

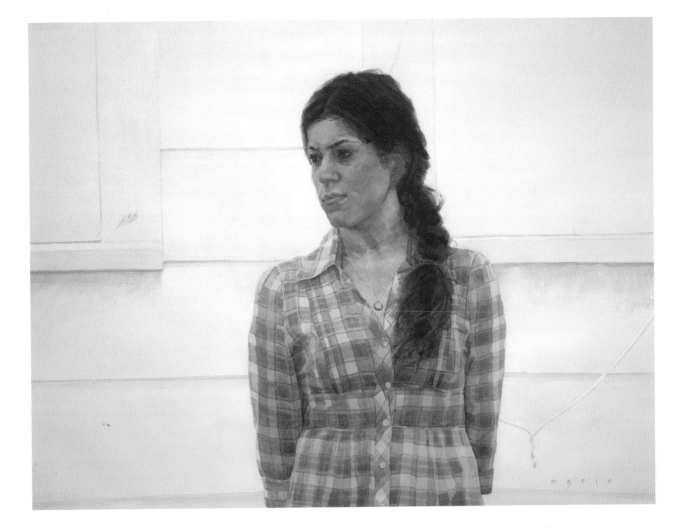

POINT PLEASANT LOCAL, 2013
WATERCOLOR ON PAPER, 22 X 30 INCHES (56 X 76 CM)

I painted the plaid pattern of the model's dress, paying close atten-
tion to the contours of her body. The position of each stripe and
square on the dress gives the figure a three-dimensional appearance.

also enhance the form of a subject's body and create a three-dimensional effect.

The repeating patterns of the dress in *Point Pleasant Local*, above, roll over the contours of her body and give the appearance of depth. This illusion is based largely upon the interplay between the light areas and the shadows. The light squares, which are more exposed to the light, appear to come forward and the darker squares seem to recede. The dress possesses a sense of realism, based largely upon the changes in value.

When preparing to paint Staff Sergeant Jacobs I vacillated between a few different poses, before settling upon the one you see on page 56. My first instinct was to project my personal feelings, based upon my own service in the United States Army, toward the uniform. But then I realized how easy it is to forget that, beneath the uniform, there's a human being with individual hopes

and dreams, so I decided, instead, to focus on who she is and represent her as a soldier. Her body is angled away from the viewer in a nonconfrontational manner and her expression is relaxed. Her eyes reflect the strength and resilience of a soldier, while retaining her femininity with eye shadow, which matches her uniform. My goal was to humanize her while celebrating the sacrifices our men and women in uniform make for all American citizens.

When I first started painting with watercolor I needed to confront the various textures of clothing. I noticed that summer apparel is lighter in weight, and the colors tend to be brighter. Fall and winter outfits, by contrast, lean

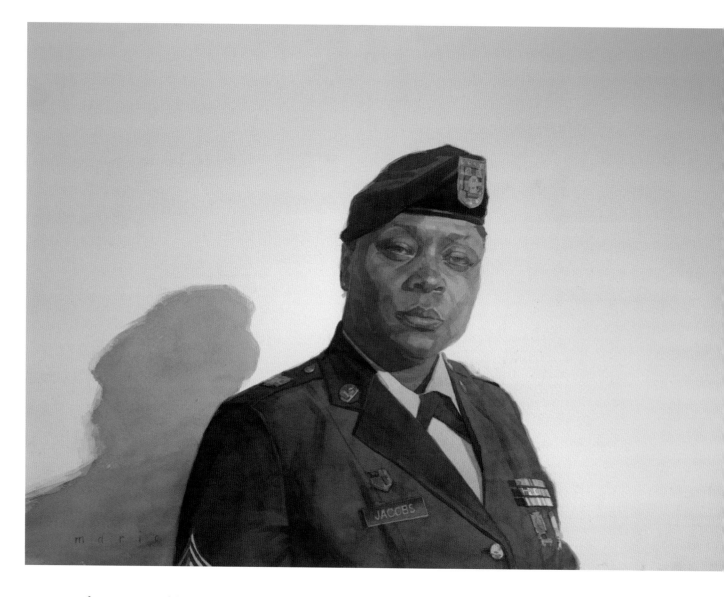

toward more textured fabrics, and the colors are darker and subdued. I found that lighter clothing presented a far greater challenge for me than darker clothing. There is an inherent beauty in the contrast between light and dark objects in sunlight.

Shadows should be painted wet-in-wet, in order to avoid a stagnant, cutout appearance. I achieved the shadow in the watercolor by turning the paper on its side and allowing the water to flow away from the sleeve of the model's dress on the opposite page. Then, I flooded the desired shadow area with water, which gave me an extended amount of time to introduce the color. If you

STAFF SERGEANT JACOBS, 2012
WATERCOLOR ON PAPER, 18 X 24 INCHES (45.5 X 61 CM)

When painting clothing outdoors, I aim to be efficient with the number of glaze layers I apply, since the more layers I use, the less light will be reflected from the paper and the more objects will appear opaque. Her jacket has a sense of light, while the darker tones maintain a certain depth.

notice a hard edge forming when painting a delicate piece of clothing, such as this dress, use a wet brush to soften the edge of the shadow. If the area dries too light and a second pass is necessary, be sure to wet the shadow area prior to applying more color.

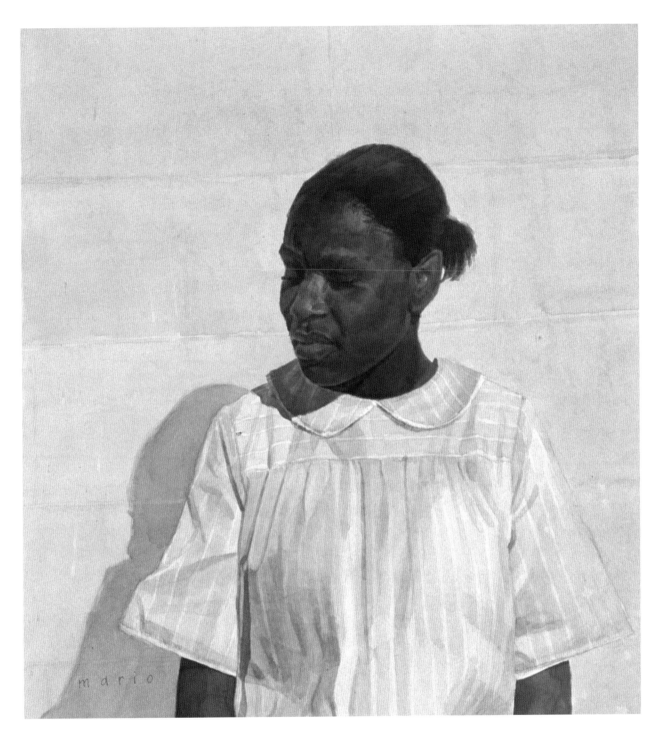

SUN KISSED, 2004
WATERCOLOR ON PAPER, 22 X 20 INCHES (56 X 51 CM)

While pursuing mastery of a particular painting style, it's important to focus on your subject.

PROPS

Using props in a painting is a simple device that can create compositional interest. These might be an accessory, such as the mirrored sunglasses I featured in *Leslie's Tire Service*. The stark light in the lenses, reflecting the expansive landscape in his view, offer a glimpse into Leslie's world. The juxtaposition of the tools of his trade, seen in the background, and his relaxed demeanor creates an interesting dynamic.

Blues, shown opposite, was one of my first few attempts to paint in watercolor. The linear cross-hatching style I employed in my work with pastel naturally appeared in my early watercolors. In this painting I relied heavily upon cross-hatching in order to create texture and tie certain areas together. As I advanced in the medium of watercolor, however, I gradually came to use the cross-hatching technique in a more subtle and nuanced manner. Nevertheless,

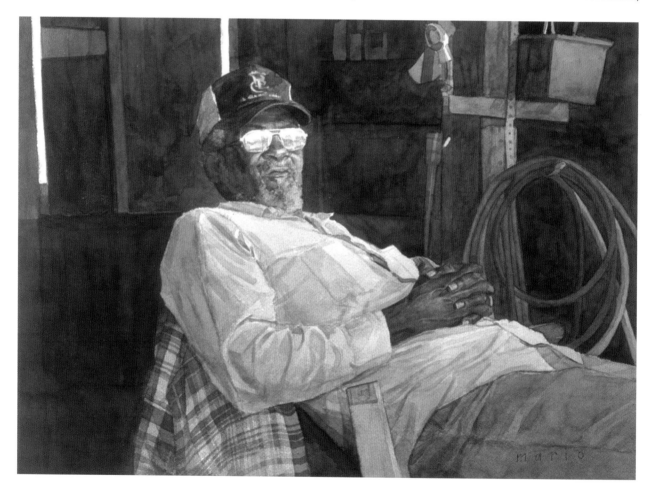

LESLIE'S TIRE SERVICE, 2005
WATERCOLOR ON PAPER, 18 X 24 INCHES (45.5 X 61 CM)

I simplified the background with a large wash of neutral tint. This prevented the objects from competing with the subject in the foreground. I only highlighted the tools, which were the most essential aspect of the narrative.

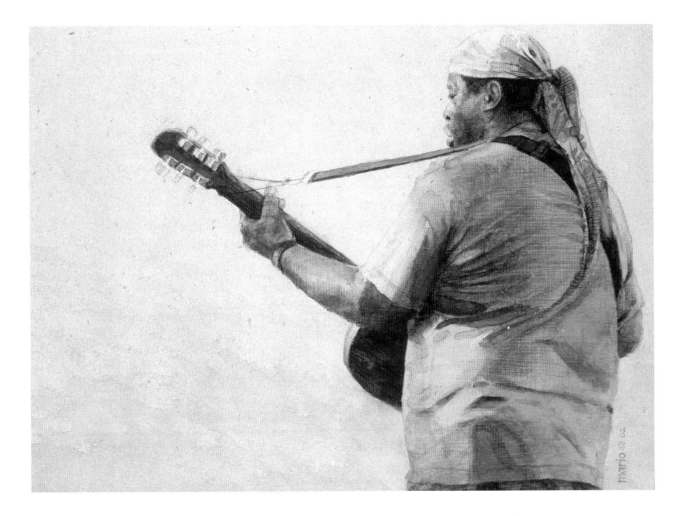

BLUES, 2002
WATERCOLOR ON PAPER, 9 X 12 INCHES (23 X 30.5 CM)

As this gentleman captivated a crowd in New York City's Washington Square Park, I was relegated to sitting behind him. This vantage made me think about how much sense his outfit made with his guitar in his hands. Without his instrument, he would appear to be another fashionably eccentric person hanging out in the park.

the guitar (the main "prop" in this image) leaves no doubt as to where this man's interest lies. I eliminated the people he was playing for, on the street. Instead, I opted to focus on a more personal interaction between him and his instrument.

Sometimes props can be incredibly subtle, and you must use your judgment to insure they enhance your vision. As I painted the portrait of Mr. Templeton, shown on the next page, he shared stories from his past, including the time he served in the United States Navy. Listening to stories that centered around his love for our country and the experiences that shaped it, I allowed my eyes to wander and a theme became apparent to me. His patriotism was evident in the red, white, and blue afghan draped over the back of his chair, the colors of the flag on a ribbon, which adorned the lapel of his suit jacket, and several other areas in his living room. These elements offered insight into the life of the subject, but I needed to distill the information and incorporate it in an effective manner.

Be careful with your use of props, however. It is easy to overshadow your subject with an extraneous amount of objects. Be sure to edit the scene and use the props to enhance the subject. A prop can be utilized to further describe an environment in which your subject appears.

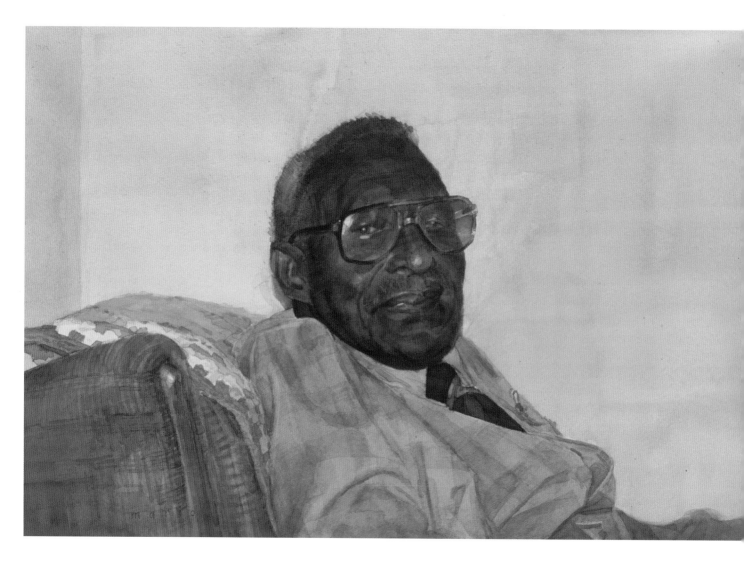

MR. TEMPLETON, 2010
WATERCOLOR ON PAPER, 14 X 20 INCHES (35.5 X 51 CM)

Mr. Templeton is a God-fearing man and was on his way to a meeting at his church following our session. His suit hints at the rituals that govern his lifestyle.

For instance, if you were to paint a ballerina, the predictable props would be a ballet bar and mirror in a dance studio. A more creative option might be to paint the same girl peering into a mirror in her bedroom, as the ballerina outfit appears on a hanger behind her. The viewer is left to contemplate the subject's circumstances, rather than having all the blanks filled in already.

Whether it's a fictional novel or movie with a thrilling plot, the most captivating stories take us on an emotional roller coaster. Great art is no different. The imagery within a work of art can conjure deep-seated emotions, such as sadness or sorrow. It can also transport us to an uplifting state of joy and triumph. Your point of view is unique and painting people, places, or objects that are meaningful to you personalizes your work and distinguishes you from your peers.

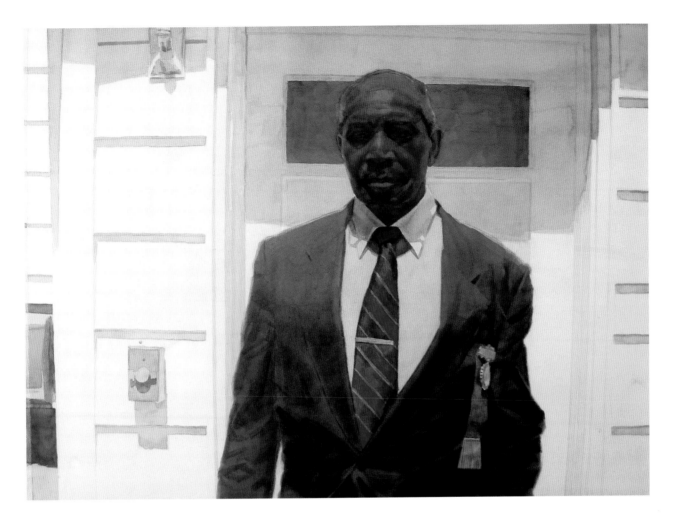

EDITING EXTRANEOUS DETAILS

MR. REELS, 2010
WATERCOLOR ON PAPER, 18 X 24 INCHES (45.5 X 61 CM)

The darkest darks only appear to be deep in value, due to the brightness of the white of the paper in the background. It's important not to overstate the contrast between your lightest and darkest values.

One of the more frequent questions I receive pertaining to my watercolors is: "How do you decide when to include objects in the background as opposed to leaving it blank?" Photographs can provide a great deal of information when used as reference for painting. The temptation of working from photos, however, is to copy them "verbatim." The result can be an overworked version of the photograph with a distracting amount of detail and a lack of subtlety.

I've painted certain subjects who possess an overwhelming presence and have the ability to capture and hold the attention of the viewer without the distraction of a background. In other cases, my goal has been to elevate the importance of the subject's surroundings, thus including pertinent information, such as aspects of their living room or a section of a landscape. Editing a composition can be as simple as removing one object from a scene.

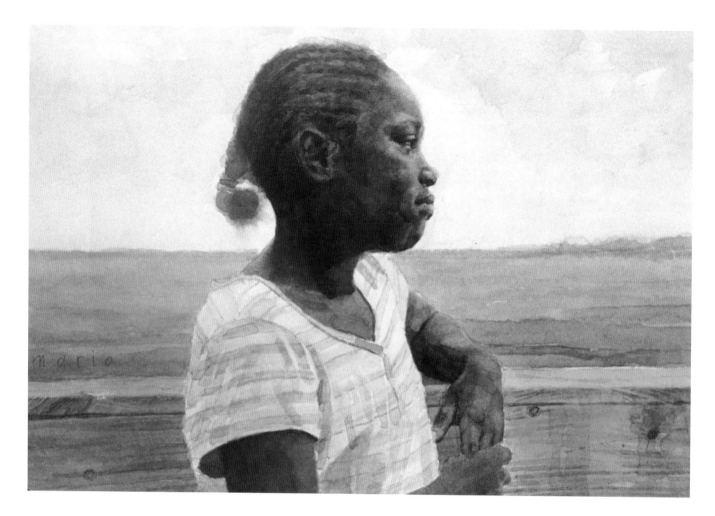

DANEISHA, 2003
WATERCOLOR ON PAPER, 9 X 12 INCHES (23 X 30.5 CM)

I removed the houses in the background and opted for a more rural setting, based upon her melancholy disposition. The difference between painting and photography is the ability to create a world that may not fully exist in reality.

In the world of fashion, I've heard stylists say: "Before you leave the house, take off at least one item off." The conventional thinking is that our strong desire to present ourselves in an impressive manner causes us to overcompensate. The old adage of "less is more" can also be applied to paintings. The subject should shine brightest in your painting. It can be tempting to show off your painting skills and paint every blade of grass in a field; however, such a display of skill only points back to the artist. The true power of a work of art is a combination of the captivating presence of a subject and the artist's ability to transport the viewer into that world. This can be as simple as rearranging a model in a scene before painting him or her. In the case of *Mr. Reels*, on the previous page, I simply moved him a few feet away from a cluttered background to a nearby area of the church, which was cleaner and full of light. The spontaneity of my decision determined the overall feel of the painting.

There are moments when I find it necessary to edit certain elements of a scene in order to move the painting in a different direction. When painting *Daneisha*, shown above, she was originally posed on the deck of a house with neighboring houses in the background. Her expression appeared reflective. Therefore, I decided to replace the suburban scene with an expansive field and open sky, created from my memory. The look and feel of the finished painting is dramatically different than the actual background.

WORKING WITH A MODEL

The artist's model is the centerpiece of a portrait painter's life's work. I typically work with models who are friends or family members. If you are planning to work with a new model, you should resolve a few issues in advance. The model's fee is the first order of business. It is important that the agreement is clear and understood by all parties involved. Once the terms are agreed upon, a contract needs to be signed and dated. When photographing a model for reference, a release form, granting you permission to use the model's image, will protect you when you want to reproduce your work in various media outlets. Depending on your relationship with your family members and friends, use your discretion when considering a contractual agreement.

Painting a live model is a dramatically different experience than photographing one. Having a person sit or stand in a pose over a long period of time can be grueling and taxing on their body. I tend to work in 25-minute intervals when working from life. If I'm at a pivotal stage, I'll ask the model for an extended period of time to resolve a particular issue, prior to taking a break. The advantage of working from photographs is that you can work uninterrupted, without considering the needs of the model. The

Working with models outdoors is similar to "wearing the hat" of a director on location. There's an abundance of information from which to choose, and making the correct decision for your composition can be a challenge. I generally have an overall idea for a painting in place prior to photographing, and choose the wardrobe to bolster my concept.

LEXIE, 2010
WATERCOLOR ON PAPER, 12 X 9 INCHES (30.5 X 23 CM)

Responding to the dark, ethereal mood of the background, I instinctively asked Lexie to close her eyes. This simple action ushers in a sense of quiet contemplation.

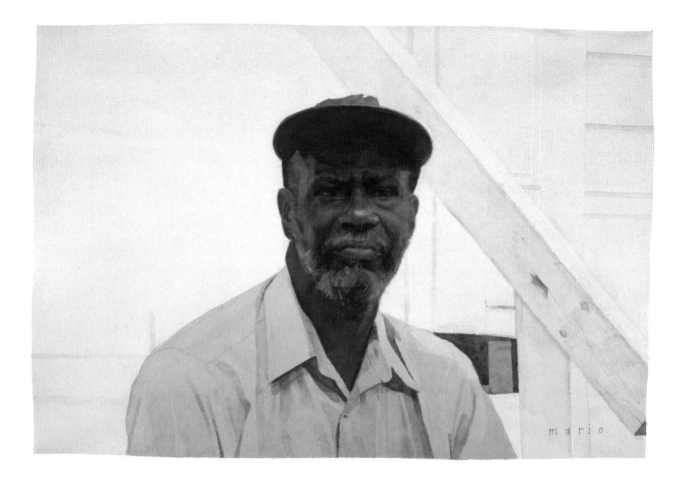

downside is the static quality of the information and the temptation to copy every minute detail, which results in an overworked version of the photograph.

My recommendation is to paint and draw from life as often as possible. The reality of paying a model each time you have an inspiring idea for a painting can be daunting; however, attending open studios or life drawing sessions are options to study the human form. When I began my career, I was unable to afford models for my work, however I attended Spring Studio in New York and, for less than $20 per session, I could draw or paint a live model. Working alongside other artists once a week inspired me and allowed me to gain a comprehensive knowledge of anatomy.

Of course, it isn't always possible to paint from life, and photographs can expand your options. For instance, I've found that working from photographic reference allows

GEORGE, 2007
WATERCOLOR ON PAPER, 18 X 24 INCHES (45.5 X 61 CM)

Tougaloo College is located on a former plantation in Jackson, Mississippi. I have taught workshops on the campus, and my interest in the former slave owner's house grows with each visit. I asked George to pose on the steps of the house. His connection to the college, as an alumnus, was captivating in the face of the property's complicated past.

me to spend more time choosing an effective composition. The viewfinder of the camera provides definitive borders in which the scene must fit. Prior to painting *Lexie*, shown on page 63, I had to decide how I wanted to utilize the gate in the background. The repeating vertical lines of the bars were distracting in a full-length composition, as they competed with the plaid pattern of the model's dress. However, once I cropped in on her upper body, the subtle indication of the steel bars beautifully framed her head. Another advantage to photography is that it allows you

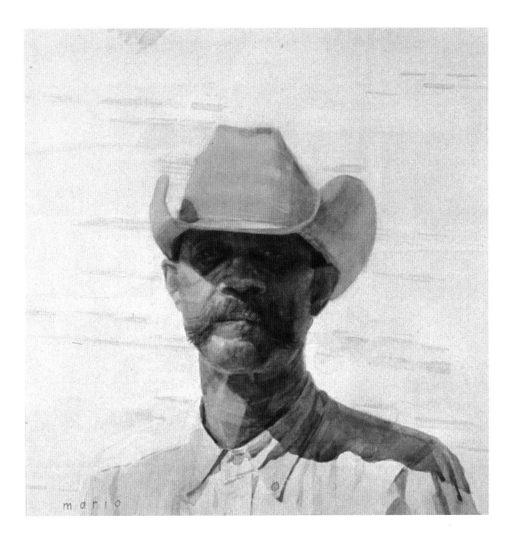

WHITE HAT, 2009
WATERCOLOR ON PAPER, 15 X 15 INCHES (38 X 38 CM)

I used cerulean blue as the dominant color of the shirt. While it's a beautiful color, it must be stirred voraciously to prevent it from settling in the bottom of a mixture.

to view your model in various scenarios and contemplate the various effects. Upon reflection, I realized the photographs of the model with her eyes open were not as effective as when her eyes closed, when they correlated with the haunting darkness of the background.

Working with a model on a consistent basis is advantageous for several reasons. It offers you the opportunity to build a relationship with the sitter, as you work closely on projects. Also, the familiarity of the model's features and body language become more readily available, through repetition. I have worked with George Dixon for several years and have explored multiple facets of his life. He's a Mississippi native and a graduate of Tougaloo College in Jackson. The campus is rich with history, as it was a former plantation and later instrumental in the Civil Rights

Movement. The paintings I've made of George reflect his love for the college and were all painted at various times on the campus. His signature pipe (which appears in the image on page 74) is a mainstay in the series, with the exception of one rare moment, depicted opposite, when I convinced him to remove it from his mouth. George is a talented artist who hails from a different time and place than I do. Working with him has been such an enlightening experience.

PAINTING THE WORLD AROUND YOU

A large part of my body of work consists of close friends, elders, and family members. I admit they are less inclined than professional models to remain still for long periods of time, nor are they able to resist striking up a conversation for the entire session. The experience is always enjoyable, however, and I've managed to learn more about their lives in these intimate situations. In our fast-paced culture it's rare for human beings to slow down and share quiet moments. The portraits of older subjects resonate on a deeper level, as they continue to pass on. Sometimes younger subjects view the portraits I've painted of them in the past and wonder where the time has gone. The stories

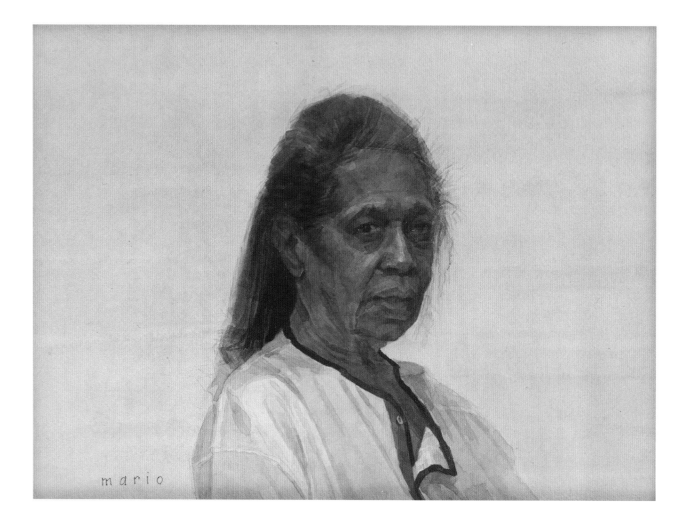

CHARLESTINE, 2007
WATERCOLOR ON PAPER, 12 X 16 INCHES (30.5 X 40.5 CM)

The drybrush technique allowed me to add detail to the subject's face, especially in the highlighted areas. By contrast, the neck recedes due to the lack of drybrush strokes and the prevalence of broad washes.

I seek to tell are personal, yet universal in terms of the lived experience.

Working from life can be challenging for many reasons. In the case of *White Hat*, page 65, I painted my father on location. He has posed for me several times; however, he enjoys talking and can be difficult to reign in. The Oklahoma sun is also formidable; therefore, whenever I paint him I must allot plenty of time for breaks. One advantage of this environment, though, is that glazes dry quickly in the sun. I applied the shadow in this watercolor once the face, neck, and shirt were completely dry. Glazing over those areas too quickly could have resulted in lifting paint from the surface and ultimately ruining the painting. I used a glaze of neutral tint over the entire shadow area. I worked expeditiously over the face and added water to the edge of the shadow on the lighter side. The consistency of the neutral tint glaze was comparable to the layer over which I applied it. The glaze should be transparent, rather than opaque.

Watercolor gives the artist permission to use the white surface of the paper to create brilliant highlights. To do this successfully, the values within the painting must be properly analyzed, as it's easy to exaggerate bright whites, which do not exist in nature. When painting *Charlestine*, shown opposite, I washed a mixture of burnt umber and French ultramarine over the entire sheet of paper. This helped me establish the proper value of the highlighted areas of the shirt. Next, I carefully worked around the initial wash to create shadows. There are only three layers of

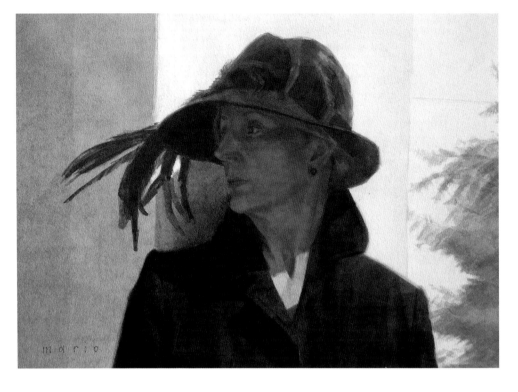

RAVEN, 2010
WATERCOLOR ON PAPER, 14 X 20 INCHES (35.5 X 51 CM)

Watercolor is often referred to as a lightweight medium for hobbyists. The truth is that watercolor requires an enormous amount of dexterity. The medium is capable of displaying the most dazzling white, as well as the deepest black. Notice the translucent quality of the feathers on the hat, which could only be captured by the transparent property of watercolor.

color on the subject's shirt, which allows the white of the paper to give it the appearance of light radiating from it. The darker values in the shadows intensify the luminosity of the white areas.

I painted *Raven*, shown above, shortly after my wife's mother passed. I wanted to capture the treasured memories she has of her mother, rather than showcasing the pain felt from the loss of a loved one. The counterbalance between the dark silhouette of the figure and the stark white background dramatizes the weight of the moment. The tension in the scene would have been lost if the background featured more muted, darker tones.

FEATURING COMPELLING BACKGROUNDS

Painting a subject within the context of their everyday life offers a glimpse into their world. Each individual is unique, as well as the objects with which they surround themselves. Leslie, owner of Leslie's Tire Service (see image page 58), converted the garage at his home into a fully equipped tire service. The tools of his trade are on display as he comfortably leans back in his broken office chair. His rural surroundings are reflected in the mirrored sunglasses he's wearing.

Including backgrounds in your paintings increases interest and offers the viewer additional information regarding the subject. Working wet-in-wet on the objects in the background is an ideal way to create an appropriate spatial relationship with the subject in the foreground. Introducing a blurring effect on abstract forms can propel a subject forward, while moving the viewer's eye around the painting in a pleasing and effective manner. When you view a watercolor that possesses the same

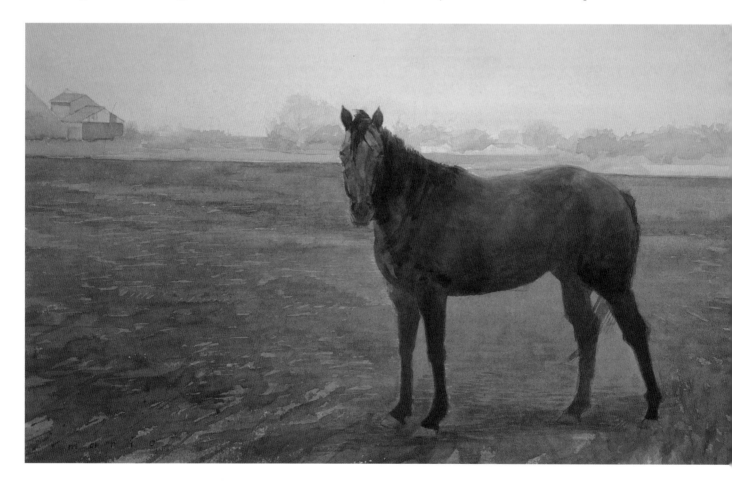

STANDOFF, 2013
WATERCOLOR ON PAPER, 12 X 16 INCHES (30.5 X 40.5 CM)

Watercolor does not require the use of white paint in order to lighten the hue of a particular color. I achieved the background in this painting by applying water to the surface of the paper, then working in a diluted wash of color to create the illusion of depth.

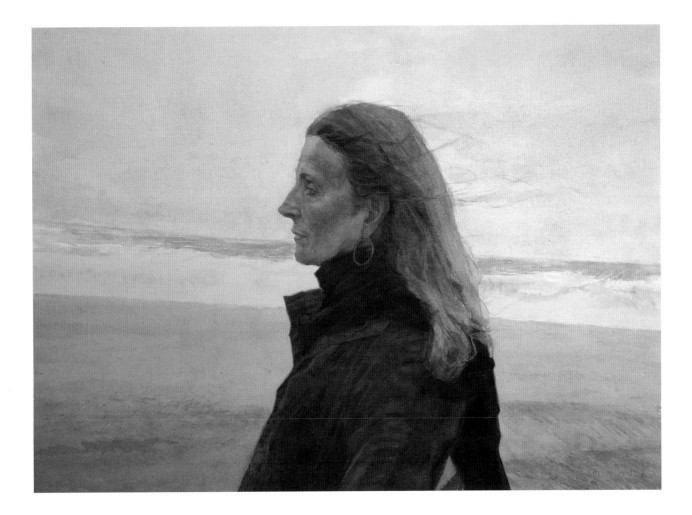

level of finish in the entire composition it reads differently than the objects would have appeared in nature. In reality, as we focus on an object in the foreground our peripheral vision is obscure, while the background is not clearly in focus either.

The closer we come to mastering these elements in our paintings, the more impactful the images will become. The ability to compose a scene requires practice, but as your sense of design develops, you'll become increasingly adept at making sophisticated choices. Knowing when to place a subject into a particular environment is crucial. Painting the right subject in the wrong place can confuse the viewer and therefore undermine your efforts. The majority of my subjects are painted in their everyday surroundings. I find that when a person is comfortable in

a setting, it translates and the painting simply reflects what is occurring in the moment.

When you ponder the term *portrait*, you'll soon realize the dominant subject of the genre has been humans. However, a portrait is not simply a picture of a person or a group of people captured by a photographer or a visual artist. In the seventeenth and eighteenth centuries, English aristocrats employed artists to paint their terriers, racehorses, and prized bulls. The expectation was that the artist would not merely paint a generic version, but would

imbue the portrait with a sense of the animal's personality and individuality.

While visiting a local farm in the town of my birth (Altus, Oklahoma), I noticed, as I photographed the herd, that one of the horses was more "suspicious" of my actions. In *Standoff*, shown on page 68, you can see the tension between the two of us. I wanted to communicate his mood through watercolor, rather than just paint a pretty horse in a field. I minimized the importance of the farm in the background by lightening it, in order to build up the solid form of the horse in the foreground. It's not always necessary to give the objects in the background the same level of importance as your main subject, rendering them in high detail. Rather, it can be equally impactful if the background receives a slight nod while you focus on your point of emphasis.

When creating *The Day before Sandy*, shown on the previous page, I wanted to show the raw power of nature and its effect on human beings. You can feel the unbridled energy of the ocean in the background as it charges toward the shore. I pushed the watercolor around quickly in each area of this image to capture the frenetic energy of the wind, resulting from the outer bands of Hurricane Sandy. Working at a quick pace allowed the watercolor to flow in a less restrained manner. Typically, in watercolor painting this kind of spontaneity is generally rewarded.

When contemplating your subject, be careful not to force the decision about whether or not to incorporate the background. To determine whether or not it is appropriate, it may help to ask yourself the following questions:

- Does the subject fit organically into the scene?
- Does the background distract or add to the narrative of the painting?
- Is the background properly composed?
- Is the activity in the background more interesting than the figure in the foreground?

Based upon your answers to these questions, you may want to reconsider your decision.

TELLING A STORY

My first encounter with the work of Andrew Wyeth was in a public library in Huntsville, Alabama. The reference section had books with beautifully illustrated plates of his work. I was mesmerized by his mastery of watercolor and egg tempera. I returned the next day to further investigate the books and I discovered that what attracted me was primarily his storytelling ability. I couldn't believe I was twenty-seven years old and hadn't been exposed to his work. He painted the people and places he loved and often married the two in his unique compositions. Wyeth's imagery seemed to pose questions and leave the viewer to draw his or her own conclusions.

There are times when I like to mix things up and experiment with objects in my backgrounds. Glass is a surface that seems tailor-made for watercolor. The reflections and translucent surface can be achieved with the proper skills. In *Cotton Country*, opposite, I used gum arabic to add sheen to the reflection on the door on the left side of the composition. The medium has a honey-like consistency and only requires one or two small drops in a mixture of watercolor to work effectively. The result is a slight sheen, which resembles the appearance of glass. I also use gum arabic periodically when painting windows.

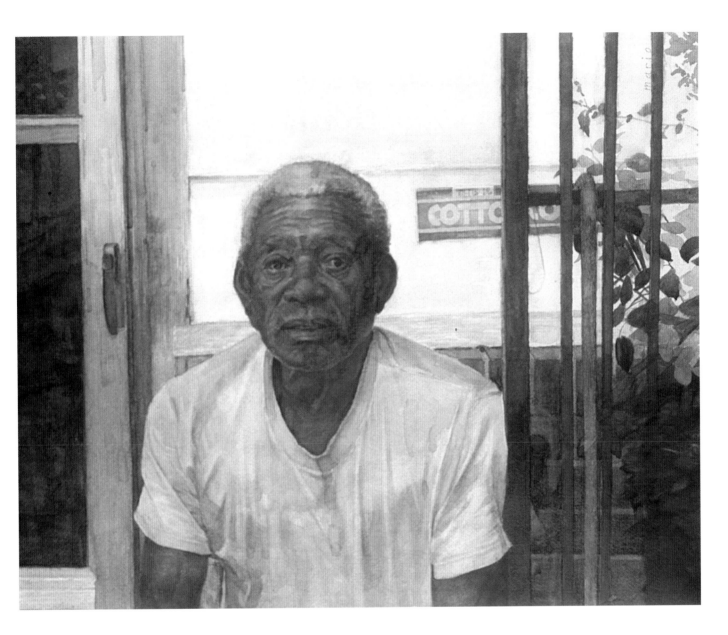

COTTON COUNTRY, 2005
WATERCOLOR ON PAPER, 16 X 20 INCHES (40.5 X 51 CM)

While my paintings generally tend toward more serious concerns, there are moments of humor. The bumper sticker in the background, from which the painting gets its name, made me shake my head when I initially saw it on my grandfather's house. This seems to sum up the small town in which I was born.

It's no accident that the paintings in this chapter feature my family members, close friends, and a few interesting people to whom I was drawn. I am always on the lookout for moments that interest me. The people in my world wouldn't be considered different than the average American; however, the fact that I choose to tell their stories is what makes these people extraordinary. Don't feel pressured to keep up with the status quo. Feel free to celebrate the people and places that impact you—and trust that particular individuals will be drawn to your honesty.

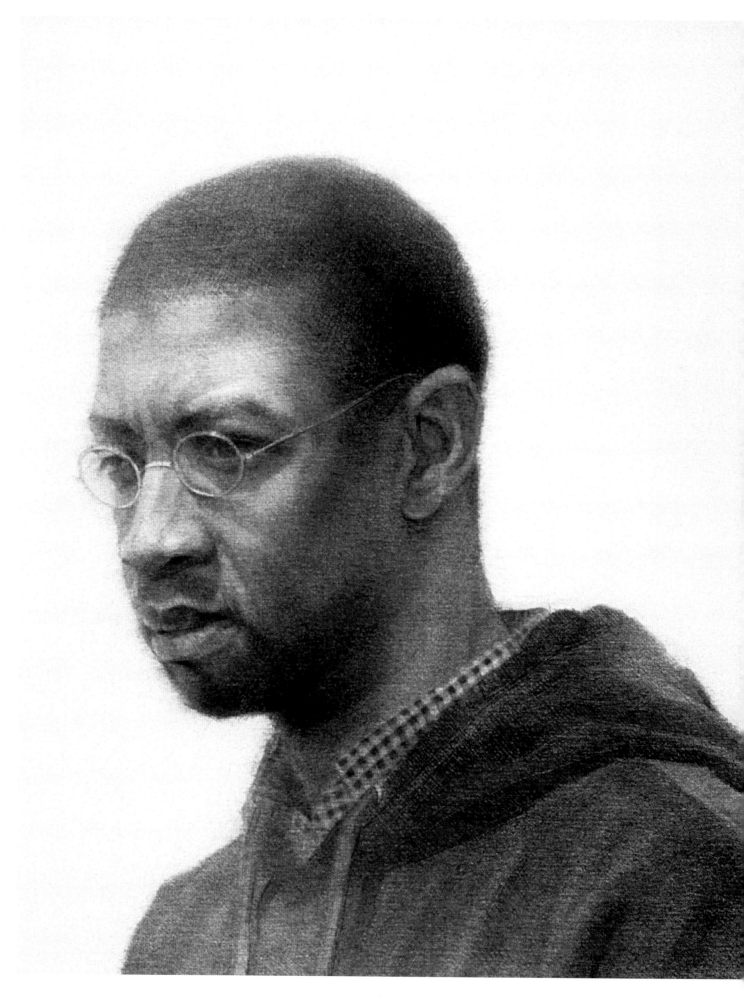

THE IMPORTANCE OF DRAWING

"If people knew how hard I worked to get my mastery, it wouldn't seem so wonderful at all."

—Michelangelo

Drawing is the foundation upon which all forms of art are built. The ability to process information and express artistic ideas in a clear and concise manner can be attained solely through a commitment to draftsmanship. The act of sketching, despite its apparent simplicity, transports an idea into reality. Due to the immediacy of the medium, the artist's thought process can be viewed in a revelatory manner. Painting (especially when an artist uses oil paint, pastel, and acrylic, all of which are fairly opaque) covers up a multitude of sins, whereas drawing exposes an artist's deficiencies. The strength of a powerful work of art—at least one that possesses a high level of realism—depends heavily upon the artist's ability to draw.

Because watercolor artists are unable to correct mistakes during the act of painting, it's critical for us to map out our direction ahead of time. Doing so helps to avoid chaos. For this purpose, I am more meticulous during the drawing stage of my watercolors than I would be when I paint in other mediums. For instance, oil paint and pastel lend themselves to constant correction during the painting process, while watercolor is unforgiving.

My drawings provide me with a controlled environment within which I am able to work out the problems I'll face during the painting process. When I'm painting a watercolor my decision-making process is rapid, and because each decision is permanent, the stakes are higher than with any other painting medium. For this reason, it's tremendously useful to have the knowledge I gain from making a preparatory drawing or sketch.

The success or failure of a representational painting rests largely upon the strength of the artist's drawing skills. The ability to accurately render objects and compose

SELF-PORTRAIT, 2012
GRAPHITE ON PAPER, 10 X 10 INCHES (25.5 X 25.5 CM)
I can truly assess the accuracy of my drawing when I draw my own likeness. It's the image with which I am most familiar.

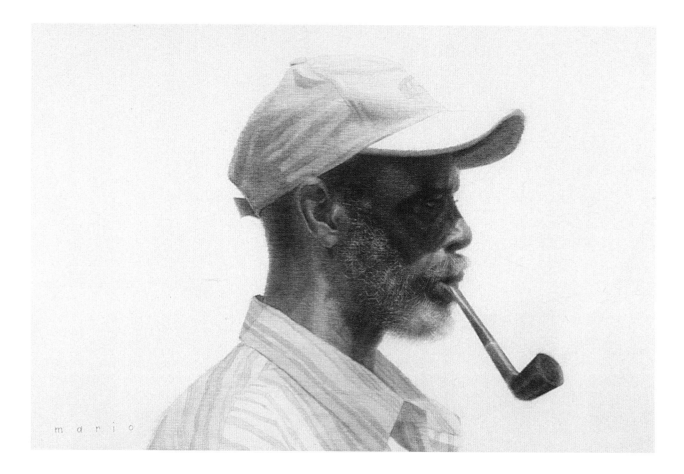

scenes are the building blocks of realist art. This finished drawing *George*, shown above, demonstrates how I use lights and darks to describe form. I worked from the lightest value to the darkest, in the same manner I would in painting. This technique requires me to slow down and establish each value, prior to moving on to the next one.

When I draw I am in a contemplative state. The process of slowly building an image, stroke by stroke, allows my mind to slow down and become immersed in the experience. As I work, I lay down the lightest values and then build to the darkest areas, just as I do with my watercolors. The knowledge I gain from each study and finished drawing carries over into my watercolors.

Through my drawings and studies I've found that I begin with a light touch when drawing or painting a subject such as *Charles*, shown on page 76, who's surrounded by light values. When drawing this image, I was

GEORGE, 2010
GRAPHITE ON PAPER, 14 X 17 INCHES (35.5 X 43 CM)

My drawings are replicas of the block-ins for my watercolor paintings. I work through the value range in this way, prior to adding color.

cautious as I moved through the value range in order to preserve the light running through the piece. In the case of a more moody composition with darker values, such as *The Apprentice*, opposite, I tend to proceed with a more aggressive style. While the medium you use to create may change, the sensibility with which you proceed should be the same.

There are times when painting can seem like a big production. I have set up a drawing station in a quiet corner of my studio to counteract the daily demands of painting. I find the simplicity of my setup brings me back to those simpler times as a youth when I would sit and draw for hours on a coffee table. Keeping a sketchbook is like

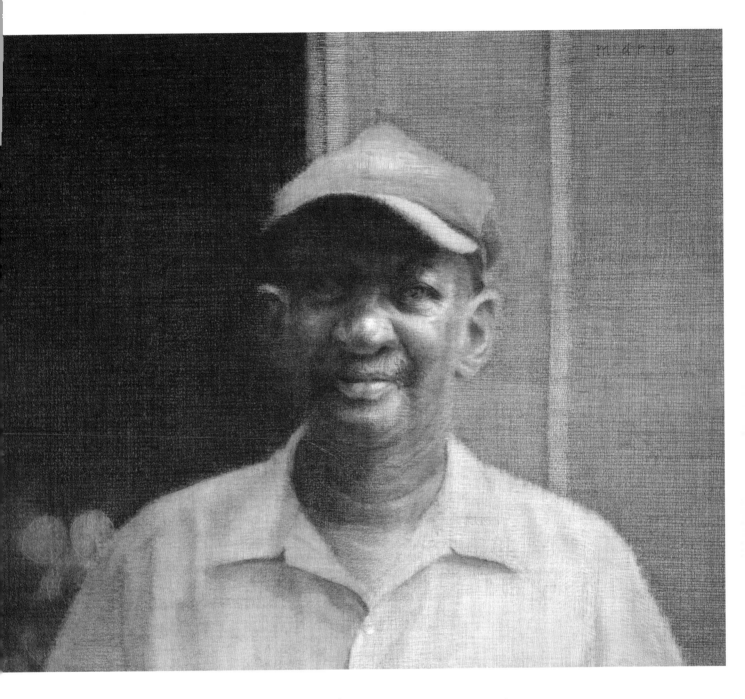

recording your innermost thoughts in a diary. Sketches are intimate and their contents are not subject to the scrutiny of works viewed by the public. Sketching offers artists a place of solace to express ideas in a pure and unfettered way. Oftentimes these images possess an honesty that is rarely manifested in finished works.

THE APPRENTICE, 2006
GRAPHITE AND CHARCOAL ON PAPER, 14 X 17 INCHES
(35.5 X 43 CM)

The texture I applied to the subject in this drawing was helpful when I painted the scene in watercolor. The drybrushed strokes of watercolor mimicked the strokes of charcoal in his face, as I built the form.

CHARLES, 2008
GRAPHITE ON PAPER, 14 X 14 INCHES (35.5 X 35.5 CM)

Drawing is the skeletal framework of a realistic watercolor. The success of the painting relies upon the strength of its infrastructure.

My antique drawing desk. I enjoy having an area to create sketches or drawings, rather than removing my paintings from my drafting table.

SKETCH OF SERA, 2015
GRAPHITE ON PAPER, 5 X 7 INCHES (12.5 X 18 CM)

I enjoy sketching in my sketchbook. The delicate lines are playful and honest. I find satisfaction in completing a sketching session and storing my sketchbook away in the drawer of my drawing table.

BEING PREPARED TO DRAW AT ALL TIMES

Having the proper drawing tools is invaluable. So, too, is having tools that are easily transported. There's no way to predict when a burst of creativity will present itself; therefore, it's a good idea to keep a drawing pad and pencils at your disposal at all times. I travel frequently around the country and there's quite a bit of down time, spent in airports or on trains. Rather than endlessly people-watching, I prefer to use that time to sketch ideas or create doodles of fellow travelers. I'd liken the act of drawing for an artist to exercising for an athlete. The activity itself sharpens the mind. Furthermore, the more time you dedicate to draftsmanship, the more you will increase the coordination between your hand and your eye.

These are my drawing tools (left to right, on either side of *Chrissy*, graphite and charcoal on paper, 2014): Sandpaper block to keep my pencils sharp during the drawing process; graphite pencils (6H, B, and 6B); charcoal pencil (medium); blending stump; and kneaded eraser.

COMMON DRAWING TERMS

Every profession has its own unique culture, and this culture is generally facilitated by a language that is spoken by those who populate it. The art community is no exception. Certain words are used by artists to describe working properties of the particular medium in which they work. I've listed a few key words that pertain to the act of drawing.

ADVANCE To move forward or become more distinct. (*See also* Recede.)

BLENDING The technique of shading through smooth, gradual application of dark value.

COMPOSITION The way in which art principles are used to organize elements of color, line, form, shape, value, and texture.

CONTRAST A technique and a principle of art whereby a focal point is created by using distinct difference in elements.

CROSS-HATCHING A technique for shading with a series of two or more crossed sets of parallel lines. (*See also* Hatching.)

HATCHING A technique for shading with a series of fine parallel lines. (*See also* Cross-hatching.)

HIGHLIGHTS Small white areas in a drawing or painting. A reflection of the greatest amount of light.

RECEDE To move back or become more distant. (*See also* Advance.)

VALUE Three-dimensional quality inherent in every form.

CROSSHATCHING DEMONSTRATION

Each artist has a preferred method of drawing. The style I use relies upon applying small strokes of graphite to build form and create texture.

Figure A

Figure B

Figure C

Figure A is an example of a basic hatching stroke, using 2H lead. This can be modified, using curved lines, in order to follow the form of a round object.

In the top half of Figure B vertical lines have been added to the crosshatched lines, darkening the area significantly. The same 2H lead was used as in Figure A; the shifts in value are solely the result of crosshatching. There are infinite possibilities for using the crosshatching technique to carve out value shifts.

In Figure C, rather than crosshatching, I wanted to show the difference between the two techniques. In order to demonstrate this point, I used the same lead, 2H, to shade the area, first by applying the graphite with the side of the pencil, then by smudging the graphite with a finger. I do not recommend this technique. Notice the flat appearance of the blended area.

COMPOSING YOUR SUBJECT

The term *composition* refers to the manner in which objects are arranged within the frame of a painting or drawing. If you think of your painting in terms of a movie, the main character is the most prominent subject and your background is the set. As the director, you are responsible for the flow of the story and the actors' delivery to the audience.

An artist utilizes visual elements, which are interesting and capture the imagination of their viewer, to compose a scene. You hone these skills over time, and the more you're aware of the compositional element, the stronger your sense of design will become. A good place to begin would be your comfort zone. As you peruse your body of work, you may notice a distinct pattern in the manner in which you place objects on the paper. Make a conscious effort to diversify the appearance of your work. Challenging yourself in this area can energize you and allow you to view familiar subjects in a new and exciting way.

The key to creating a strong composition is thinking strategically. In *Dominican Church House*, right, the woman on the far left is lower in the frame than the other woman. The ultimate goal in situating the two women this way is to lead the viewer's eye into the church and then back out into the foreground. If you drew a diagonal line from the top of the women's heads, it would end up at the top of the window in the background. The three shapes are basically positioned as stair steps. The central woman's face is lightly sketched in with diluted washes of color, in order to allow the eye to continue its journey through the composition. If her face were highly rendered, the eye would rest upon it and further investigation would be curtailed.

DOMINICAN CHURCH HOUSE, 2015
WATERCOLOR ON PAPER, 30 X 20 INCHES (76 X 51 CM)

Watercolor allows me to exaggerate the contrast between light and dark. The impact of the white wall in the foreground is accentuated by the juxtaposition of the dark area next to it.

The negative space in a painting can be a crucial element in its composition, as is the case with *Intermission*, shown on the following page. The rich, dark skin of the subjects is surrounded by varying degrees of white in the

INTERMISSION, 2012
WATERCOLOR ON PAPER, 16 X 20 INCHES (40.5 X 51 CM)

I was struck by the camaraderie of these two street musicians, during a walk around the island of St. Kitts. Upon further observation, the manner in which their white T-shirts were radiating light next to their dark skin inspired me to paint them.

background and foreground. The viewer's eyes move around the composition and ultimately rest upon the darker elements of the painting. The darker areas of the subjects' faces are comprised of multiple thick glazes of color. Working with thicker mixtures requires confidence; however, the potential risk is worth it, as the lighter areas are enhanced by the richness of the dark colors.

I enjoy painting my family and close friends; however, I realize they are perfect strangers to those who view my work. In order to create interest in the people and places I paint, I must rely upon my knowledge of composition to make them compelling. Even though a large volume of my work derives from actual events, a certain level of orchestration must always be done. The composition in *Morning*

in Altus, shown opposite, is strengthened by placing the figure in the lower right corner. Once the subject is located in the scene, the viewer's natural inclination is to engage him, while peering over his shoulder to investigate the interior of the building. The drama of this encounter is heightened by surrounding him with darkness, as he stares back at the viewer. Experimenting with the placement of objects in a composition can sharpen your sense of design.

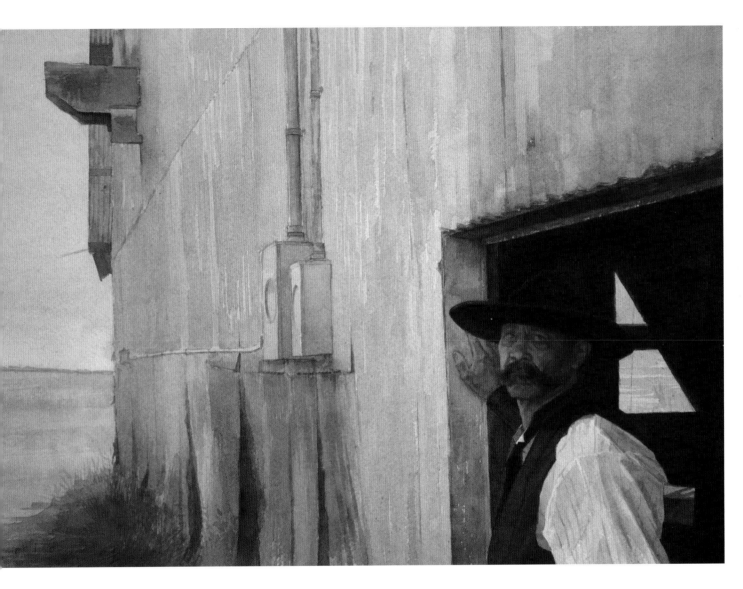

MORNING IN ALTUS, 2012
WATERCOLOR ON PAPER, 14 X 20 INCHES (35.5 X 51 CM)

With the exception of a few glazes of color over the figure's attire and background, the entire watercolor was created solely with burnt umber and French ultramarine.

CREATING THUMBNAIL SKETCHES

I generally sketch a few thumbnails to gauge the level of interest in each composition. Once I've chosen one of them, I execute a simplified value study, which allows me to edit out any extraneous information. This same principle can be applied when taking photographs for reference. Using the viewfinder as the borders of your artwork, you can preview the composition and decide upon any necessary edits in real time.

My thumbnail sketches are typically 4 x 6 inches (10 x 15 cm). By keeping them small, I intentionally force the information I capture to be abstract and devoid of detail. This stage, creating thumbnails, is intuitive and based solely on my personal aesthetic; therefore, I work expeditiously. In essence, I'll know it when I see it.

In the sequence of images shown here, I wanted to capture the true essence of the Coast Guard headquarters, which is located on an inlet of the Atlantic Ocean in the town where I reside. Hurricane Sandy decimated many of the structures in close proximity to the Coast Guard headquarters; however, this house remained intact. I was attracted to the red roof and the delicate, wrought-iron rail surrounding the top tier of the building.

I began by sketching the building from different angles, in search of a composition for the painting. The first sketch appeared to be too literal, as the angles were not interesting. My second attempt highlighted the repeating shadows on the roof and the repetitiveness of the shutters. By observing subtle nuances of the house in my

COAST GUARD HEADQUARTERS (POINT PLEASANT, NJ), STUDY # 1, 2015
GRAPHITE ON PAPER, 8 X 12 INCHES (20.5 X 30.5 CM)

This study focuses on particular elements of the building's façade. I was searching for the most effective way to feature the historic attributes it possesses.

COAST GUARD HEADQUARTERS (POINT PLEASANT, NJ), STUDY #2, 2015
GRAPHITE ON PAPER, 12 X 14 INCHES (30.5 X 35.5 CM)

While I was fairly certain that this angle was the one I preferred for the final composition, I needed to see a visual representation of it on paper.

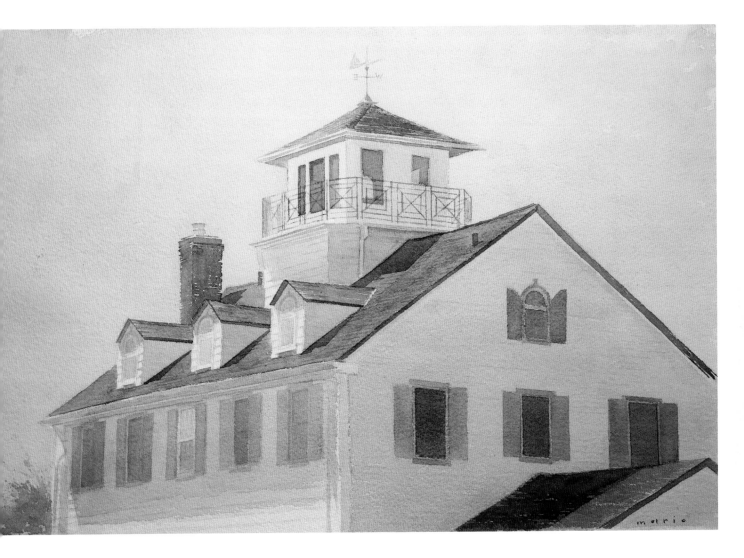

preparatory drawings, I was able to fully understand the effect of light on the form, while making conscious decisions concerning the simplification of the various shapes on the building's exterior. I purposely emphasized the darkest areas in my drawing as a reminder of how I would organize them in the painting.

COAST GUARD HEADQUARTERS (POINT PLEASANT, NJ), 2015
WATERCOLOR ON PAPER, 14 X 20 INCHES (35.5 X 51 CM)

When painting the watercolor, I added water to each entire window, prior to adding color to the area. A softer edge on windows, shutters, doors, and other architectural objects is closer to reality than overly straight edges.

LISTENING TO YOUR DRAWINGS

Your creative life is merely an extension of your daily life. Consider how smoothly your daily activities run once you have a plan in place. Whether it's going to a doctor appointment or taking a family vacation, the comfort of knowing what to expect when you're entering a situation sets your mind at ease and makes the activity more enjoyable. The same can be said for the painting process. While painting a watercolor an abundance of potential errors await you. The unforgiving nature of the medium leaves little room for error, thus highlighting the necessity to map out a clear direction beforehand.

Use your artistic discretion when deciding how much

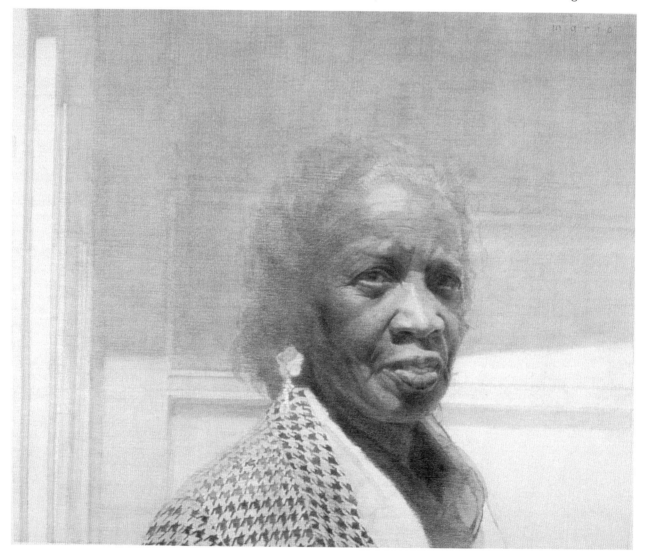

MRS. REELS, 2007
GRAPHITE ON PAPER, 14 X 17 INCHES (35.5 X 43 CM)

It's important for me to continue searching for a pose that highlights the unique set of characteristics of the person I'm painting. Drawing assists me in that pursuit.

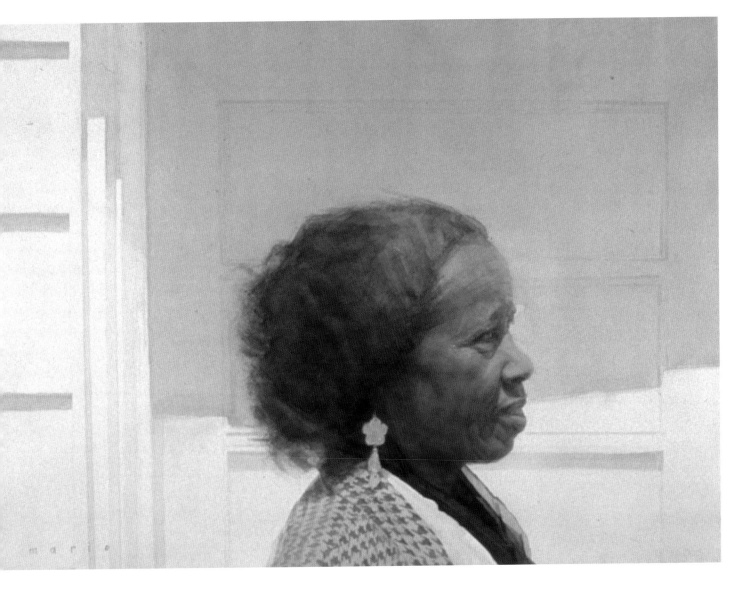

MRS. REELS, 2007
WATERCOLOR ON PAPER, 18 X 24 INCHES (45.5 X 61 CM)

For the watercolor I made a simple edit, which deviated from my study of this subject. Her profile fits organically in the composition, while the viewer is more inclined to observe the painting more closely without confronting the gaze of the model.

planning you may need, particularly in terms of your preparatory drawing. I am not recommending that you draw every leaf on a tree and carefully paint each one separately. It's important to strike a balance between organization and compulsion. In my work, I include a large amount of detail in the areas of interest, and leave the others loose, as you can see in the graphite drawing *Mrs. Reels*, opposite. My final drawing will be a constant reminder of the initial vision I had for the painting.

Prior to applying a glaze to my painting, I chart out the direction the water will flow. Once the water hits the surface of the paper, it's on the move. If you're not careful, it can become a game of cat and mouse as you chase the water around with your brush. The area in which water

settles on the paper is as important as where it begins. Water can settle and create unwanted hard edges or spill over onto an unintended area, as you scramble to remove it with a paper towel. Taking a few moments to take a deep breath and strategically plot your next move can give you clarity as you approach your painting.

The planning stage that lead to the creation of *Mrs. Reels*, shown above, was instrumental in my decision about how much of the patterned jacket to include. I was concerned

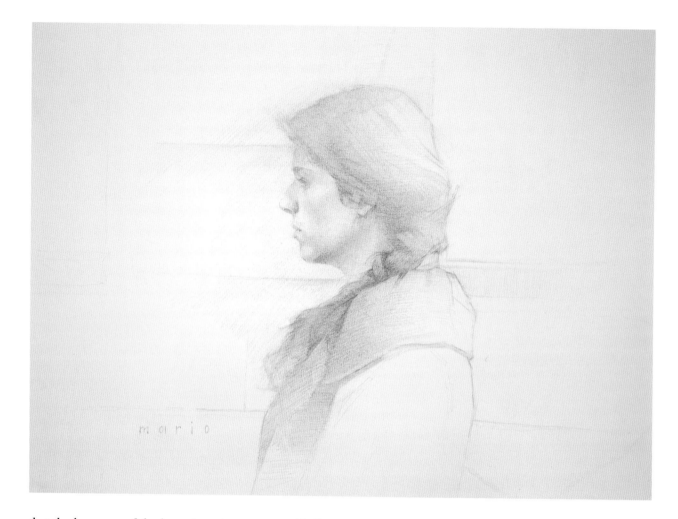

FACING THE ATLANTIC, 2014
GRAPHITE ON PAPER, 9 X 12 INCHES (23 X 30.5 CM)

When I execute preparatory studies, my only goal is to work out a problem prior to painting a subject. A sketch can contain a few lines or a high level of detail.

that the busyness of the houndstooth pattern would distract from the subject's face; therefore, I ultimately decided to crop out a portion of the jacket. In addition, my initial drawing featured a confrontational element, which didn't capture the essence of the subject's mild demeanor. Placing her in profile allows the viewer to interact with the painting in a more relaxed manner. Preparatory studies allow an artist to organize his or her thoughts in order to execute a fully realized work of art.

Simple preliminary sketches can prove to be as valuable as detailed drawings, which possess a full value range. After sketching out a few other compositions for *Facing the Atlantic*, I settled upon the pose shown above, and wanted to insure that the model's silhouette properly fit the square format. I was pleased with the simplicity of the sketch and set out to capture that spirit in the painting. There's a temptation in the world of realist painting to follow the current trend of oil painters and render every painting as tightly as possible. While there are times when I find that style appealing, I am drawn to the light that watercolor is capable of capturing. I created my painting *Facing the Atlantic*, opposite, using as few washes of color as possible.

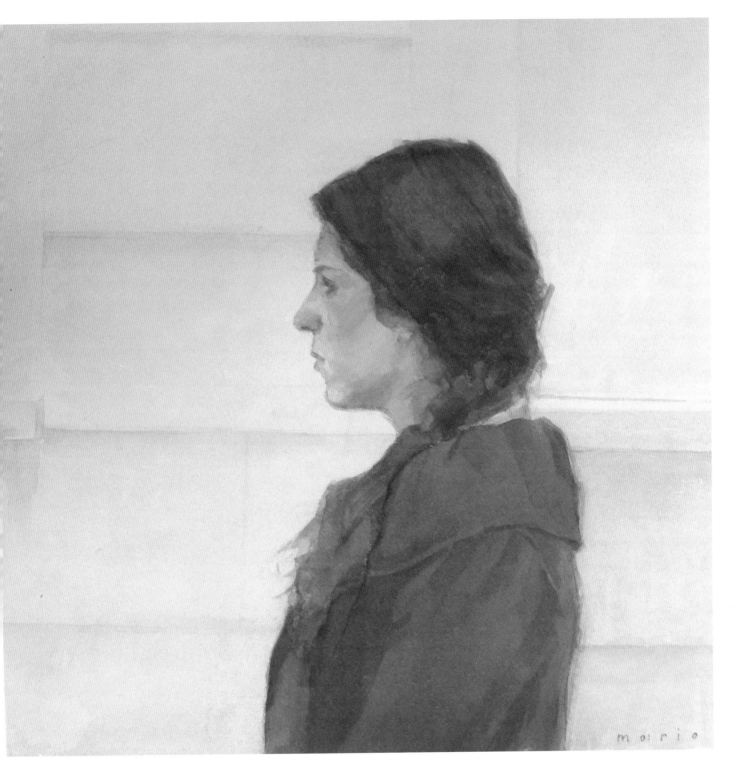

FACING THE ATLANTIC, 2014
WATERCOLOR ON PAPER, 10 X 10 INCHES (25.5 X 25.5 CM)

I preserved the light in her coat by avoiding the application of excessive glaze layers. Once I had applied the basic form of the coat, using burnt umber and French ultramarine, I applied one finishing layer of indanthrene blue and sepia.

SKETCHING WITH WATERCOLOR

Working on a small painting is similar to producing a short film, as opposed a creating a larger painting, which is more like releasing a big-budget movie. The areas of coverage are smaller, thus increasing the margin for error. I consider my small watercolors a step up from a sketch and a step down from a highly finished larger work. It's important for me to keep the small works in perspective, in order to avoid the temptation to overwork them in an attempt to implement unneeded details. The smaller brushstrokes require discipline, which assist me when I'm working in confined areas in larger paintings. Leaving the background white, as I've done with *Diana*, shown below, gives the illusion of space, as opposed to adding a dark background, which would have closed the composition and made it appear smaller.

The practice of sketching is a leisurely activity that should be enjoyed. It can be a bonding experience with fellow artists or a solitary experience, working in a journal. Either way, you should not feel the need to complete the sketch or come away with a masterpiece. There is freedom in making mistakes and attempting a new technique you wouldn't attempt in your serious work.

My watercolor sketches, such as *Anya*, shown opposite, rely upon loose applications of color, and I allow the white of the paper to show through more than I would in my highly rendered works. Sometimes, however, I start with a light wash over the entire sheet of paper, as I did with *Sophie*, shown

DIANA, 2014
WATERCOLOR ON PAPER, 5 X 5 INCHES (12.5 X 12.5 CM)

Sketching allows me to push boundaries and introduce working methods I would like to implement in my finished works. Here, I challenged myself to work the entire painting using burnt umber and French ultramarine with only one finishing glaze of flesh tone. The result is the appearance of more light in the highlighted areas of the model's face.

ANYA, 2014
WATERCOLOR ON PAPER, 14 X 20 INCHES (35.5 X 51 CM)

My finished watercolors may seem to have a high level of control throughout the process; however, they are painted loosely, with bursts of exuberance in the early stages.

opposite. It all depends upon the manner in which I decide to build up the tones in a sketch. I enjoy having the flexibility to begin a painting in an unorthodox manner and the option to stop working on it whenever I choose. Creating a visual diary relieves the pressure of presenting your efforts to the public. In essence, it's an investment in your maturation as an artist.

Painting a portrait from a live model challenges the sensibilities of the artist, particularly due to the limited amount of time allotted for the process. I spent approximately one hour on this sketch of Sara, below right. Toward the end, I could feel myself working at a faster pace, in an attempt to include more detail. As I look at the sketch, I'm glad I stopped when I did. Doing so allowed me to preserve the simplicity of this work.

Oftentimes sketching an idea can give you a visual indication of how it will be perceived, prior to spending valuable time and energy on a finished work. I was planning a large-scale painting, using the pose of Sophie reclining, shown in the top image here. However, after sketching the figure, I felt the model did not seem comfortable. This became abundantly clear within a few minutes of laying in washes. I *did* enjoy working with the subject, however, so I continued painting for a while longer. As you build a comprehensive body of work, you'll develop an innate ability to decipher a good idea from a great one.

SOPHIE RECLINING, 2013
WATERCOLOR ON PAPER, 6 X 12 INCHES (15 X 30.5 CM)

Sketching in watercolor is a way to become used to the flow of water on paper, without the added pressure of glazing layers.

SARA, 2014
WATERCOLOR ON PAPER, 12 X 12 INCHES (30.5 X 30.5 CM)

I am constantly seeking to simplify the manner in which I apply color.

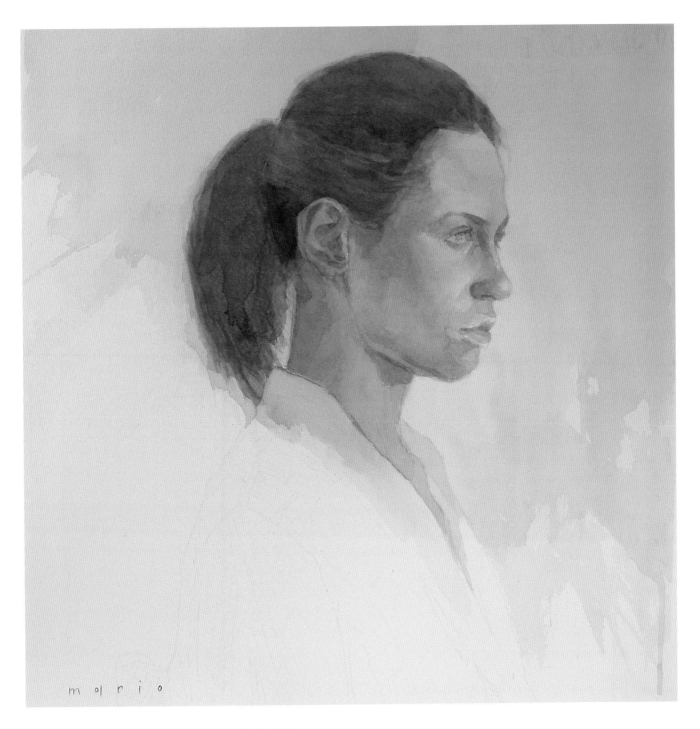

SOPHIE, 2013
WATERCOLOR ON PAPER, 14 X 14 INCHES (35.5 X 35.5 CM)

When creating this sketch I applied a light wash of Payne's gray and burnt umber over the top of the paper, which gave the painting a cool tone. The successive layers of the flesh tone and hair included Payne's gray in the color combinations, which enhanced the coolness of the painting.

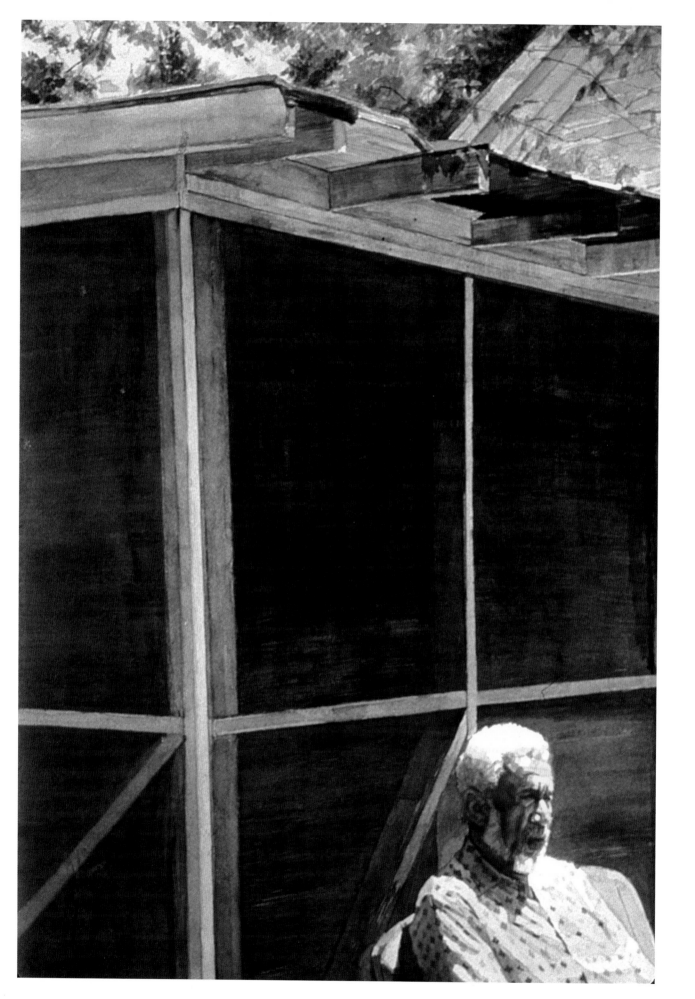

WATERCOLOR TECHNIQUES

"Technique is the test of sincerity. If a thing isn't worth getting the technique to say, it is of inferior value."

—*Ezra Pound*

When you think about the work of great artists, the manner in which they painted is equally as important as what they painted. Whether it's Vincent van Gogh's *The Starry Night* or Rembrandt van Rijn's self-portraits, their paintings have a distinct appearance and are worlds apart in terms of their paint application. An artist's finished work is akin to his or her handwriting—unique in its execution and clearly identifiable with a trained eye.

I recently attended an exhibition at the North Carolina Museum of Art that featured miniature works by Dutch masters and their contemporaries. Many of the paintings were the size of my hand or slightly larger. From a distance, the images were barely discernible, which forced you to closely inspect them. Along one wall there were a number of works of art created by a student of Rembrandt, and, from a distance, they possessed a resemblance to the master's work. As I got closer to one of the paintings, however, I distinctly observed the brushwork for which Rembrandt is recognized; I didn't even have to refer to the information next to the painting to know, with certainty, that it was a Rembrandt.

Attending art school or studying privately with an artist can inspire you and introduce you to the proper methods and materials required for improving your artistic skills. As easy as it may be to follow in your mentor's footsteps, it is incumbent upon you to carve out a niche and develop your distinct working style. The manner in which you hold a brush or the way your brush distributes water across the surface of the paper constitute elements that cannot be taught. We are all genetically designed differently, and the beauty of art is the gift of individual expression.

My first *watercolor only* exhibition was at Ann Long Fine Art (in Charleston, South Carolina) in September 2005. I began to feel comfortable about the painting style I had cultivated during the previous four years. I had

FISHING SHED, 2005
WATERCOLOR ON PAPER, 24 X 18 INCHES (61 X 45.5 CM)

All of the wood in the painting, as well as the leaves in the background were painted wet-in-wet, which generated a muted appearance. Meanwhile, the man was painted by applying thin glazes of color over completely dry layers. The highlighted areas in his hair and shirt are a result of the white of the paper showing through.

learned how to add water to areas I intended to soften as well as use drybrush to enhance details. In *Fishing Shed*, on page 92, you'll notice how I navigated the area in the top left of the painting, where the trees meet the sky. Rather than simply glazing the trees over the blue area of the sky, I worked the green pigment over a wet surface; this allowed the mass to recede faintly back into space. I desired a distinct appearance for my watercolors. I spent countless hours introducing various methods to achieve

it. The style I use today is derivative of the techniques I developed during the early 2000s.

The gentleman in *Fishing Shed* moved from the west coast to Arkansas to care for his deceased parents' home. As he gave me a tour of his father's shed, which held his boats and other accessories for fishing, and shared numerous personal stories, his emotion was palpable. I placed him in the lower right-hand corner to showcase his father's shed. In many regards, it was a portrait of the father and son.

GLAZING

The technique of glazing involves applying a transparent mixture of color over a completely dry layer of paint. The more layers a watercolor possesses, the richer the colors will appear. When light hits the white of the paper, it illuminates the transparent color layers, making them appear to be backlit. The result is a brilliant effect, which is exclusive to the medium of watercolor.

Prior to applying a glaze, the surface of the paper should be dry to the touch. Painting into a damp layer can result in lifting color from the painting, whereby creating major damage or even ruining the piece. Some artists use a hairdryer to speed up the process; however, if it's too intense, the heat can cause the paper to buckle. I prefer a natural drying time, which is uniform and allows the paper to simulate the stretching process.

When applying a glaze, be sure to assess the area to insure your brush is the correct size. You may need to glaze over an area as small as an eyeball or as large as an open sky. Using a brush that is too large can result in over-flooding an area with color and causing it to bleed, while using a brush that is too small can lead to creating hard water marks that form a distracting pattern on your painting. In order to maintain a clean appearance in your work,

apply your glazes in one direction. For instance, if you begin on the left side of the paper, complete the stroke and return to the left side, working the glaze down the paper. Resist the temptation to push the water back and forth, as the water will begin to pool in certain areas and settle, creating marks on the paper once it dries.

My palette comprises mostly transparent and semitransparent colors. (Winsor & Newton paint tubes indicate the paint's properties on the label: the letter "T" stands for transparent and "ST" stands for semitransparent.) Using transparent colors increases the purity of a glaze once colors are mixed together.

Take a close look at *Ella*, shown opposite. I used transparent glazes in a number of places, most notably in the glasses and on her skin. Once I had established the general shapes of the subject's eyes, I glazed in the reflections in the sunglasses. I kept all the shapes reflected in the lenses abstract by working the glaze colors wet-in-wet, long after the initial layer had dried. When working wet-in-wet it's best to mix each color in advance, as timing is crucial. (Once a particular color begins to dry, a hard edge will appear when another color is introduced; the purpose of working wet-in-wet is to produce soft edges.)

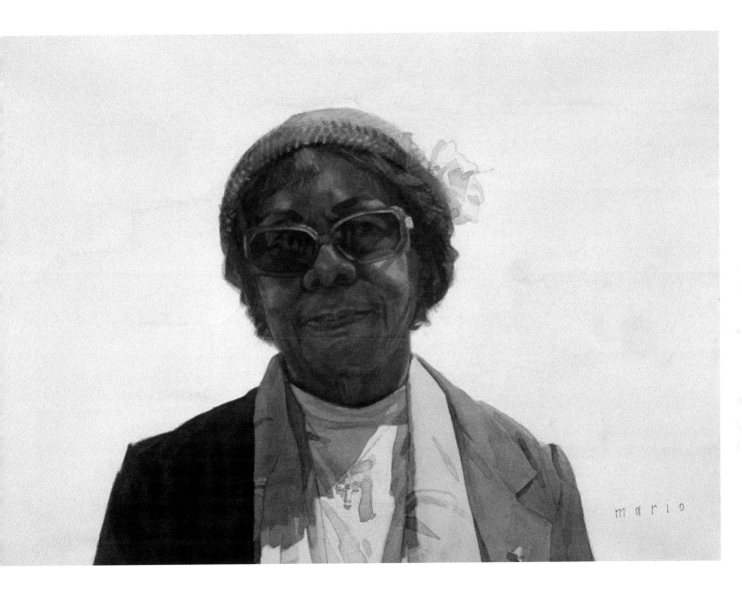

ELLA, 2010
WATERCOLOR ON PAPER, 14 X 20 INCHES (35.5 X 51 CM)

I added a glaze layer of neutral tint over the left side of her jacket to create a dramatic shadow. This gives the right side of her jacket the appearance of an invasive amount of sunlight. Darkening a tone near a lighter one is an excellent way to create contrast.

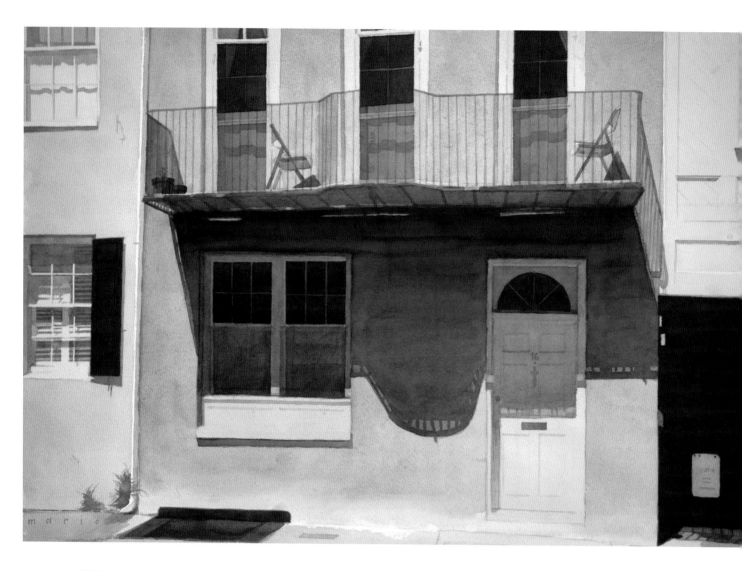

SIXTEEN BROAD STREET, 2012
WATERCOLOR ON PAPER, 18 X 24 INCHES (45.5 X 61 CM)

The key to painting a successful façade of a building is a smooth glaze, devoid of hard watermarks. If you are inexperienced with watercolor, I recommend adding a few drops of ox gall into your mixture of color. This will increase the flow and prevent the water from drying as quickly on the surface of the paper.

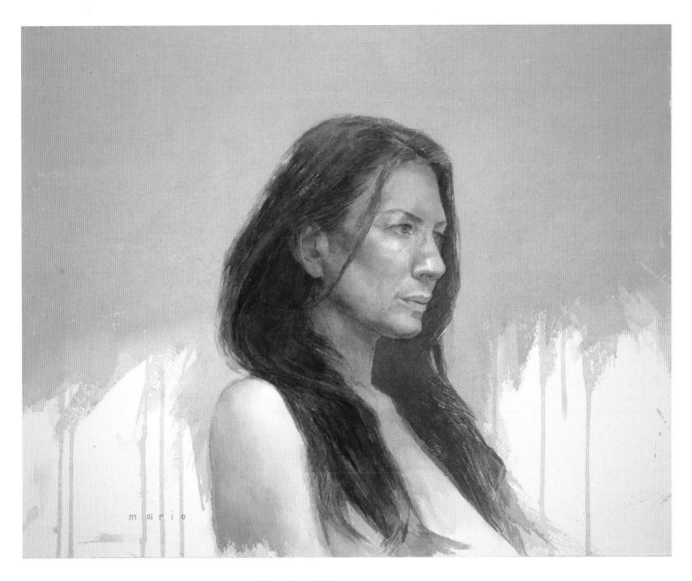

SAM, 2015
WATERCOLOR ON PAPER, 16 X 20 INCHES (40.5 X 51 CM)

The flesh tone of this subject was achieved by using three thin glazes of color. A simplified approach to the medium of watercolor showcases its true essence.

When capturing the intricate topography of an older person's skin, I use an excessive amount of glazes. With *Ella*, I wanted to capture the expressive creases in her skin; therefore, I had to continuously reinforce the darker shadows of the folds, as well as the shadows cast by a few of them. There must be a balance, however, because it's easy to fall into the trap of overemphasizing the hardness of the lines on the face of an older person. This will result in an unrealistic depiction of the person's likeness. I am careful to add water to the paper's surface prior to painting a demarcation on the face.

The majority of *Sixteen Broad Street*, shown opposite, was achieved using a monochromatic block in. There are several different values of white in this painting. I used the white of the paper to produce the white area on the bottom of the door and ledge to the left. There are only two thin glazes of color. Notice how the ledge of the bottom window and the bottom half of the door on the ground floor appear to come forward. However, both of these areas allow the white of the paper to radiate with light. I am always amazed at how a small glaze can have a big impact on a painting.

GLAZING DEMONSTRATION

When I view a great work of art, my first reaction is a deep level of appreciation for the artist's skill set. Eventually, I begin to deconstruct the masterpiece, in an attempt understand each component used to create it. This requires me to look far beyond the surface and deeper into the underlying layers and ultimately onto the ground layer. In this demonstration, I build a portrait, using thin washes in the ground layers and finishing with slightly thicker glaze layers of color. This "simple" approach to glazing allows light to reflect off the paper and gives the subject a luminous appearance. Audrey has distinct, chiseled features, which I wanted to showcase. The overhead light source created dramatic shadows on her face, which allowed me to accomplish my goal.

STEP 1

I BEGAN BY USING washes of burnt umber and French ultramarine to establish the subject's facial structure. Using multiple glazes, I layered in the shadow areas to break up the planes of the face. Once I was satisfied with the depth of the darkest shadow areas, I applied a wash over the entire face in order to unify the value range.

STEP 2

I APPLIED A THIN GLAZE OF COLOR (opera rose, raw sienna, and Payne's gray) over the subject's face, neck, and shoulder, while reinforcing the shadows with an additional layer of the same mixture. I premixed the color for the hair (raw sienna, burnt umber, and neutral tint), which allowed me to work the edges of the hair along with the face to avoid creating a hard line between the face and hairline. I preserved the highlighted areas by applying clean water, prior to pulling color into it. Attempting to lift color with water after it's been applied can result in hard watermarks.

STEP 3

I ADDED TWO WASHES of burnt umber and French ultramarine to the background to identify the desired value of the face. Next, I glazed a layer of burnt sienna to add warmth to the shadows and applied an additional glaze layer of color over the flesh tone. At this stage, my glazes remain thin, due largely to the fair complexion of the model. If the shadow areas are too dark, it creates an unrealistic contrast between them and those areas that are exposed to the light.

STEP 4

AFTER ASSESSING each component of the painting, I determined that the background needed an additional layer of color, while the shadows required a dark glaze. Therefore, I added a layer of indanthrene blue, sepia, and alizarin crimson to the dress. Next, I used a diluted mixture of the "dress color" to the shadows. I finished by adding a few details to the hair, avoiding the temptation to over-work any particular area.

AUDREY, 2015
WATERCOLOR ON PAPER, 14 X 20 INCHES (34.5 X 51 CM)

During my painting process, I use a spare piece of watercolor paper to make a note of my choice of colors. This insures that there's unification of colors in my painting. The test piece of paper must be identical (in terms of weight and surface) to the one on which I am painting, as this prevents the distortion of a particular color.

WORKING WET-IN-WET

Working wet-in-wet offers a watercolorist the ability to mix colors in a spontaneous manner, while maintaining soft edges. This technique is intuitive, which is an exciting prospect—*once the wash dries and the result is pleasing,* that is. With other mediums a particular technique that has been successful can be replicated to achieve a certain effect. Not true with watercolor. The fact that, when working wet-in-wet, you are potentially risking the future of your painting, with no control over the outcome, is an inexplicable reality of painting with watercolor.

Painting with watercolor forces the artist to be present in the moment and accept the medium's unpredictable nature. When introducing a new wash, be sure that it contains the same amount of pigment as the previous wash. Failure to add enough pigment will result in rinsing color from the surface and creating a bloom. When I employ the wet-in-wet technique, I make it a habit to premix all the colors I plan to add. If you begin to mix a new color while the current wash is drying on the surface, you may miss the opportunity to properly apply the new color.

Watercolorists tend to work in two predominant styles—the wet-in-wet approach or glazing. These techniques can be used independently of each other or in conjunction to offer a painting variation. If you desire a looser appearance to your work, you'll choose to work wet-in-wet; however, if you prefer a more controlled aesthetic, then applying glazes over dry layers would be your choice. I prefer to mix the two styles throughout each of my paintings, depending on the edges or texture I seek to replicate. For the purpose of demonstration, I applied these techniques to each apple at right to show their differences.

The wet-in-wet technique is especially useful when painting skies. I always wet the entire area, prior to adding

APPLE, 2015
WATERCOLOR ON PAPER, 6 X 6 INCHES (15 X 15 CM)

In this illustration, I wet the surface of the paper prior to applying color to each layer. The soft edges are a result of the wet-in-wet technique. Timing is crucial when employing this technique. If you add color to the water too quickly, the color will bleed profusely. You can clearly see this happening around the top of the apple.

APPLE, 2015
WATERCOLOR ON PAPER, 6 X 6 INCHES (15 X 15 CM)

In this illustration, I used a standard glazing technique and allowed each layer to dry thoroughly prior to applying an additional layer of color. The realism of the apple was heightened with a small amount of drybrush in the shadow areas.

color to a sky, regardless of the amount of clouds. As you observe the sky in *Spirit on Channel Drive*, below, you'll notice the clouds do not possess hard edges. This is because I was diligent about keeping the surface soft and continuing to work wet-in-wet as I painted these details. I rarely apply color to a watercolor without wetting the paper between layers. This allows me the flexibility to control edges as well as the staining strength of the pigment.

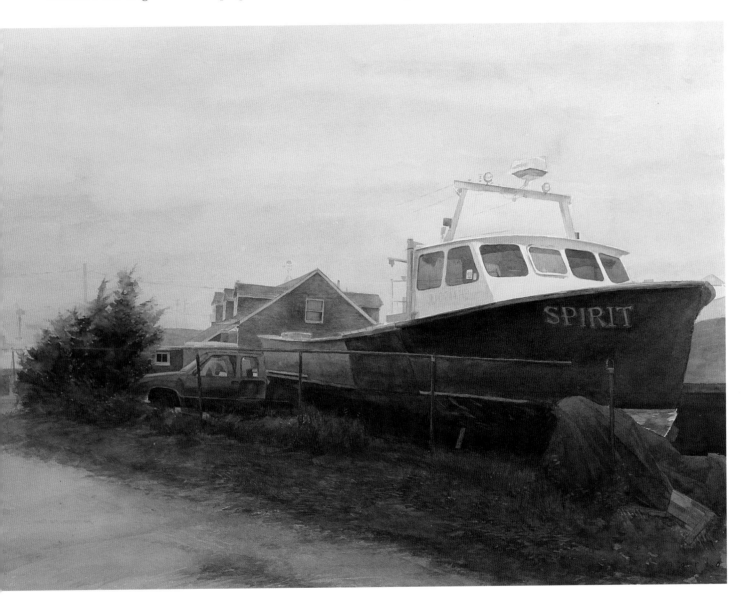

SPIRIT ON CHANNEL DRIVE, 2014
WATERCOLOR ON PAPER, 22 X 30 INCHES (56 X 76 CM)

The grass in this painting was created, using three different glazes, wet-in-wet with a stippling motion with a round. The mixtures of color converge to form a tonal rhythm, loosely defined as the texture of grass.

WET-IN-WET DEMONSTRATION

The blending of two disparate color mixtures on a piece of paper produces a subtle complexity of tones. In this demonstration, I worked in sections of the painting to show how to work wet-in-wet. I used clear water in certain instances to assist me in controlling the staining properties of the pigments. While it is possible to apply watercolor in a straight-forward manner, I recommend a nuanced approach to achieve high levels of realism.

STEP 1

I BEGAN BY BLOCKING in the shadow areas of the painting using burnt umber and French ultramarine blue. Once the darkest values were established, I felt confident in moving on and adding color.

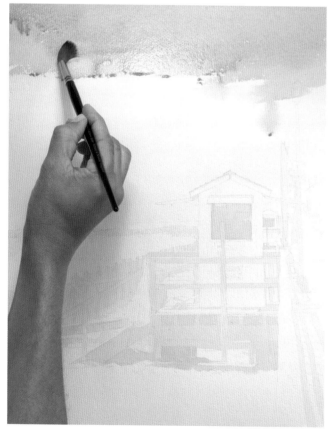

STEP 2

NEXT, I APPLIED CLEAN WATER to the entire area that was designated for the sky. You can see the water glistening, as there was an ample amount of water resting on the surface of the paper. I brushed in the block-in colors (burnt umber and French ultrama-rine) and added a mixture of local colors, consisting of cobalt blue and permanent rose.

STEP 3

I CONTINUED TO METHODICALLY pull the glaze down, moving my brush from right to left. The wet-in-wet technique requires a swift pace while the brush intermittently adds color to the paper. I was careful to limit my brushstrokes to one direction, in order to avoid the formation of watermarks.

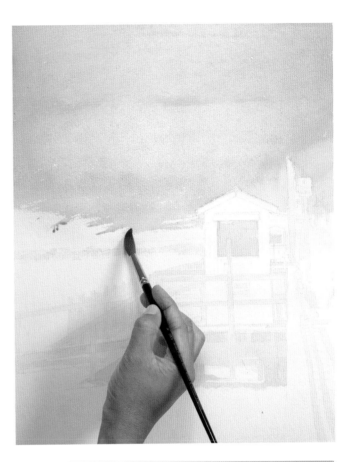

STEP 4

I APPLIED CLEAN WATER to the area near the horizon line, in preparation for a second pass of color. I began glazing the sky with a mixture of cobalt and permanent rose, resulting in a smooth gradation of color as the horizon appeared lighter to indicate distance. I added a base color to the sand, using dark brown, burnt sienna, and raw sienna.

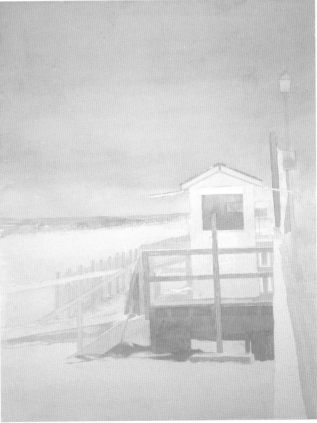

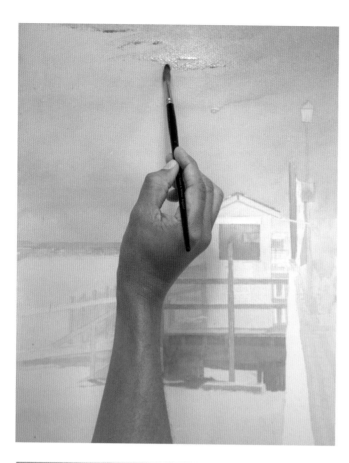

STEP 5

AFTER ALLOWING THE PAPER TO DRY, I introduced a fresh application of paint as well as clean water to the middle of the sky area to create a blending effect. My goal was to add a darker tone to the upper region of the sky to enhance the illusion of distance. Working wet-in-wet not only refers to mixing color mixtures into one another, but adding clear water to color mixtures on the surface of the paper, as well.

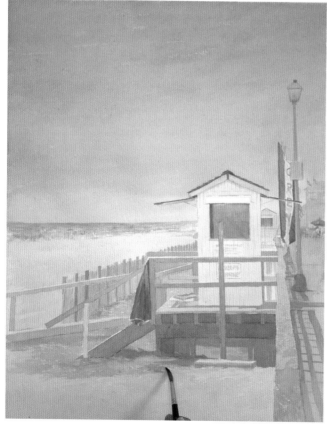

STEP 6

IN THIS SECTION, I CREATED TEXTURE in the sand by laying down two separate mixtures of color. The first mixture consisted of dark brown, permanent rose, and neutral tint, while the second was dark brown, raw sienna, and Payne's gray.

These boxes show the two separate color mixtures used for the sand.

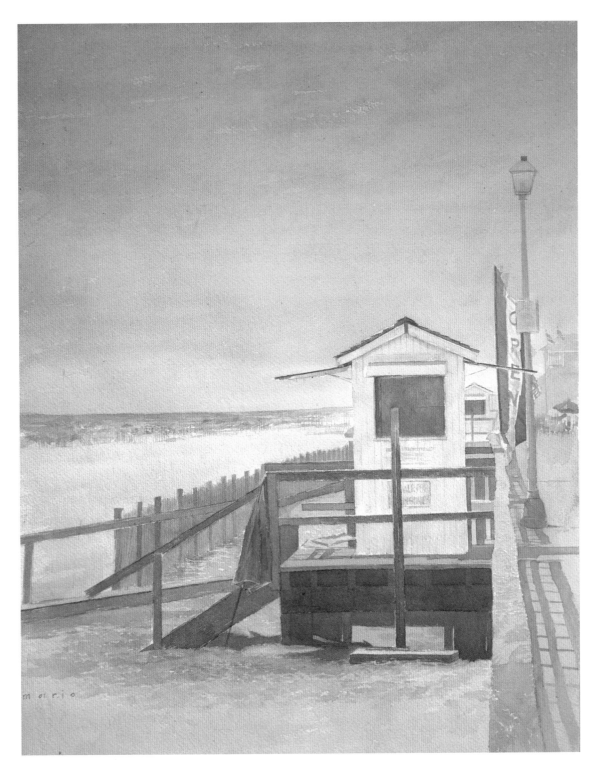

STEP 7

THE FINAL PAINTING is a culmination of several sections, which were completed using the same techniques I employed in the previous steps. I balanced the loose wet-in-wet applications of color with controlled glazes over dry areas, creating an interesting tension.

POINT PLEASANT BOARDWALK, 2015
WATERCOLOR ON PAPER, 20 X 16 INCHES (51 X 40.5 CM)

EMPLOYING WASHES

A wash is simply a flat layer of color that is applied to an area for the purpose of deepening its value or changing its color. For example, if I'm painting a person's face and I find that the tones are too warm, I can add a cool wash of Payne's gray over the entire face for balance. Washes are instrumental in the beginning stages of my paintings, as they allow me to establish the correct values. Depending on your desired use, a wash can be applied to a completely dry area of your painting or a wet one.

Painting white houses or white walls generally requires a series of thin washes. Using a diluted mixture will allow you to gradually darken the value of the object. I typically establish the tone of my whites with either a mixture of burnt umber and French ultramarine or a mixture of burnt umber and Payne's gray.

The effect of light and shadow upon surfaces plays a vital role in the manner in which we perceive objects. The doors of the building in *Altus Church House*, shown below, seem to vibrate with intensity, while the shadow areas on either side tend to recede and capture less of our attention. The medium of watercolor allows an artist to employ this principle to a higher degree than any other medium.

Washes are an essential component to a watercolorist's repertoire. They are pivotal when you would like to make changes to the appearance of a painting. You can utilize them to make delicate changes to the brightness of a white area or you can wash over a large mass with a darker color to unify a "busy" area.

The absence of a background in a painting can often be as powerful as the implementation of strong imagery. The silence can be deafening when a subject is left alone with his or her thoughts, with no distractions for the viewer to peruse. This device cannot be used for each person I portray; however, certain personalities, such as Torkwasé, opposite, possess a great amount of presence within a composition. This decision must be made prior to adding elements to the background, as watercolor doesn't offer viable editing options.

ALTUS CHURCH HOUSE, 2011
WATERCOLOR ON PAPER, 9 X 12 INCHES (23 X 30.5 CM)

One of my favorite things to paint is white clapboards. While it may appear that the shadows of each board are fully represented, in reality they all receive varying amounts of detail. Wet-in-wet washes, assisted by a few distinct horizontal "lines" across the exterior of the church, allow the eye to fill in the details.

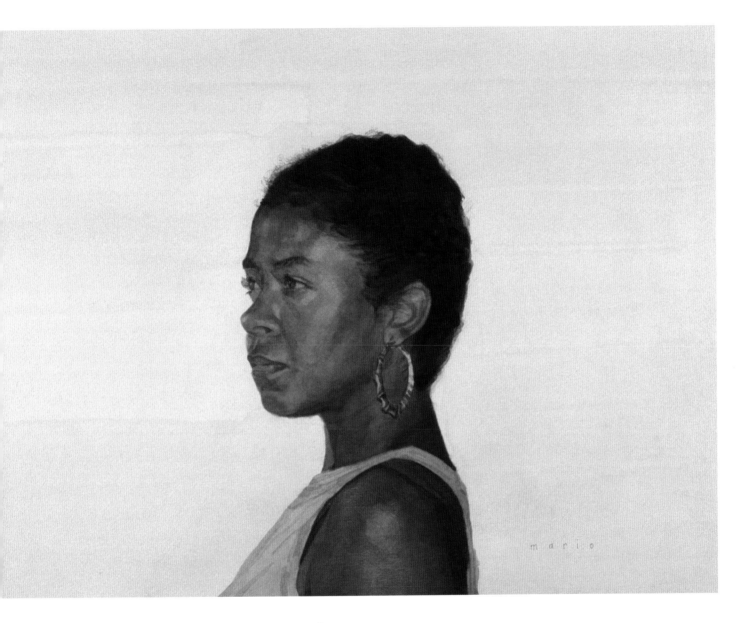

TORKWASÉ, 2008
WATERCOLOR ON PAPER, 18 X 24 INCHES (45.5 X 61 CM)

Due to the high risk of ruining a watercolor, I tend to be reluctant about applying excessive amount of washes to my backgrounds. I added two layers of burnt umber and French ultramarine to this image. I worked quickly around the figure to avoid the color sitting on the paper, which could lead to watermarks.

WASH DEMONSTRATION

I executed the following demonstration in a simplistic manner, with the intent to break down a technique, which is normally applied expeditiously. As you develop your skills in watercolor, your brush speed will increase. This will allow you to apply watercolor washes quickly, in order to avoid acquiring unsightly watermarks on your paintings. Practicing on scrap pieces of paper is a good way to sharpen your hand–eye coordination as you apply washes.

STEP 1

I SUBMERGED MY BRUSH into the container of watercolor, allowing the hairs to become fully saturated. (If the brush is partially dry, it can cause streaking as it moves across the surface of the paper.) Beginning at the top of the paper, I guided the water straight across, applying only minimal pressure on the brush. It's ideal to allow the water to glide the brush, rather than dig into the paper with the brush. The wash will appear more even when minimal brushstrokes are employed during the application.

STEP 2

I CONTINUED in a linear fashion, applying color from right to left and methodically moving downward with each new application. As you'll notice, there's a white area of the paper on the left, which was missed. As long as the wash was wet, I was careful to keep my brush beneath the area of color, as I filled in the void. Pushing color back into an established area of color will cause a "bleeding" effect.

STEP 3

AS I REACHED the bottom of the paper, I quickly removed the excess water from the paper, in order to avoid blooms. I should mention that I adjusted my drafting table to an upright position to allow the water to flow as freely as possible during this process. However, it's most important to work in the position in which you're most comfortable.

STEP 4

THE RESULT IS A SMOOTH, flat wash of color, devoid of hard watermarks and streaking. I included the embossed logo in the demonstration to show how thin the wash of color is. The combination of small amounts of pigment in the water and a purposeful motion with my brush stains the paper in a more gradual fashion, rather than an aggressive one.

THE DIFFERENCE BETWEEN A WASH AND A GLAZE

The amount of water added to the color constitutes the difference between a wash and a glaze. In this illustration, I used rose madder genuine to demonstrate the consistency of the two applications. I put a piece of paper in each mixture to show its density, and then applied each mixture to the paper in the foreground to show its effect.

The mixture on the left is considered a wash. It is more transparent because it has been more diluted with a considerable quantity of water. The wash I applied to the paper was light and only slightly changed the color of the white paper.

The mixture on the right is considered a glaze. The consistency is thicker; therefore, the paper is hardly visible, as it's submerged in the water. When I applied the glaze to the paper it created a robust, yet thin veil of color. Glazes of this kind can be used to achieve a realistic watercolor with a full value range.

When mixing colors, be sure to mix ample amounts to insure you don't run out in the middle of applying a wash or glaze. The "muffin pans" allow me to have more than enough color at my disposal.

SOFTENING TRANSITIONS

Being able to manage the softness of edges in watercolor paintings is a highly important skill, one that separates good watercolorists from great ones. Timing is everything when balancing color application, and avoiding the appearance of hard edges throughout the painting. Painting portraits requires practice in this area, due to the manner in which light moves across the surface of the skin. When painting a portrait, I am always cognizant of hard edges—from the earliest stage of blocking in values to the finishing touches of the painting. When working on areas where a lighter area is transitioning to a darker one, I apply water to the paper, which dilutes the edge of the glaze. Prior to applying clean water to the surface, I make sure the paper is dry to the touch, which helps me avoid lifting color from the painting.

The most effective way to become comfortable using clear water in conjunction with watercolor to soften edges is to practice regularly. A simple exercise, such as painting a round object with light, middle, and dark values, can be invaluable, since it is unlikely to generate any trepidation and will give you a chance to find your comfort zone with the technique. Anxiety tends to surface when there's a risk of potentially ruining a work of art in which you've invested time and energy, and you feel uncertain. So, practice, practice, practice.

The younger a subject is, the more water has to be mixed into the pigment, whether it's directly into a wash or onto the surface of the paper, to prevent the hard edges from forming on the areas of their skin. It is difficult to achieve volume with successive layers, which contain minute amounts of paint; therefore, I recommend that you apply water to the paper either before or during the application of color to soften the edges.

Case in point: Look at *Lila*, right, which shows the young girl's smooth skin. When creating this painting, my brush was in constant motion to avoid the appearance of hard edges on her face. Lila and her family were residents of Mississippi, but at the time I painted her portrait, they had been displaced due to Hurricane Katrina. They were living out of suitcases in a hotel while their home was being repaired. Lila's disposition was jovial and optimistic; however, beneath the surface there were traces of trauma and uncertainty.

Capturing the features of an individual is relatively easy compared to projecting his or her soul upon the paper.

When painting children it is crucial to use thin washes in a controlled manner. With *Lila*, I simply added water to the surface of the paper, prior to applying each layer of glazes. You would be surprised at the effect that one hard watermark can have on a young person's face. It can increase his or her age exponentially. Also, the idea that portraits of children must reflect a blissful naïveté misrepresents their multifaceted personalities. When working with models, it's important lay aside preconceived notions and stereotypes.

Children are capable of expressing a gamut of emotions. For example, this young boy in *Market Street*, shown on page 112, was selling sea grass he had crafted into flowers for five dollars apiece on the street in Charleston, South Carolina. I instinctively made him a deal to buy one of his flowers if he agreed to pose for a photograph. He agreed. However, as I directed his pose he began to focus intently

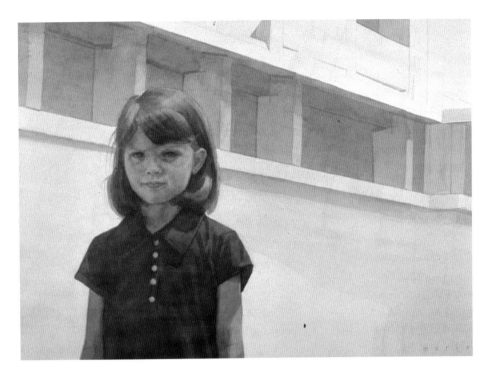

LILA, 2008
WATERCOLOR ON PAPER, 18 X 24 INCHES (45.5 X 61CM)

I used a large, 2-inch brush to apply the wash to the white areas in this painting. Having ample color on your brush will help you avoid streaking; a weak wash will dry prematurely and a hard line will form on the paper as you continue to paint.

on the tourists walking past us, the smile he initially gave me turning into a more serious expression. I realized he was anxious to return to selling his wares. My anxiety was fairly high because I knew he would only allow me to snap one shot. Since I was shooting with 35mm film, I also knew I would have to wait until the film was developed to find out the quality of the reference photograph. In the end, the painting possesses an interesting tension, which emerged organically.

I am particularly aware of the lack of hard shadows on a model when his or her flesh is inundated with light, as with *Silk Blouse*, page 112. It's a challenging proposition to add layer after layer, employing a wet-in-wet technique to achieve this luminosity—but one that is well worth it in the end. Placing my subject directly in front of a window

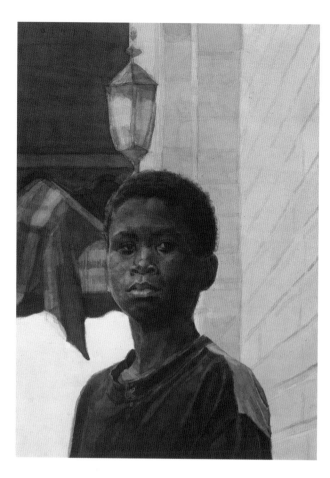

MARKET STREET, 2006
WATERCOLOR ON PAPER, 20 X 14 INCHES (51 X 35.5 CM)

As I began to study this young boy's face, I noticed multiple colors swirling over his skin, especially in the darker shadow areas. I wanted to include these colors, melding them together and keeping the transitions soft. You can see the embellishment of Chinese white, drybrushed to further meld the light and mid tones throughout the topography of his face.

SILK BLOUSE, 2012
WATERCOLOR ON PAPER, 20 X 16 INCHES (51 X 40.5 CM)

Painting a successful watercolor depends on your ability to manage the staining power of the pigment. I used clean water at pivotal moments to preserve the light areas of the model's face. The transitions are soft, due to the manipulation of water throughout the process.

bathed the front of her face with cool light, giving her skin a radiant quality. With the intent to keep all the transitional edges on her skin soft, I used a thin mixture of rose madder, raw sienna, and Payne's gray to glaze the highlighted areas of her flesh. The second pass, featuring the same mixture, deepened the middle tones. I added burnt sienna to the deepest shadow areas, such as the cheek, eye socket, and so forth. When using thin glazes of watercolor to capture light in a painting, the key is to practice restraint.

MANAGING THE FLOW OF WATER

One of the most exciting aspects of painting with watercolor is navigating the constant movement of the water. In fact, painting with watercolor is sometimes likened to driving a car without brakes. There's no feasible way to fix

mistakes once they occur; therefore, one can only proceed in a forward direction, while carefully avoiding potential pitfalls.

I had worked extensively with soft pastel for ten years before I gained the courage to attempt my first watercolor. The first thing I noticed was, once the loaded brush made contact with the paper, the water was on the move. I had a finite amount of time to make decisions; therefore, it was imperative to have a strategy. I advise students in my workshops to have a good idea as to what their goals are for each glaze of color and mentally plan the route the water will take. Also, have a sheet of paper towel handy to absorb any excess water that pools on the paper, as it will stain and create an unwanted watermark.

A high-quality watercolor brush is capable of holding large amounts of water in its hairs. I keep a layered sheet of paper towel taped to my drafting table to absorb excess water on the tip of my brush, and dab my brush on this blotter prior to applying a wash or glaze. This prevents unwanted drops of water from running aimlessly down the surface of my painting. When applying color, be sure to have an ample amount of water on your brush, as the color should glide across the surface, rather than be tightly controlled. Long, sweeping strokes will gently guide the watercolor along; handling your brush in this manner diminishes the possibility of it pooling and forming distracting watermarks.

Lighting conditions are important to consider when choosing to utilize the white areas of the paper. The sky and field in *The Oklahoma Native*, above, are extremely

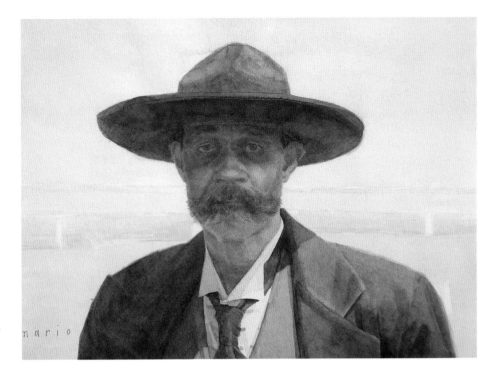

THE OKLAHOMA NATIVE, 2011
WATERCOLOR ON PAPER, 14 X 20 INCHES (35.5 X 51 CM)

When I paint an interesting character, such as my father, I avoid the use of complicated backgrounds. I prefer to place the attention solely upon the subject.

bright, and the black tie lying on the white shirt also possesses a light value. Each component supports the choice to use the white of the paper on the highlighted area of the shirt. There are no overly dark areas in the scene that would create an unrealistic contrast.

When a viewer looks at a watercolor painting, there is no way for him or her to identify the various techniques required. For instance, look at the right side of the subject's suit jacket in *The Oklahoma Native*. The light creates a highlight, due to the protrusion of his shoulder. In order to describe this in watercolor, I had to employ a wet-in-wet technique to create the highlight and soften the transition from light, middle, and dark. I wet each layer before I brushed in color, gradually working my way down the jacket.

UTILIZING DRYBRUSH EFFECTS

This term can be confusing, as it doesn't accurately depict the technique. Drybrush strokes are created with a damp brush and offer the artist a greater amount of control over the paint application than would large washes applied with a round brush. If you are a stickler for detail, this technique will allow you to work in the minutest areas. The side of a medium-sized round brush can be utilized to execute broken strokes of color to create texture when painting the bark of a tree. A miniature size 00 brush can be utilized for line work, such as eyelashes.

A word of caution: The level of control that you experience when using the drybrush technique may feel empowering; however, drybrush is most effective when used sparingly. Drybrush is generally weaved over large glazes of color to increase detail in particular areas. The process is similar to drawing with strokes of color, and it's easy to become immersed in the tightness of the details, thus overworking the painting and losing the essence of the watercolor.

In *Mrs. Lockhart*, shown below, the drybrush technique allowed me to add detail to the subject's face, especially in the highlighted areas. The neck recedes, due to the lack of drybrush strokes. To achieve these drybrush details, I mixed cadmium red, cadmium yellow, and Chinese white. Drybrush is a technique that requires practice in order to attain the temperament necessary to propel a watercolor to the next level without overworking it.

Applying a drybrush technique over broad washes of watercolor heightens the level of realism in a painting. The most effective use of drybrush is selecting particular areas of interest to build texture or render the form. This point is evident in *Summer in Guntersville*, shown opposite, as you notice the drybrush details on the front of the subject's face. His head has a two-dimensional quality to it, based largely upon the placement of cross-hatching in key areas. The drybrush technique is similar to drawing with a brush. While the details in a painting add dimension, it's important to exercise a level of restraint to avoid an overworked appearance. The loose washes of watercolor play a vital role in balancing the components of the foreground versus the areas that recede into the background.

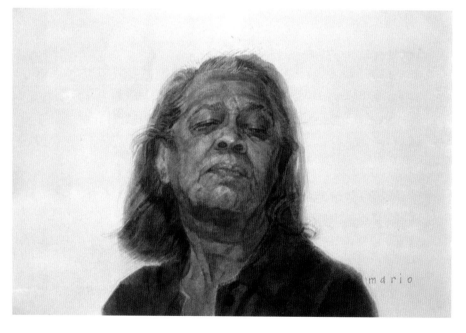

MRS. LOCKHART, 2005
WATERCOLOR ON PAPER, 14 X 20 INCHES (35.5 X 51 CM)

Interior settings aren't filled with as much natural light as outdoor scenes. The highlights in this image aren't as distinct and the tonal range is more subdued. I use larger amounts of French ultramarine in the flesh tones, in order to darken each glaze layer, in preparation for adding rich darks, using drybrush in the shadows.

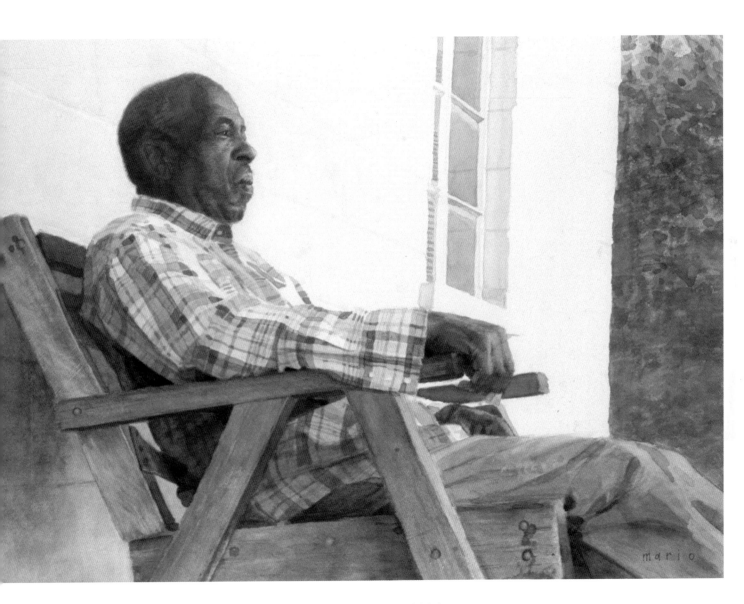

SUMMER IN GUNTERSVILLE, 2006
DRYBRUSH WATERCOLOR ON PAPER, 18 X 24 INCHES (45.5 X 61 CM)

Once I made the decision to push the limits of this watercolor by adding drybrush details, I began to leave the light areas unfinished. I slowly built up the hatched strokes of color in the highlights, particularly on his head and hands, to magnify the appearance of light.

Stephen Scott Young's use of drybrush in the painting *Sienna Scarf*, shown at right, elevates its level of realism. The tightly rendered areas are enhanced greatly by the loose areas, which appear to recede back into space. His controlled use of use of drybrushed strokes is particularly evident in the child's face, which is imbued with a cool light.

I recommend completing the stage of your watercolor in which you're massing in areas using washes and glazed layers of color, before you consider drybrush. This will allow you to assess your painting and decide on the areas to which you would like to add drybrush details. In *Sanctuary*, opposite, I decided to add a small amount of drybrush to the right side of the model's sweater to exaggerate the texture of the cable knit. Notice how the cross-hatching draws the eye to the detailed area, while the other side recedes. I also included drybrush in the shadows on the tie to give it form. It's not necessary to cover the entire painting with cross-hatched strokes of color, rather it's more effective to strategically pinpoint a few spots to highlight.

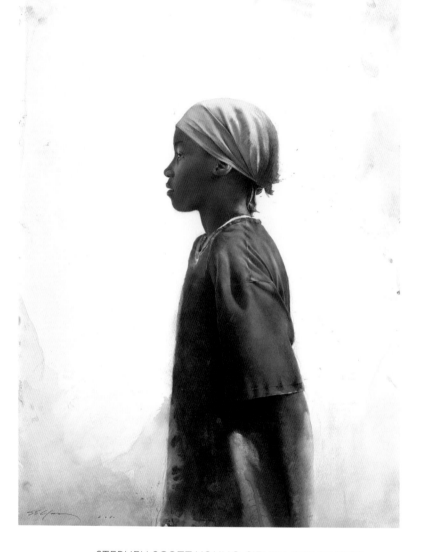

STEPHEN SCOTT YOUNG, SIENNA SCARF, 2010
DRYBRUSH WATERCOLOR ON PAPER, 22 X 16 INCHES
(56 X 40.5 CM)
COPYRIGHT © STEPHEN SCOTT YOUNG

Stephen Scott Young's masterful blending of loose, explosive washes of watercolor and meticulous drybrush strokes of color results in a symphonic weaving of the two techniques.

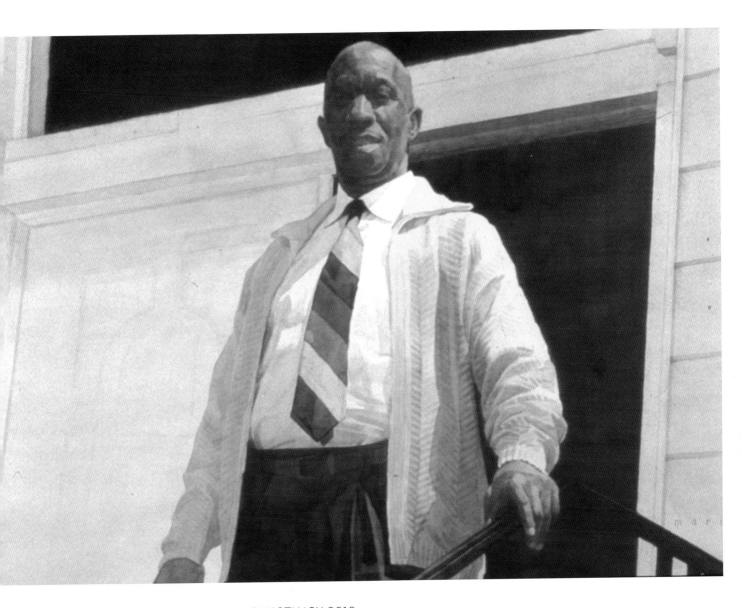

SANCTUARY, 2010
WATERCOLOR ON PAPER, 18 X 24 INCHES (45.5 X 61 CM)

The support for this watercolor is 140-lb. cold-pressed watercolor paper, mounted on card-board. I choose paper based upon the subject I plan to capture. In this case, my main objective was to focus mainly on the flatness of the architecture and the stark white highlights of the shirt. The surface of the mounted paper is smooth and the staining process of the pigments is slower. The watercolor moves across the surface quickly and the glazes are more transparent, due to the less porous paper.

DRYBRUSH DEMONSTRATION

The process of drybrush is relatively simple. After painting a watercolor and allowing it to dry, assess the areas you would like to heighten with more detail. Mix the colors to match those areas. For instance, if you would like to add detail to a brown eyebrow, mix the colors that closely match it. Adding a color that's too dark in drybrush will leave the strokes exposed and will create a distracting appearance. The purpose of drybrushing is to subtly blend areas, while increasing definition. Dip your brush into the color, and absorb the excess color with a paper towel or your fingertips. For fine detail, use the tip of a small brush and apply a few semi-wet strokes of color until the brush dries out completely; then repeat this process until the desired effect is achieved. This technique is time-consuming, as you're working in small, confined areas with very small amounts of color on your brush. The pace of drybrush is slow and more meditative than laying down larger washes of watercolor.

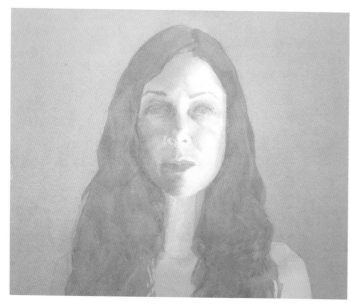

STEP 1

I APPLIED A SERIES of thin washes onto the flesh tone, using a mixture of permanent rose, raw sienna, and Payne's gray. In this initial stage I was concerned foremost with the light and middle values, since I knew that I would be implementing the darker tones, using a drier application with a round brush and ultimately a drybrush technique, at the next stage.

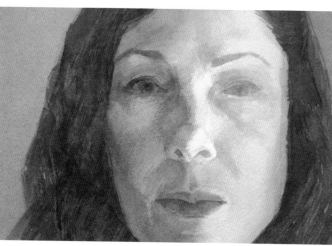

STEP 2

AFTER ADDING GLAZES of alizarin crimson and Payne's gray to key areas of the model's face, I glazed in a mix of Payne's gray and burnt umber to the shadow areas. With the glazed layers established, I began to add small drybrush strokes. My goal during this step was to blend the strokes of color into the existing glazes of color. Notice how the left side of the face, which has been drybrushed, is defined, while the right side possesses a flat appearance.

STEP 3

I ADDED DARKER VALUES to the eyes, using Payne's gray and burnt umber. In preparation for the drybrush details, I wet the surface and laid in light washes of alizarin crimson. Next, I used a diluted mixture of alizarin crimson and Payne's gray to drybrush the right side of the face. The value of the drybrushed strokes of color must be close to the value of the glaze upon which you're applying it. If the hatched marks are too dark, they will distract the viewer.

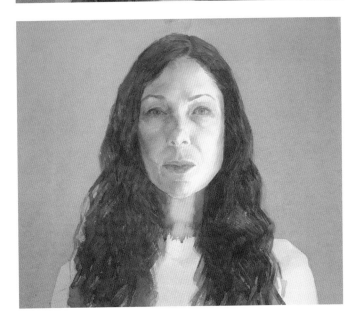

Step 4

I CONTINUED TO DRYBRUSH the edge of the face and the shadow areas of the hair. The result is an image with a sense of dimension. The combination of loose watercolor glazes and detailed drybrush strokes offers a heightened sense of realism.

TRANSITION (STUDY), 2014
WATERCOLOR ON PAPER, 16 X 22 INCHES (40.5 X 56 CM)

EXPLORING TEXTURES

The appearance of watercolor is generally flat, unless the artist takes steps to add nuance to his or her strokes, thereby thinking out of the box in terms of color application. As you observe the world around you, you'll notice the various textures each object possesses. Mastering your ability to properly assign the look and feel of a particular subject will raise the level of realism in your work. For example, consider the difference in texture between a fur coat and a trench coat—one is voluminous and soft, while the other is flat with subtle shadows. You can add textural effects to your watercolors by simply taking excess water off your brush.

While in her mid-thirties, my grandmother lost the ability to speak, due to a stroke that also paralyzed the left side of her body. Her eyes remained incredibly expressive, however, lighting up whenever she laughed. As you can see in *Altus House*, opposite top, the minimal background pushes the subject forward in the composition and allows the viewer to solely focus on her face. I achieved the texture of the fur jacket by applying multiple glazes, each increasingly more viscous than the previous one, with the final layer being the consistency of maple syrup. This gradual buildup of colors in the initial layers left the jacket with a shimmering quality that catches the light in distinct areas. The final glaze consisted of indanthrene blue, sepia, and burnt sienna.

Painting a portrait of an older person challenges me to utilize aggressive brushwork to capture the undulating patterns of the face, as is evident in *Mrs. Neals*, opposite bottom. To achieve this texture I built up the multiple shadow areas gradually, using thick glazes of color. I relied heavily upon the monochromatic block in to establish the shadow patterns in the subject's face. This allowed me to easily locate the important features in the later stages of painting, while giving me permission to brush pure glaze layers over the entire face. The simplicity of the background enhances the textural quality of her features.

The amount of texture you include in your paintings is a personal choice. In my opinion, the more information you include pertaining to a subject in your work, the more invested a viewer will become. Painting in a realistic manner is not merely copying what we see in nature; however, it requires a response to objects we observe.

In this example, I used a Winsor & Newton series 7, size 8 round to apply a flat wash of color.

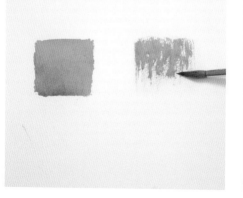

I removed the excess water from the same brush, and then used the sides and point to create the appearance of texture, employing short, feathery strokes.

The difference between the two squares is apparent. These two techniques can be used independent of each other or one on top of the other.

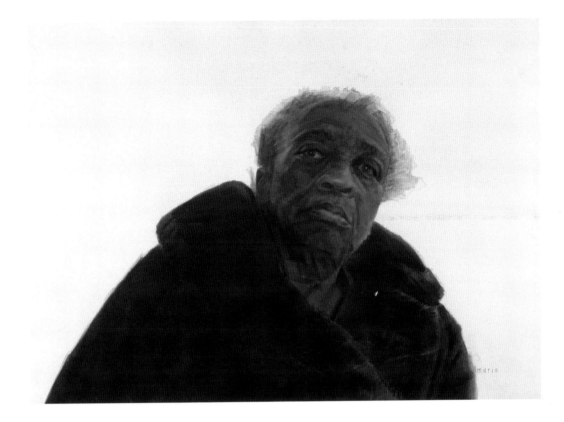

ALTUS HOUSE, 2007
DRYBRUSH WATERCOLOR ON PAPER, 18 X 24 INCHES (45.5 X 61 CM)

I used drybrush in a few selected areas, which were exposed to light. The combination of thick, repetitive glazes of watercolor and drybrush bolstered the appearance of texture in the fur jacket.

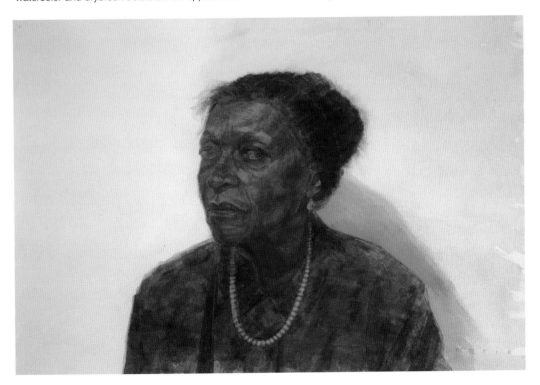

MRS. NEALS, 2012
WATERCOLOR ON PAPER, 18 X 24 INCHES (45.5 X 61 CM)

I used drybrush to increase the texture of Mrs. Neals's wool beanie. I believe it enhances the undulating contours of her face.

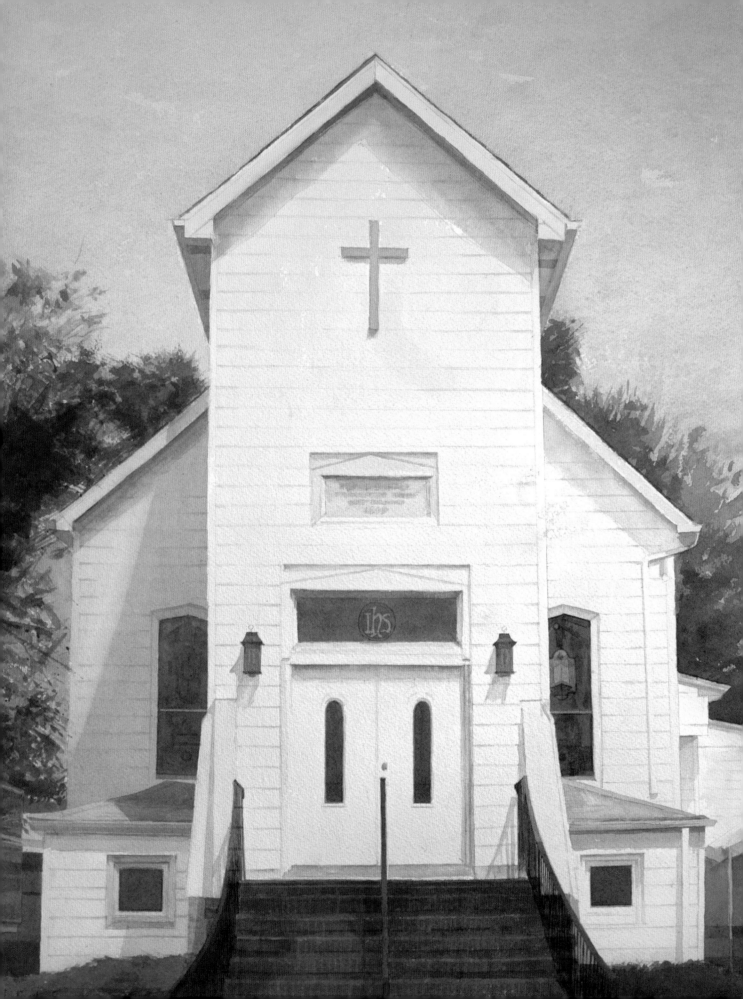

CONSIDERING VALUE

*"In watercolor there are no absolutes.
You simply do what you have to do for the
painting. Just attack it."*
 —Henry Casselli

The lightness or darkness of a color, apart from its chroma or hue, is what artists refer to as *value*. It is the most important visual element in art. Our perception of images in a realistically rendered painting is based largely on how light illuminates the objects in varying degrees, ultimately to create form. Depth perception in art (and in life) is due to the effect value has on objects in the foreground versus those that are farther away. Generally speaking, an object will appear darker than an identical object that is farther away. For instance, when you're standing on a beach in front of an ocean, the colors of the waves crashing at your feet are rich and vibrant; however, when you look into the distance, the water seems faint.

In life, and in art, it is sometimes hard to really see value—in part because color is what often captures (indeed, seduces) the eye. Luckily, wherever you are, you can always employ this age-old trick: Squinting both of your eyes will help you identify the values of objects, as this simple act reduces the details and forces the eyes to view things in an abstract manner. Try this the next time you are struggling with a painting. Visually "removing" the color from your paintings will reveal the value shifts in your work.

When I teach or give demonstrations, I receive multiple questions concerning the amount of "gray" with which I begin each of my watercolors. I have come to notice that value is not fully understood by all artists. The lightness and darkness of objects must be measured against each other in order to create a successful painting. The edifice in *Second Baptist Church* (Keyport, NJ), shown opposite, may appear to be bright white, however upon closer inspection you'll notice the series of grays on its surface. The darker values, which surround the church's white areas forced me to add washes of gray, even to the lightest lights, in order to prevent an unrealistic contrast.

SECOND BAPTIST CHURCH (KEYPORT, NJ), 2012
WATERCOLOR ON PAPER, 27 X 22 INCHES (68.5 X 56 CM)

The architecture of a city or town represents the character and ideals of its residents. This historic church, which I attended as a child, stands majestically as a pillar of the community. The Gothic Revival–style stained glass windows shine like precious jewels in the midday sun.

I am a proponent of using the white of the paper, providing the neighboring values are properly considered. There is no other medium that captures the brilliance of white more effectively than watercolor. A common mistake I notice beginner-level artists make is using the white of the paper for the lightest highlight, without compensating for the surrounding values. For example, if the front of a white house is in direct sunlight, the side of the house (in shadow) can only be a few values darker, since they're in the same light. Painting the side of the house that is in shadow a value near the bottom of the value scale demonstrates a lack of understanding of values. If I were to assign numbers to the values in the watercolor *Second Baptist Church* (Keyport, NJ), I would compare both sides. On a scale of 1 to 9 (with *1* being the lightest, and *9* the darkest), the right side would be considered a *1*, while the left side would be a *4*.

In addition to rendering three-dimensional form, value can also serve as a compositional element in a painting. For instance, the cast shadow on the café is the focal point in *G & M French Café*, shown below. The darkness of the shadow provides contrast and gives the sunlit areas a heightened sense of luminosity. I kept the shadow lively by working wet-in-wet, as well as adding warm tones to counterbalance the cool whites of the highlights. When handled thoughtfully shadows can add a sense of mystery to a painting, while accentuating the sunlit areas of an outdoor scene.

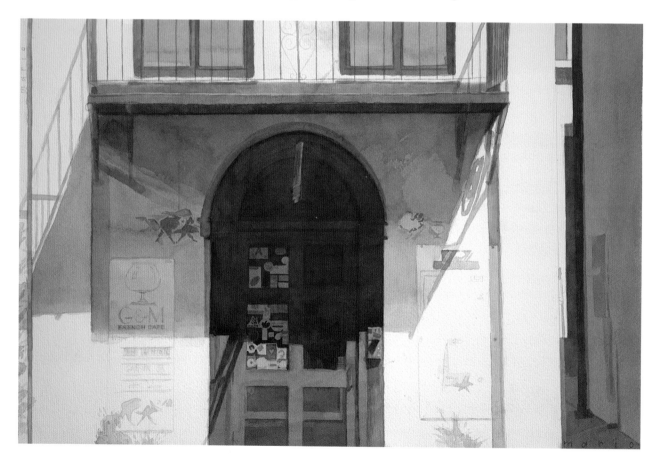

G & M FRENCH CAFÉ, 2011
WATERCOLOR ON PAPER, 12 X 16 INCHES (30.5 X 40.5 CM)

The interplay between light and shadow is an essential tool when painting architecture.

CREATING MONOCHROMATIC BLOCK-INS

Watercolor is unique, in that all other painting mediums adjust values with the addition of black, white, or both. Watercolorists, however, work through the value scale from the lightest value to the darkest in a totally different manner. Rather than adding white to lighten a value, we dilute a color with water until we achieve the proper value. There are, of course, occasions when the use of white is necessary in a watercolor painting, due to the unforgiving nature of the medium; however, the opaque appearance of white paint can be a poor substitute for the pristine white of watercolor paper.

To establish the proper values in my paintings, I begin with a monochromatic block-in, such as *Sketch of Sera*, shown at right. Oil painters refer to this process as *grisaille (pronounced griz-eye)*, which is a French word that means "gray tones." I begin by mixing equal parts of burnt umber and French ultramarine in a watery wash. By combining these two colors, the result is a perfect balance between a warm and cool color, preventing the gray from swinging too far in either direction. I wash over the entire sheet of paper to establish the lightest light in my painting.

Once the paper is dry, I examine my reference, and if the lightest value in the painting needs to be darkened, I continue to add more layers until I have properly achieved the correct value. Once the lightest lights of the painting are established, I apply washes to the mid tones, and ultimately to the darkest darks, using the same mixture. The multitude of thin washes creates depth, while maintaining a transparent quality.

To be an accomplished realist painter it is vital to have an understanding of value and to utilize it to your advantage. The initial layers of your monochromatic block-in will appear darker than they will ultimately appear, in the absence of contrasting mid tones and darker tones. When I perform demonstrations, the question always arises: "Isn't that skin tone too gray?" My answer is often delivered in two parts. First, watercolor will appear darker when it's initially applied and will lighten in value once it dries. If

SKETCH OF SERA, 2015
GRAPHITE ON PAPER, 15 X 15 INCHES (38 X 38 CM)

Improper values in a painting can minimize the effectiveness of a beautifully rendered painting. I use a muted block-in to insure that my light, middle, and dark values are established, prior to adding color.

you are uncomfortable with any color you're applying, it may be a good idea to brush it onto a test sheet and wait for it to dry, in order to view the true color. Second, once the dark values are added, the areas that seemed to be too

dark may eventually appear too light. Applying color over a monochromatic block-in allows me to focus on other factors, such as chroma and hue.

MONOCHROMATIC VALUE SCALE

You must establish a value range that works best for you and the work you seek to produce. Regardless of the lights and darks, it's important to gradate your values in an orderly fashion. When glazing colors, I prefer to move from light to dark in an incremental manner.

In 1907, painter, art collector, and scholar of art history and theory Denman Ross introduced a value scale that is still used today. It helps artists identify lights, mid tones, and darks. The seven squares shown in the illustration above, demonstrate how a single glaze of color can be utilized to capture light, middle, and dark values for an underpainting. When creating watercolors in a realistic style it is important to establish a comprehensive value range prior to introducing color.

As mentioned earlier, I begin each of my watercolors with a monochromatic block-in, using French ultramarine and burnt umber. This combination of colors creates a gray that can be as cool or warm as I desire, based on the amount of each color I choose to add to the wash. I have been asked by artists whether the two colors I use for the block-in ever change, based on the subject matter. There's no need to adjust the colors in the underpainting when working on various subjects. It's applicable to people, places, and things.

So let's walk through the process of creating your own value scale, similar to the illustration on this page. It is a wonderful exercise, one that will give you a greater appreciation for value range and how to achieve it. First, mix the French ultramarine and burnt umber in equal parts until you achieve a neutral gray. Your concern at the next stage will be to establish a complete value range—in essence, lights, middle tones, and darks. For now, simply make a neutral gray.

Now, using a pencil, lightly draw seven 1-inch (2.5 cm) squares on your paper. Put them close to one another,

Figure A Figure B Figure C

Reading value in watercolor is important, especially when your lightest light must be established before you move on to darker values. If you misread the very first value, the successive values will be incorrect.

as you will be painting within each square. As you work toward the darkest value, you do not need to add additional color to thicken your original gray paint mixture; rather, you will create the variations in value simply by applying more washes to the darker squares. The more the color blocks the amount of light being reflected off the paper, the darker the area will appear.

It's time to start painting. The box on the far left receives one wash of color, while each successive box to the right receives an additional glaze of color. (In other words, the seventh box has seven layers on it, thus resulting in a dark color with a luminous effect.) Using glazes to create dark values in increments adds depth to watercolors; whereas thickly applied darks are opaque and flat in appearance.

When applying these concepts to an underpainting, it will take practice to properly judge the values. As a way to familiarize yourself with this technique, you may try working from black-and-white photographs.

Now that you have a sense for creating a range of grays, it's time to see how this idea applies to color. In the illustration above, I used phthalo turquoise to show how one color appears lighter or darker, based upon the amount of water added to the pigment. The box on the

left (Figure A) is diluted with a large amount of water, resulting in a light, transparent wash of color. The middle box (Figure B) has a little more pigment than the first box on the left, and is the glaze I use the most. The box on the right (Figure C) has the most pigment and would be used for a finishing layer to add deeper values, as less light is reflected in it.

COOL GRAY AND WARM GRAY

As mentioned earlier, I begin each one of my paintings by blocking in shadow areas and establishing the proper values. The majority of the colors on my palette are either transparent or semitransparent, and, therefore, they reflect the light bouncing off the white surface of the paper. In order to give an area of a painting the appearance of darkness, I simply glaze more layers to block the reflected light. It's reminiscent of a shade being pulled down over a window.

Examine Figure D in the example below. The rectangles on the top row represent pure burnt umber (left) and pure French ultramarine (right). They were mixed together in equal proportions to achieve a neutral gray, depicted in the rectangle on the bottom row. This is the color combination upon which I rely the most for blocking in the initial layers in my work, as it does not compete with the successive layers.

Figure D Figure E Figure F

Mixing color is like adding ingredients to a culinary dish. The proper amount of each component must be mixed in to insure a successful outcome.

Now look at Figure E. The rectangle on the top left represents a larger amount of burnt umber added to the mix than the lighter box on the top right, consisting of French ultramarine. The result in the box on the bottom is a warmer version of gray. Personally, I rarely modulate the temperature of the initial block-in color. However, I do certainly adjust the gray tones in other areas of my painting, so it is helpful to understand the concept.

The dominant color in Figure F is French ultramarine (right). This dynamic produces a cool gray. It does not require large amounts of one color to change the temperature to warm or cool. And this principle doesn't just apply to the creation of neutral colors. In general, if you add more of a certain color to a mixture that color will determine the mixture's intensity, in terms of temperature.

TIP

- When adding color to a mixture in search of the proper temperature, be sure to continue to add water to dilute the wash. Failure to do so will result in a thicker application of color.

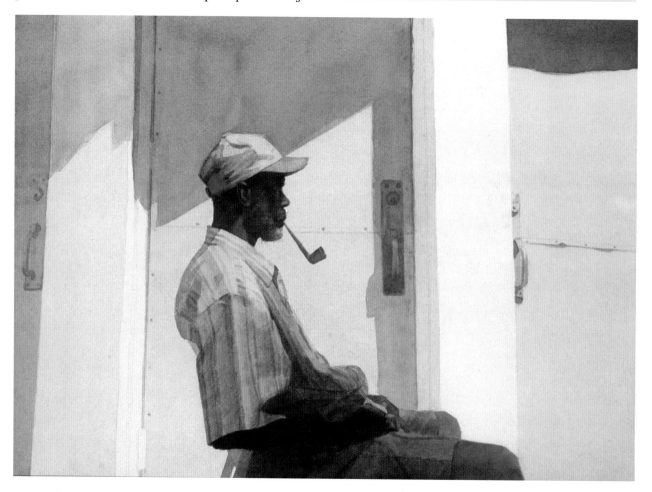

TOUGALOO RELIC, 2008
WATERCOLOR ON PAPER, 9 X 12 INCHES (23 X 30.5 CM)

Your selection of subject matter will determine the look and feel of your work. Outdoor scenes with bright sunlight allow you to highlight the transparent qualities of watercolor.

EMPLOYING THE WHITE OF THE PAPER

One of the most distinctive characteristics of watercolor is the use of the paper to capture light. As you darken the value of an object next to an untouched area of the paper, the white of the paper will appear increasingly brighter as you apply each successive layer of paint. I do not personally use masking fluid, as it can leave jagged edges behind. I also find it to be messy. Nevertheless, it can be an effective aid to an artist who feels reluctant to navigate around intricate areas of a painting.

In my painting *Bradshaw Beach (Point Pleasant Beach, NJ)*, shown on page 6, I worked around the white areas of the paper to capture the light reflecting off the front of the shack. The values of the shadows, which fell upon the white areas, are not dramatically dark. I did this intentionally, in order to prevent an unrealistic contrast between the two values. This concept is also true for every other component of the painting. Due to the brightness of the shack, the value of the painting, as a whole, needed to remain lighter.

The white of the paper can be considered in other regards as well. Because transparent layers of color appear to be backlit by the light bouncing off the surface of the white of the paper, the medium of watercolor is ideal for capturing bright, bouncing sunlight in outdoor scenes, such as *Tougaloo Relic*, shown opposite. Be sure to consider the color of the paper on which you're painting. Watercolor paper is offered in an assortment of tones, such as warm, cool, or bright white. The choice of paper could influence the color of light in the scene you intend to paint.

Winslow Homer's ability to create dazzling effects using the white of the paper is masterful. The simplicity of the cerulean blue wash he employed on the water

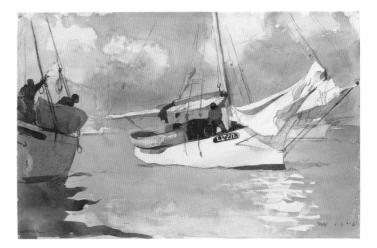

WINSLOW HOMER, FISHING BOATS, KEY WEST, 1903
WATERCOLOR ON PAPER, 13¹⁵⁄₁₆ X 21¾ INCHES
(35.5 X 55.5 CM)
COURTESY OF THE METROPOLITAN MUSEUM OF ART
(NEW YORK, NY)

Winslow Homer exaggerates the whites in this watercolor by leaving certain areas of the paper untouched. The result is a dazzling display of light, which is reflected off the paper's surface.

in *Fishing Boats, Key West*, shown above, is bolstered by the stark, white ripples of the waves. The hint of red that dances around the composition moves the eye around, ultimately bringing it to rest on the white boat in the center of the frame. Homer's ability to extract an ordinary tropical scene and amplify it through a sophisticated sense of color and design is genius. I would submit the style in which he works appears effortless; however, he honed his skills over a period of time in order to achieve that appearance.

In the hands of another distinguished American watercolorist, Michael Lowery, the white of the paper is used to create dazzling highlights on a whitewashed house, in *298 Main Street*, shown on the following page. The composition is simple with elements of abstraction. The artist's

MICHAEL LOWERY, 298 MAIN STREET, 2014
WATERCOLOR ON PAPER, 12 X 12 INCHES (30.5 X 30.5 CM)
COPYRIGHT © MICHAEL LOWERY

This watercolor is a comprehensive display of how powerful values are in a work of art. If you squint, you can clearly see the light, middle, and dark values that lend themselves to the illusion of light on the house.

hand is prevalent in the execution of the loose, textural effect on the roof, while the muted tones are a perfect backdrop for the American flag. In our fast-paced society, where superficial trends rule the day, the artist's imagery reminds us of the inherent value of a simple life.

As you view my body of work, you'll see that a majority of the settings are outdoors. I am enamored of the immense presence of the sun and the effect it has on people, places, and things. There are times that I exaggerate the light in a scene to influence the viewer's perception of a subject. The background in *Philip*, shown opposite, is

an example of how I manipulated the area to accentuate the white of his hair. The actual tone of the background is a darker shade of gray. By lightening it, the dramatic effect of chiaroscuro is magnified.

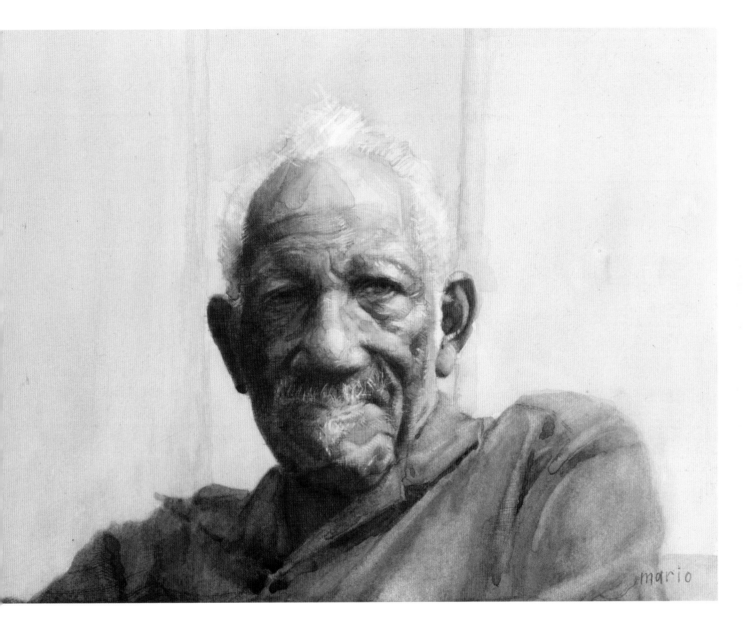

PHILIP, 2007
WATERCOLOR ON PAPER, 9 X 12 INCHES (23 X 30.5 CM)

Using Chinese white is an effective way to embellish highlights. The less color you use beneath the white pigment, the more brilliant the area will appear.

USING THE WHITE OF THE PAPER DEMONSTRATION

This demonstration will show the delicate nature of creating a watercolor painting, dominated by what is commonly known as the "white of the paper." This term simply means that the paper's pristine white surface is exposed to create a highlight or it's been lightly washed over, thus leaving gradated shades of white. It's important not to overshoot the mark when working with light values. The moment you apply a value that is too dark, you'll be forced to resort to lightening it by lifting, scrubbing, or blotting. The effectiveness of these measures is questionable, and in some cases may exacerbate the situation. I recommend a measured approach that preserves the integrity of the paper.

THUMBNAIL SKETCH OF DAKOTA, 2015
WATERCOLOR ON PAPER, 5 X 5 INCHES (12.5 X 12.5 CM)

STEP 1

A SMALL WATERCOLOR SKETCH can assist you with simplifying shapes and value patterns. It can also prepare you for the challenges that may arise during the painting process. In this sketch, I identified the areas where it would be necessary to apply water to the surface of the paper, in order to create soft transitions from light to middle values. Soft edges are especially important when painting subjects who possess smooth skin or a youthful appearance. I was also able to use the white paper as a barometer for the value of the model's face, as opposed to the background. There is little room for error when working with compositions dominated by white. Once your values are too dark, it's difficult to reverse course and lighten them.

STEP 2

I CREATED A DETAILED line drawing of the subject, indicating all the shadow areas, which would be instrumental in the block-in stage. The more I have mapped out with the lines of the drawing, the less I have to worry about locating these areas while I'm focusing on painting. I used a hard 6H lead, which gave me a precise line. Also, the light appearance of the graphite allowed me to erase unwanted lines from the completed painting.

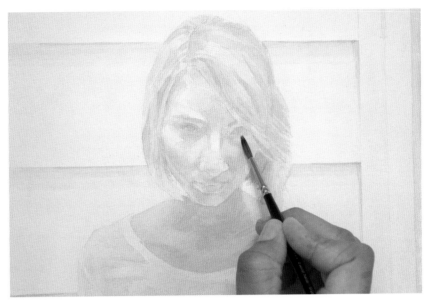

STEP 3

IN THE EARLY STAGE of the painting, it was important for me to apply water to the paper, as a precaution, prior to adding color. The model was a teenager and her skin was supple; therefore, there were no hard lines in her face, which would have created hard shadows. The shadow areas on her skin were soft, and in order to capture her likeness, I had to be respectful of that. Therefore, I also began with a more diluted mixture to circumvent any aggressive staining of the pigment. The combination of her youthful appearance and the large areas of white required a high level of restraint. I began the block-in using thin washes of French ultramarine and burnt umber. My intention was to simply fill in the shadow areas I established with my drawing.

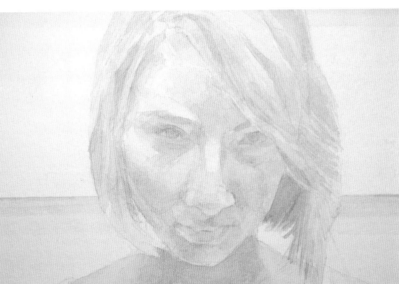

TIP

When using French ultramarine as part of the monochromatic block-in, be sure to vigorously stir it prior to applying it to your painting. The color has a tendency to settle at the bottom of the water mixture and if you are not mindful of this, you can ruin your work. The dark streaks of paint are difficult to scrub out, without lifting previous layers of color. Notice how the French ultramarine is settling and staining the paper on my test swatch of paper.

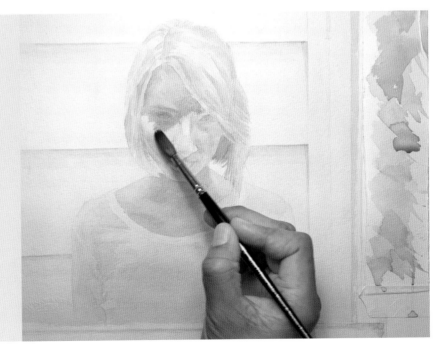

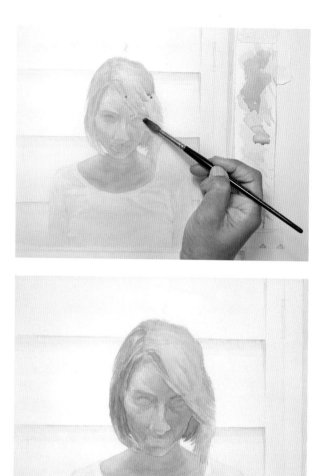

STEP 4

ONCE I COMPLETED the first pass of color on the face, I moved on to add the lightest color to the hair by mixing raw sienna and Payne's gray. Notice that I've added water to the lightest areas, such as the tips of the hair on the left side and the crown of her head, in order to capture the lightest lights. It is rare that I simply apply watercolor to a painting without using clean water to soften edges and lighten certain areas while the color is flowing. If watercolor is allowed to pool and dry on the surface, without additional water, hard edges will appear. Adding color to the hair while the face was in its early stage allowed me to match the values more easily and adjust them together as the painting progressed. If I added the darkest values to the face and began the hair separately it would be akin to playing catch-up.

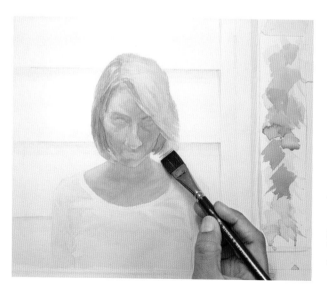

STEP 5

THE WARM TONES OF HER HAIR cast warm shadows onto both sides of her face; therefore, I washed in colors I used for her hair. As the tones of her face deepened, I mixed Payne's gray and burnt umber and brushed it into the shadow areas of her hair, using both the sides and edge of a ¾-inch flat brush. The chiseled edge made thin lines, while the side of the brush created smooth, flat areas.

I advise that you test every color you plan to apply to your painting. This will insure that the color and consistency of the mixture are correct.

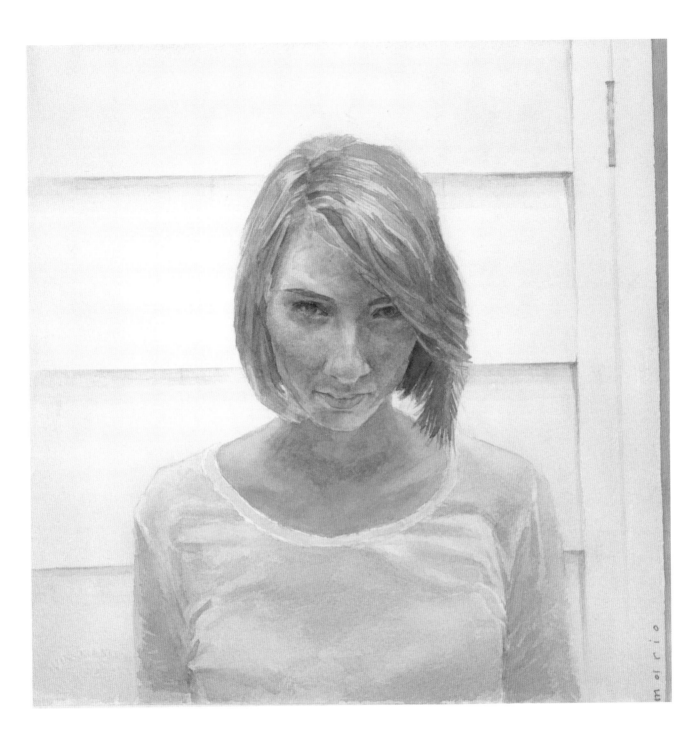

STEP 6

AFTER ADDING AN additional wash of burnt umber and French ultramarine to the background, I added the pupils of the eyes to round out the value range. I used a semi-dry round size 3, series 7 brush to even out the subject's skin tone. I kept the folds of the blouse soft by introducing water to the entire area prior to applying thin washes.

DAKOTA, 2015
WATERCOLOR ON PAPER, 11 X 11 INCHES (28 X 28 CM)

CELEBRATING THE LIGHTS

Watercolor offers the most brilliant highlights and dazzling lights of any medium. The manner in which light reflects off the white areas of the paper can produce captivating effects. One of the more difficult concepts for artists who are accomplished in another medium and then decide to experiment with watercolor is that color is applied from light to dark. When working in other mediums, artists lay the groundwork in darker tones and embellish with lighter colors as they make revisions along the way. This means that artists who are new to watercolor are forced to think about building their paintings in a totally new way, which can be challenging.

Because the light values of a watercolor painting dominate the direction and overall appearance of the piece, it is important to begin a watercolor with a watered-down wash of color, one that you can visually see through. I use a white plastic muffin pan to mix my colors. This allows me to see the color I'm mixing, as well as the consistency

THE SILVER VAULT (CHARLESTON, SC), 2013
WATERCOLOR ON PAPER, 18 X 24 INCHES (45.5 X 61 CM)

It was challenging to paint the objects in the window without the aid of masking fluid. I was able to control the lights and darks, while maintaining soft edges, by freely painting dark tones around the silver and glass.

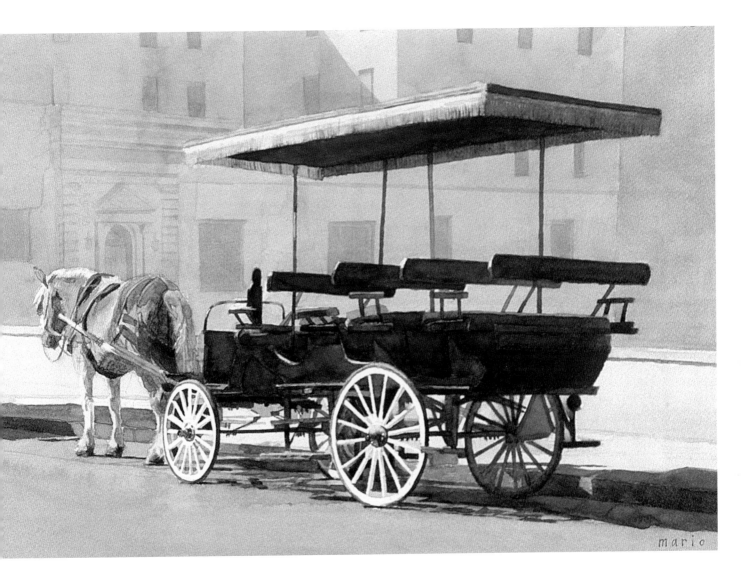

GHOST TOWN, 2005
WATERCOLOR ON PAPER, 14 X 20 INCHES (35.5 X 51 CM)

The strength of this painting rests largely upon the definitive light source entering the composition from the left side. Understanding the use of light in your work will increase its success.

of the mixture. During the mixing process, the consistency often becomes too thick, in which case I simply add water until I achieve the proper pigment-to-water level. The pans are 1 inch (2.5 cm) in depth, which allows me to keep my glazes thin in the early stages of the painting.

The term "fat over lean" refers to the thickness of the glazes being applied. A "fat" glaze holds more pigment and is safe to apply to the previous layer. A "lean" glaze contains more water and will damage a "fat" layer beneath, possibly even washing it off the surface of the paper. Glazes should always be applied fat over lean.

Watercolor gives the artist permission to utilize the white surface of the paper to capture dazzling whites and highlights. Outdoor scenes appear to be bathed in sunlight, due to the transparent quality of the medium. No matter how white an object may appear in nature, I always apply a light wash of burnt umber and French ultramarine to adjust the value of the paper. As darker values are added to the painting, the lightest areas will inherently appear brighter. The sparkling highlights in *The Silver Vault*, shown opposite, may appear to expose the pure

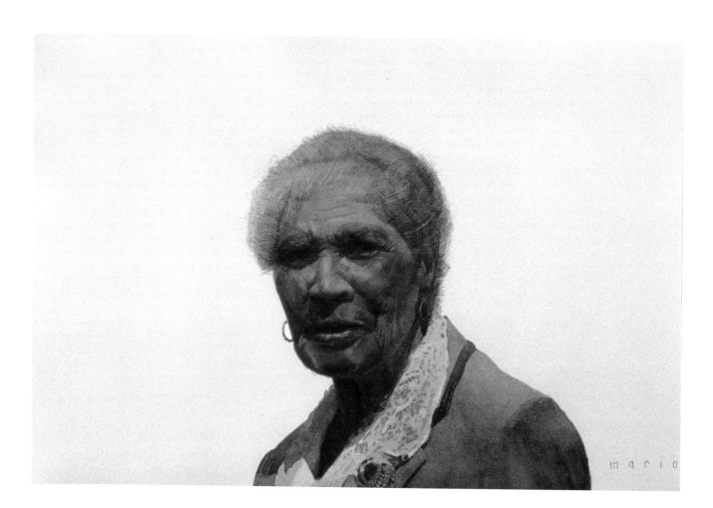

MRS. LAWSON, 2006
WATERCOLOR ON PAPER, 14 X 20 INCHES (35.5 X 51 CM)

The lace collar in this painting is white; however, once it was placed upon the model's blue suit jacket, the tone and value shifted. Painting in a realistic style demands discipline and a keen eye for observation.

white of the paper; however, this illusion is largely due to how far the dark values of the surrounding areas have been pushed. There is no right or wrong way to manage the values in your paintings.

I painted the scene captured in *Ghost Town*, shown on the previous page, from a photograph I took in an area of Charleston, South Carolina, that was heavily populated with tourists. The empathy I felt for the horses that were working for the tour guides compelled me to eliminate all the people from the painting. I wanted to quiet the scene and focus on the plight of the horse. The true mid tones in the reference photograph I used competed with the horse in the foreground, so I decided to leave the buildings light, which entices the eye to further investigate the horse and carriage. I also used a light wash to gently indicate the presence of the buildings in the background.

A painting can evoke a range of emotions—from fear to calm, from excitement to boredom. Cityscape imagery tends to burst with energy at high decibels, while pastoral landscapes are often serene and quiet the mind. My decision in *Mrs. Lawson*, above, to use a blank background, embracing the light, if you will, was my way of quieting the composition and placing the emphasis squarely upon the subject. The commanding presence of the sitter creates a powerful tension between herself and the viewer.

ADDING RICH DARKS

Adding rich dark values can breathe life into a painting, while simultaneously pushing the highlights to their full potential. Certain mediums, such as casein, can be mixed directly into a mixture of watercolor to enhance the dark areas of a painting. The versatility of the medium allows it to be applied in thin washes or thick opaque layers. Alternatively, some artists use ink in their watercolors to achieve the darkest black. I have not personally tried using ink, as I do not use the color black in my watercolors. I use a mixture of indanthrene blue and sepia to achieve a more lively black in my paintings. When I want a warm black, I add burnt sienna, and for a cool black, I add cadmium red.

The use of dark tones in a painting often creates a solemn mood. The reference photograph for the portrait *The Wanderer*, shown on the following page, was shot in daylight; however, I felt as if the subject's demeanor called

FREDERICK, 2006
DRYBRUSH WATERCOLOR ON PAPER, 22 X 22 INCHES (56 X 56 CM)

I completed the full value range of the background prior to establishing the proper tones of the face.

THE WANDERER, 2007
WATERCOLOR ON PAPER, 12 X 10 INCHES (30.5 X 25.5 CM)

When applying thicker glazes of dark colors, I recommend making appropriate adjustments to avoid hard lines. Prior to adding the dark layers to the background, I turned the paper upside down to prevent the glaze layers from resting on his shoulders.

for a somber tone. To accomplish this I simply painted his flesh tone and coat in a darker value, and then unified the painting by laying in the background.

Dark colors can be used in a myriad of ways. Immersing a subject in darkness quiets the scene and removes distractions, thus the focus is solely on the muse. You can also utilize somber tones, juxtaposed against a bright value to intensify the light in a scene. For example, I shot the reference photographs for *The Wanderer* and *Frederick*, shown on the previous page, on the same day. However, the mood is extremely different in each of them, based upon the placement of the dark colors. Likewise, in my initial sketch for *The Guardian*, right, I had the aluminum door in the background pulled closed and the dark void on the left was replaced by the its cool grays. The composition appeared flat and the repeating vertical lines were distracting. By opening up the door, there's a sense of depth and the inviting presence of darkness provokes a level of intrigue.

By contrast, there are instances when using white to embellish certain areas is the best option. The sun was intense during the painting session for *Frederick*. The model was perspiring and his skin was glistening. The only way to capture these cool highlights was to glaze thin layers of Chinese white over his warm skin tone. Also, his beard had variations of warm and cool tones with white highlights; therefore, leaving the white of the paper and brushing in small amounts of color would have looked unnatural. I made the decision to paint his beard in over the face, using a thin mix of Chinese white and neutral tint.

While applying layers of color to a realistic watercolor painting, there are a variety of textures and tones that

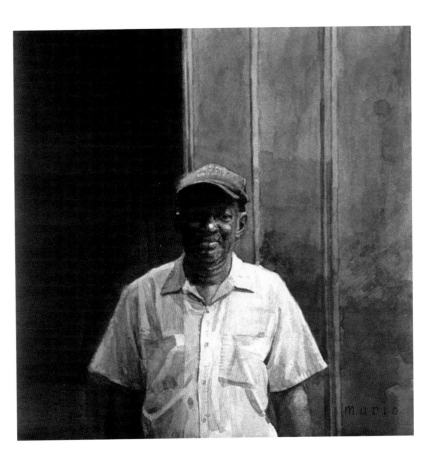

THE GUARDIAN, 2005
WATERCOLOR ON PAPER, 10 X 10 INCHES (25.5 X 25.5 CM)

I am not a proponent of using black from a tube, as it often appears flat and distracts attention from glazed layers. Mixing colors to attain the appearance of black is the ideal way to nuance the unique tone of the dark color you're applying.

require various techniques to meet these challenges. In reference to the dark colors I apply in my work, they're brushed in a more uniformed manner. The risk of hard watermarks is greater with thicker, dark glaze layers, due to the larger amount of pigment in the mixture of paint. In *The Guardian*, the textural effects on the aluminum door in the background are the result of multiple wet-in-wet applications of color. I wet the top with a brush, prior to adding the color and allowed the darker colors to meander and settle naturally toward the bottom. By comparison, I built up the black area to the left using several glazes of indanthrene blue, sepia, and alizarin crimson. This painting demonstrates how applying light, middle, and dark tones leads to a heightened sense of realism in the work.

COOL BLACK AND WARM BLACK

I choose to not use black out of the tube, as it overpowers any color with which it's mixed, and appears flat on the paper. My preference is to mix colors that appear black on the paper, while controlling the temperature with a third color. The illustration at right demonstrates the manner in which I achieve the various versions of black that I utilize.

Examine Figure A. The rectangles on the top row are indanthrene blue (left) and sepia (right), which I mix to achieve a neutral black, shown on the bottom row. I typically use this mixture as a base layer. Then I assess the temperature of the darkest dark I am seeking to capture, and before I apply the next layer, I decide whether to add a cool or a warm color to the mixture.

Now look at Figure B. Based upon my observation of the darkest area I am painting, I may need to adjust the black mixture and cool the temperature with a cool color. The small red circle represents the minute amount of alizarin crimson I added to the mixture of indanthrene blue and sepia to achieve the cool appearance to the rectangle on the bottom. Alizarin crimson is a transparent color, while indanthrene blue is semitransparent; therefore, the glazes of black will reflect light, rather than appearing flat and opaque.

And now observe Figure C. The small circle represents burnt sienna, which adds warmth to the mixture of indanthrene blue and sepia. This is the advantage you gain when mixing colors for blacks in different lighting conditions, rather than relying upon black from the tube.

Figure A Figure B

Figure C

THE NUANCES OF BLACK

While black may appear to be opaque upon first glance, in most cases it is not. Black is subject to the same rules that govern the other colors, especially rules pertaining to value. The surrounding colors in the light and middle range will determine the darkness of the darkest dark in the painting. Laying in a thick opaque black in a watercolor painting creates an unrealistic contrast and an unsightly matte area. I recommend applying two thin glazes of indanthrene blue and sepia mixture, prior to adding the complementary color for the temperature. The next few layers will be slightly thicker than the first two, and the previous layer will need to be completely dry before the addition of each layer.

BUILDING UP DARKS DEMONSTRATION

There are rich rewards in taking calculated risks with watercolor. Applying a full range of values requires confidence. Dark glazes are thicker and must be painted swiftly; therefore, brush speed plays an important role when building up darks. However, when applied thoughtfully and with skill, multiple layers of watercolor can be utilized to create a rich textured black that doesn't suffer from a flat opaque appearance.

STEP 1

PAINTING RICH, vibrant dark colors requires a bold approach with an understanding of values. I began with a monochromatic block-in, mixing burnt umber and French ultramarine, in order to approximate the model's flesh tone. At this stage, the subject appears dark against the white paper; however, I know that once I introduce the black background her face will appear lighter.

STEP 2

I ADDED THREE GLAZES of the initial mixture to the background, dress, and hair. I did not apply any additional washes on the face during this stage, but the effect of the darker surrounding values gave the face a luminous appearance. While it may be tempting to lay down a thick, opaque glaze of black, that approach will result in a flat, dull appearance. It's important to note that French ultramarine is a granulating color and settles at the bottom of a wash. Prior to every application of a wash or glaze that contains French ultramarine, it's important to vigorously stir the mixture. Failure to do so can result in blue streaks across the surface of the paper.

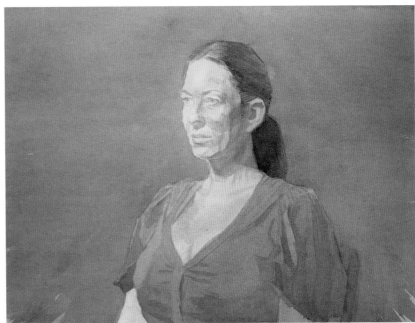

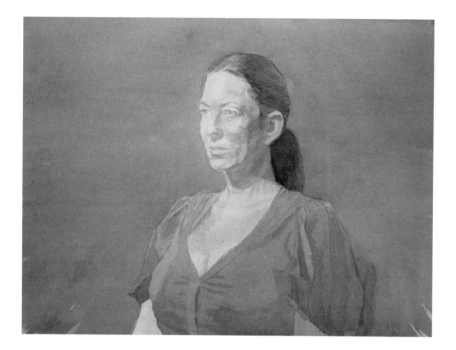

STEP 3

I ADDED NEUTRAL TINT to the initial mixture of French ultramarine and burnt umber in certain areas, including the background, dress, and hair, and they began to darken. I then added a light wash of alizarin crimson, raw umber, and Payne's gray over the face, neck, and arms. Notice how the color of the flesh tone picks up the underlying shadow areas of the monochromatic block-in. I also reinforced the shadows on the dress in preparation for a glaze of black. The placement of the folds can be lost when adding dark layers over them; therefore, it's a good idea to paint them following each layer.

STEP 4

I APPLIED A THICKER MIX of indanthrene blue, sepia, and cadmium red to the dark areas. I am cognizant of the increasing risk of ruining the painting with excessive passes on the background. The thick black glaze could easily have dripped down the subject's face and caused irreparable damage to the painting. I worked swiftly around the head, while keeping a paper towel readily available in my free hand to absorb an unwanted drip of color. I darkened the value of the face and added a warm tone to the shadows.

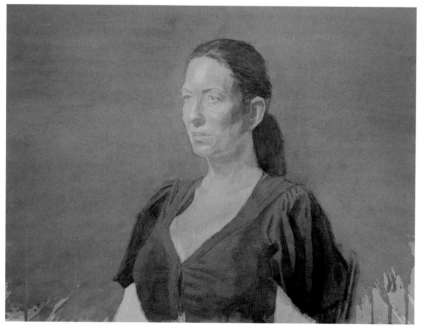

STEP 5

I COMPLETED THE PAINTING by adding middle tones and breaking up the chiseled shapes of the block-in. Then I brought in details using a drybrush technique, and added a final glaze to unify the value of the background, hair, and dress. It's important to properly observe the light and dark values in a painting such as *Reflection*. My subject is lit by a singular light source; however, the background is catching a fraction of the light as well. I had to avoid exaggerating each component by painting it too light or dark.

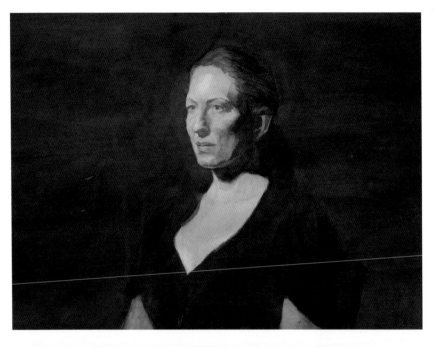

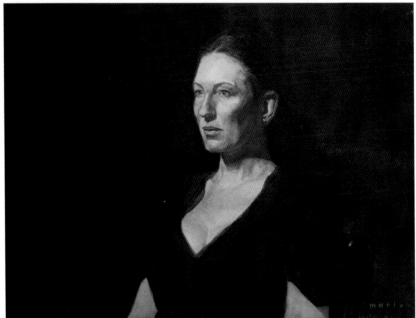

REFLECTION, 2015
WATERCOLOR ON PAPER, 18 X 24 INCHES
(45.5 X 61 CM)

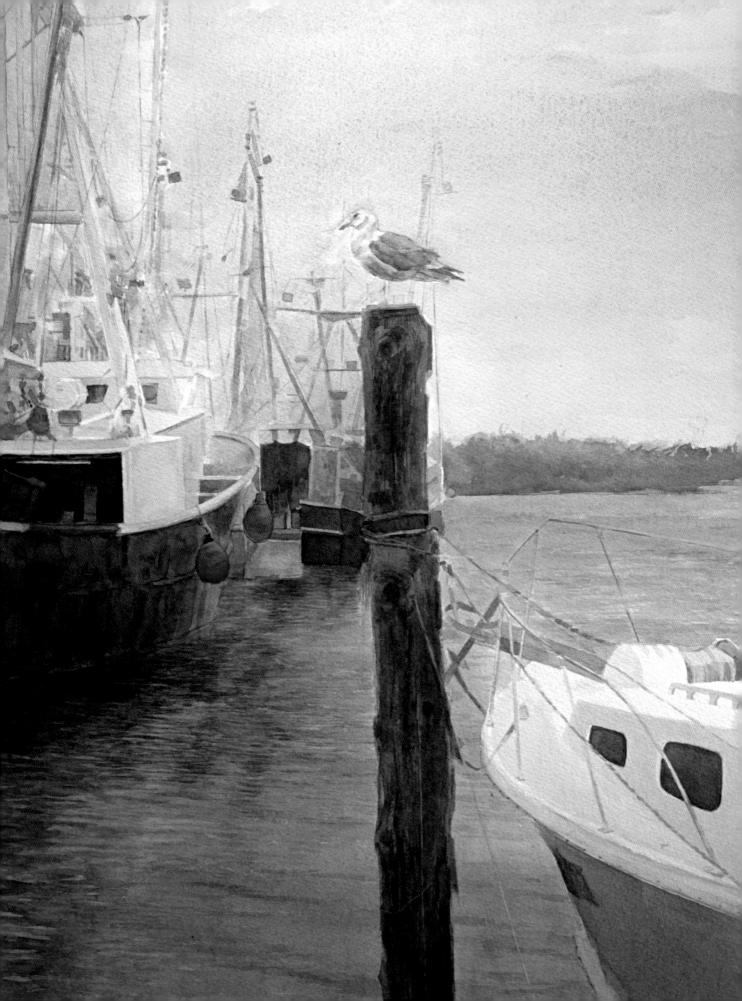

CHAPTER 7

INCORPORATING COLOR

"Color is an inborn gift, but appreciation of value is merely training of the eye, which everyone ought to be able to acquire."
—*John Singer Sargent*

Mixing colors is an art unto itself. The decisions an artist makes during this stage of the process will determine the aesthetic tone of a painting. Even from a distance, the colors in a painting are the most prominent features of a work of art. When I am asked by students to list the colors on my palette, for use in their work, I offer the caveat that their results may vary. The manner in which we view colors in nature determines the way we mix colors to achieve our objectives.

It is fascinating to take plein air trips with my artist friends and compare our work at the end of the painting session. While we share an appreciation for one another's work, our color choices are all unique. Our recent excursion this summer was near my home on the beach in Point Pleasant, New Jersey, and the element that distinguished each artist's work from the other was our color choices, in terms of capturing the sand, ocean, and sky. Their works in oil paint were colorful and vibrant, while my watercolor sketch was delicate and measured. In my more finished depictions of local scenes, such as *Spike's Marina*, I tend to apply my "blues" in a muted fashion. I am constantly

tweaking the color combinations I employ, in order to paint the ocean and sky I seek to capture.

It is important to find a selection of colors that accurately reflects the manner in which you see the world. There's no substitute for experimenting with colors to determine whether or not you feel comfortable with them. The next step is learning how to mix colors that communicate your feelings toward a person, place, or thing. Ultimately, your ability to mix colors should become innate, rather than labor intensive, as you practice your craft. I recommend testing a student-grade paint, which is more affordable than professional-grade paint, prior to committing to a certain color. There are a plethora of beautiful, bold colors on the market that may seem like a "must have" while you're shopping; however, you may discover only rare occasions to include these eccentric

SPIKE'S MARINA (POINT PLEASANT, NJ), 2014
WATERCOLOR ON PAPER, 30 X 20 INCHES (76 X 51 CM)

When painting the sea and sky, I work in thin layers in order to utilize the reflective quality of the paper to emulate the atmospheric quality these natural elements possess.

colors in your work and then the paints will collect dust in your paint box. I have settled upon the colors on my palette by adding and subtracting colors over the years. You will notice your affinity for certain colors the more time you spend painting.

Water is the vehicle by which color is dispersed over the surface of the paper. The intensity of a color is based solely upon the amount of water added to the paint. I begin my paintings with diluted washes of color. As the painting progresses, I decrease the amount of water and the mixture becomes thicker, thus producing a darker hue. Watercolor is at its purest state when a single color is diluted with water. However, secondary colors are the most commonly used to achieve realistic flesh tones in portraits, as well as colors that appear in nature. When mixing multiple colors, it's important to include

MAJOR'S GENERAL STORE, 2012
WATERCOLOR ON PAPER, 9 X 12 INCHES (23 X 30.5 CM)

Painting architecture affords me the opportunity to show my affinity for pure color. The façade of a building reflects its character.

no more than three colors in a glaze. The mixture will become muddy and cancel out the strength of the individual colors.

Harmony is defined as a "consistent, orderly, or pleasing arrangement of parts." That principle can be applied to the act of painting by using *color hamony*, which represents a satisfying balance or unity of colors. I achieved color harmony in *Major's General Store*, opposite, by using the same mixtures of color for the sky, trees, and façade of the store. One of the advantages of watercolor is the ability it affords the artist to strengthen or weaken the intensity of a color based solely upon the amount of water mixed into the pigment. Utilizing color in creative ways elevates the level of artistry in a painting. The manner in which you interpret the subjects within your paintings will ultimately determine your identity as an artist.

UNDERSTANDING HUE

The word *hue* is often associated with inexpensive, student-grade paint, which is lower in pigment and loaded with fillers to bulk out the tube. In many cases, gum arabic is used in these kinds of paint and they, therefore, appear glossy on the surface of the paper. These paints are less expensive, and a reasonable option to explore when you're learning how to paint with watercolor. Because of this, the word *hue* is often viewed in a negative light.

Hue also refers to a paint comprised of other pigments in professional-grade paints. For instance, cadmium red is made with cadmium and it's extremely toxic. Cadmium red hue is formulated to have the appearance of cadmium red, but with less toxicity. Some artists choose to avoid using harmful pigments, such as cadmiums, cobalts, cerulean, and others. There are other instances when paint color is too expensive to produce or not easily found. A paint manufacturer will combine colors to match the preexisting color. In terms of professional-grade paint, the intensity and quality of hue colors is equal to single-pigment colors.

When the term *hue* is applied to the act of painting, it simply means color. For example, in the illustration, *Grandmother's Room*, shown at right, I used cerulean blue mixed with cobalt blue to achieve the color (or hue) of her sweatshirt. The granulation of the cerulean blue created

GRANDMOTHER'S ROOM, 2008
WATERCOLOR ON PAPER, 14 X 20 INCHES (35.5 X 51 CM)

As soon as I stepped into my grandmother's room and saw the color of her sweatshirt, I felt an overwhelming need to paint it. The cool fluorescent light in the room pushed the blue to an extreme level. Her bluish gray hair assisted in unifying the tones in this painting.

a textural effect as well. In this painting, my goal was to portray the essence of my grandmother's personality. I removed distracting elements from the background, while leaving her pillow as an indication of her environment. She lost the ability to speak, due to a stroke she suffered; therefore, her eyes became a barometer for her emotions. An artist's work must reflect personal moments of triumph as well as those of tragedy.

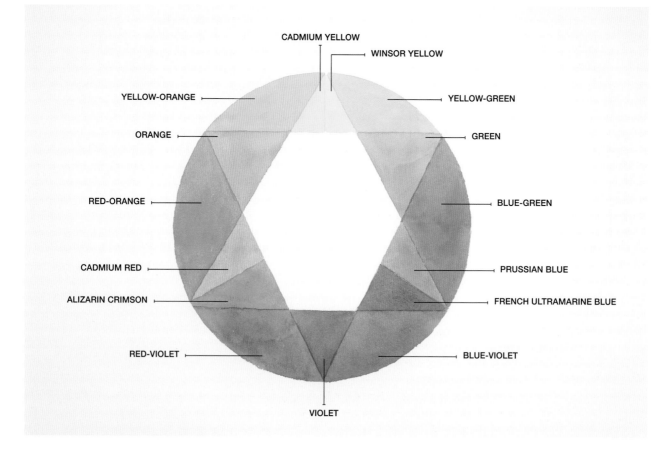

CADMIUM YELLOW
WINSOR YELLOW
YELLOW-ORANGE
YELLOW-GREEN
ORANGE
GREEN
RED-ORANGE
BLUE-GREEN
CADMIUM RED
PRUSSIAN BLUE
ALIZARIN CRIMSON
FRENCH ULTRAMARINE BLUE
RED-VIOLET
BLUE-VIOLET
VIOLET

MASTERING THE COLOR WHEEL

Balance is important when you begin to think about color more seriously. I included warm and cool primary colors on this color wheel, since they are indicative of the colors I used to achieve the colors on the wheel. The more you paint, you'll find that you're more attracted to certain colors. The color combinations you choose when mixing colors will eventually become your palette.

Learning how to use a color wheel is the most basic way to understand how to mix color. This color wheel is comprised of the three primary colors, which are yellow, red, and blue. These colors are called *primary colors,* due to the fact that you cannot mix other colors to achieve a primary color. The second group of colors represented on a color wheel is known as *secondary colors,* which are green, violet, and orange. These colors are achieved by mixing equal parts of the primary colors.

The secondaries are created thus:

yellow + blue = green

blue + red = violet

red + yellow = orange

The third group of colors represented on the color wheel are known as *tertiary colors,* which are yellow-green, blue-green, blue-violet, red-violet, red-orange, and yellow orange. These colors are achieved by mixing a secondary color with the closest primary color on the color wheel.

The tertiaries are created thus:

yellow + green = yellow-green

blue + green = blue-green

blue + violet = blue-violet

red + violet = red-violet

red + orange = red-orange

yellow + orange = yellow-orange

If you want to dull the intensity of a particular color, simply mix it with its complementary color—in other words, the color that is located directly opposite it on the color wheel.

MIXING COLORS ON YOUR PALETTE

My palette can be broken up into four sections—cool colors, warm colors, darks, and colors I use less frequently. Grouping colors in sections allows me to position them in a general location without an extraneous amount of thought. As shown here and on page 41, the colors on my palette are: burnt umber, French ultramarine, Prussian blue, cobalt blue, phthalo sapphire, opera rose, permanent rose, cadmium red, cadmium yellow, sepia, Payne's gray, neutral tint, burnt sienna, dark brown, Chinese white, raw sienna, alizarin crimson, and indanthrene blue.

An inexpensive brush that is solely allocated for color mixing can be an invaluable tool. Mixing colors can destroy the delicate hairs of a brush; therefore, it's easier to replace a brush of lesser value, when necessary. I have only replaced my mixing brush one time in thirteen years of painting in watercolor. I am comfortable with the manner in which the brush "grabs" paint from the palette and the amount of paint its hairs hold. Mixing color should become intuitive and the tools you use need to feel familiar.

There are rare occasions, such as *Frederick* on page 139, when I use white to lighten an area of a painting. My preferred choice of whites is Chinese white, which is an opaque pigment. It's important to note that it should be used sparingly, as it will dominate the transparent colors over which it's being applied. Mixing color into Chinese white prior to applying it will create a more natural appearance.

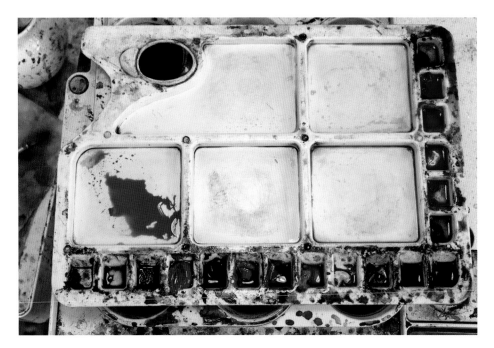

Arrange the colors on your palette in a way that makes sense to you. Your colors should be easy to locate. I have kept the order of colors on my palette the same since I began using watercolor over a decade ago.

TIP

- Rather than using black to deepen the values in my work, I mix in neutral tint, which darkens the hue without changing the tint.

GLOSSARY OF PAINT PROPERTIES

Watercolor paint contains two main ingredients: finely ground pigments, which provide the color, and gum arabic, which acts as a binder. Tube watercolors are not all created equal, as each color possesses strengths and weaknesses. It will benefit you greatly to know the characteristics of the paint you use.

FUGITIVE COLOR These colors are susceptible to fading and even disappearing over time due to exposure to sunlight. Check the manufacturers' labels for their lightfastness and permanence ratings.

GRANULATING COLOR These colors settle and dry with a large amount of texture. The color appears broken, as opposed to the flatness associated with non-granulating colors. Beginning watercolorists may have a difficult time controlling granulating colors.

OPAQUE This term refers to colors that block the light, not allowing it to reflect off the white of the paper;

rather the light bounces off the opaque color instead. Thicker areas of opaque colors appear dull.

STAINING COLOR These colors settle into the tooth of the paper quickly and are difficult to dilute or remove once applied to the surface. Staining colors mix well with each other; however, they have a tendency to dominate non-staining colors.

TRANSPARENT This term refers to colors that are pure and brilliant and allow light to pass through each layer. The white surface of the paper reflects light through the thin glazes of color to create a luminous effect.

JOHN SINGER SARGENT, BOATS, 1913
WATERCOLOR AND GRAPHITE ON OFF-WHITE WOVE PAPER,
15¾ X 21 INCHES (40 X 53.5 CM)
COURTESY OF THE METROPOLITAN MUSEUM OF ART
(NEW YORK, NY)

Watercolor is at its best in the hands of an artist with immeasurable talent. John Singer Sargent was skillful at using transparent washes of color to capture sunlit scenes.

BALANCING WARM AND COOL COLORS

The interplay between warm and cool colors maintains a balance in terms of temperature in paintings. In general, warm colors include reds, oranges, and yellows, whereas cool colors include blues, greens, and purples. Warm colors are bold and energetic, while cool colors are calm and soothing. Warm colors can be used to pull an object forward in space, while cool colors tend to recede and are useful in creating shadows.

John Singer Sargent (1865–1925) is regarded as a master of using warm and cool chromatic color to capture the feeling of light on forms. In *Boats*, opposite, Sargent makes lively exaggerations in the colorful blues of his shadows and more golden oranges in the light passages. Sargent's watercolors are vibrant and full of life. His strokes of color seem to be applied feverishly, as if the master's brush was in constant motion from beginning to end during the creation of each work. Much is to be learned by studying great artists, including gaining a greater understanding of the various uses of color.

On page 150, I introduced you to the color wheel and the ways to mix the most basic colors. Mixing color does not have to be complicated. In fact, the more you're able to simplify your color mixtures, the more pure your paintings will appear. The essence of watercolor is its ability to allow light to project off the surface of the paper, due to its transparency. The more muddy and opaque your colors are, the less light is able to penetrate the surface, resulting in a dull painting.

Figure A *Figure B* *Figure C* *Figure D*

This chart shows how I arrive at variations of orange. In Figure A I mixed equal amounts of cadmium red and cadmium yellow to achieve orange. In Figure B I mixed a dominant amount of cadmium red and a smaller amount of cadmium yellow to achieve red-orange.

In Figure C I mixed a small amount of cadmium red and a dominant amount of cadmium yellow to achieve yellow-orange. In Figure D I mixed equal amounts of cadmium red and cadmium yellow with a small amount of Payne's gray (represented by a small dot in the upper-right corner); the result is a darker, cool version of orange. I generally use Payne's gray to dull the primary colors.

VARYING TRANSPARENT AND OPAQUE COLORS

Transparent watercolors are pure and ideal for glazing over dry color. The layers possess a jewel-like quality and the white of the paper shines through to enhance the brilliance of the colors. The varying transparency and opacity of a pigment will affect the optical character of the individual color and how it mixes with other colors. Opaque colors are thicker and less pure, which blocks light from passing through them. Once an opaque color has dried, white residue is often left behind on the surface of the paper. When working in glazes, it is best to mix an opaque color (when necessary) sparingly into a mixture of transparent watercolor.

All cadmium colors, as well as cerulean blue and sepia, are opaque. While I use these colors, I primarily do so in later stages in my paintings, once I have captured the light and middle values with transparent colors. (Side note: All colors on my palette are transparent or semitransparent, with the exception of cadmium red, cadmium yellow, neutral tint, Payne's gray, and neutral tint.) Manufacturers list the properties of their watercolors on the labels. If you are unsure whether a particular color is transparent or opaque, paint a small swatch of a dark, transparent color on a scrap piece of watercolor paper. Once the paint dries, brush the color in question directly onto the dry color and if it blocks the color underneath and possesses a milky residue on the surface, it's an opaque color. Opaque colors are useful for toning down color mixtures.

I do not use masking fluid to preserve the white areas of my watercolors. I prefer to paint around them, in order to have more control over the edges. In the case of *Thaddeus*, shown below, I found that small areas were better suited to the use of masking fluid. This is the only occasion in which I use it. The repeating specks of light on the subject's face required me to mask the light areas on his nose, cheek, and the area around his eye. Once I had removed the masking fluid, using a rubber eraser, I then darkened the bright white dots by glazing over these areas using a mixture of burnt sienna, cadmium yellow, and French ultramarine. The light areas on the bridge of his nose are untouched with watercolor. His beard is embellished with Chinese white.

THADDEUS, 2003
WATERCOLOR ON PAPER, 10 X 10 INCHES (25.5 X 25.5 CM)

The white patch on the left of Thaddeus's beard is the exposed paper. Watercolor paper can be such a valuable asset when modulating the values within white areas.

MIXING COLORS WITH DIFFERENT CHARACTERISTICS

Every color has a different characteristic or "personality." Just like humans, certain personalities gravitate toward one another, while others clash. Watercolor operates in the same fashion, based upon its pigment characteristic. Learning when to use certain colors together is relatively easy once you learn the properties of the colors you use.

Figure A demonstrates how two opaque colors work together. The bottom rectangle was achieved by laying down a glaze of cerulean blue, then mixing in cadmium red wet-in-wet. The colors work well together, as neither cancels out the other. If you are unsure about how certain colors work together, this simple exercise will allow you to make a determination.

Figure B in this same example demonstrates how an opaque color reacts to a staining color. I began by laying down a glaze of cerulean blue, and then I brushed in alizarin crimson wet-in-wet. Unlike Figure A, the colors do not work well together. The alizarin crimson overpowers the cerulean blue and stains the paper, thereby showing its dominance over the cerulean blue. This is especially obvious in lighter colors, as opposed to darker colors.

Granulating colors are beneficial for painting areas that posses a textural quality. Their appearance is grainy in comparison to the smooth finish of non-granulating colors. The swatch of color in Figure C is French ultramarine, which is a granulating color. Notice how the particles of the paint settle and create a rough appearance. The swatch of color in Figure D is indanthrene blue, which is a non-granulating color. It's also a transparent color; therefore it lies smoothly and evenly upon the surface of the paper. Light also passes through the thin layer of color, which gives it a luminous effect.

Figure A

Figure B

Increasing your knowledge of the paint you use will allow you to use it in a more effective way.

Figure C

Figure D

While there are not many noticeable advantages to working with watercolor, the fact that a number of pigments possess textural qualities is a bonus. Using these colors in the right situation can assist you when you're attempting to increase the texture in a particular area of your work.

TIP

- Staining colors are more intense in chroma and should be used sparingly when mixing with other colors. Manufacturers list pertinent information on the labels on their tubes or pans. Check to see what the property of a color is prior to using it.

CREATING FLESH TONES

The illustration here shows a variety of colors I use for my flesh tones. I used neutral tint to deepen the value of each color. The column of boxes on the left contain two glazes of color, while the boxes in the center have a layer of neutral tint sandwiched between the layers of color. The boxes on the right display the order in which the glazes were applied. The first swatch in column three is the true color, followed by the second swatch, which is a wet-in-wet layer of the true color and neutral tint. The color of the last swatch in column three is achieved by laying down a base color, applying a wet-in-wet layer of the base color and neutral tint, and a final layer of the base color on the top.

The colors used are thus:

TOP ROW: Permanent rose, raw sienna, and Payne's gray
SECOND ROW: Alizarin crimson, cadmium yellow, and
 cobalt blue
THIRD ROW: Cadmium red, cadmium yellow, and Payne's
 gray
FOURTH ROW: Burnt sienna, raw sienna, and French
 ultramarine

Applying color to your paintings can seem daunting; however, approaching it with greater knowledge and understanding will propel you to create more successful works of art.

I use a few basic combinations when painting portraits of people. The flesh-tone mixtures are amended as each painting session progresses, based upon lighting conditions, reflected light on the skin, and other variables.

WARM SKIN TONE DEMONSTRATION

I enjoy painting a wide array of skin tones. The effect of light on flesh varies exponentially from one person to the next. Darker skin is one of the shades of skin for which I receive inquiries most frequently. The color of a person's skin comprises a multitude of colors. In the following demonstration, I offer one of the color combinations I commonly use when painting in the deeper range.

Figure A

Figure B

The top row of Figure A shows alizarin crimson, raw sienna, and a small dot representing the amount of Payne's gray used for the first pass of color on LeAnn's face and neck.

The top row of Figure B shows cadmium red, cadmium yellow, and a small dot representing the amount of Payne's gray used for the second pass of color on LeAnn's face and neck.

STEP 1

IN THIS INITIAL STEP, I blocked in the shadow areas and established the middle values. I continued to deepen the darker values, in preparation for the first pass of color. At this stage of the painting, I diluted the washes with large amounts of water. I mixed equal amounts of burnt umber and ultramarine blue to achieve a neutral gray. By blocking in a full value range in this initial step, I knew I could glaze the subsequent layers in a more simplistic manner, rather than darkening shadows with excessive color.

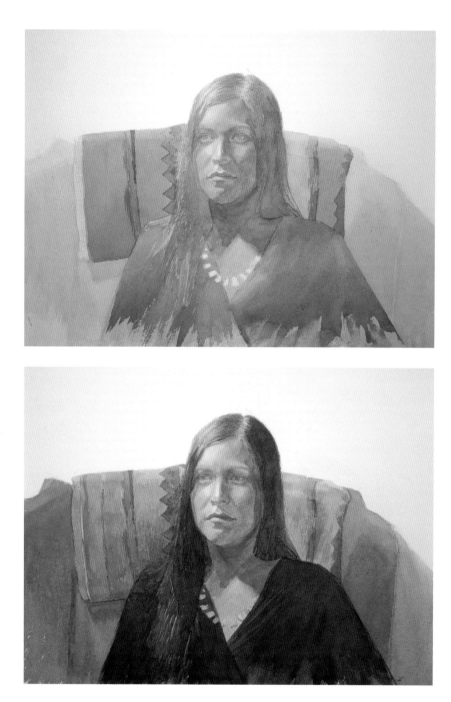

STEP 2

I GLAZED A THIN LAYER of color cover the face and neck. The mixture consisted of alizarin crimson, raw sienna, and Payne's gray. This mixture established the highlights. (In subsequent steps I would eventually work around these lighter areas as I built the darker tones of the painting.) When painting with watercolor, it is important to work from the lightest to the darkest values. The initial application of color will potentially play a role in the completed work; therefore, it's necessary for the color to be accurate. As I brought in darker values around the eyes, I added a mix of indanthrene blue, sepia, and alizarin crimson to the hair, as well. All of the values are pushed to the same level of darkness, prior to moving on to the next stage.

STEP 3

THE LIGHT SOURCE illuminating the model's skin is on the left side. In order to keep the value lighter on the left side of her face, I applied water to the surface of the paper. Then I added a mixture of cadmium red, cadmium yellow, and Payne's gray to the flesh tone. I worked wet-in-wet in order to keep the transitions from light to dark smooth. While the second pass of color was still moist, I added shadow areas to the eyes, face, and neck, using neutral tint. This color basically deepens the value of a particular color without changing the hue.

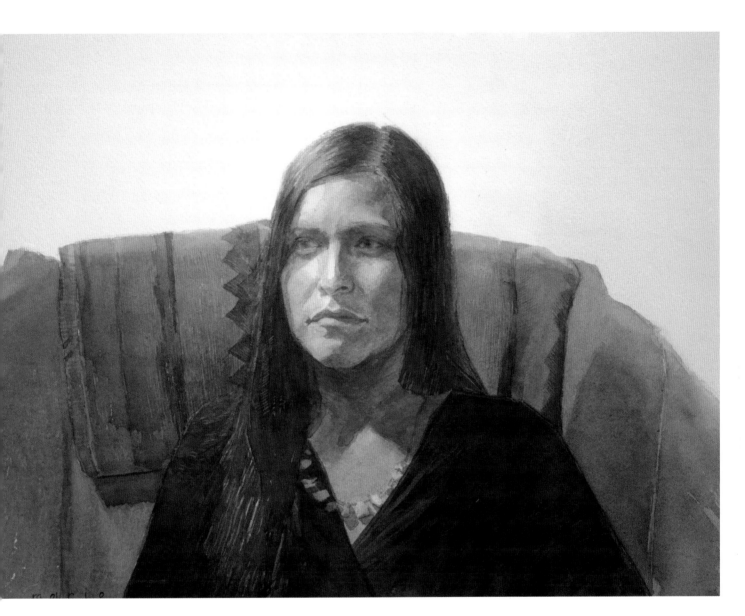

STEP 4

I PUSHED THE DARKER TONES by glazing a thicker mixture of indanthrene blue, sepia, and burnt sienna onto the hair, using a flat ¾-inch brush. The chiseled edge of the flat brush added a textured pattern to the hair. I extended the rhythm of the hair texture onto the blanket, using the flat brush. Then I reinforced the shadows of the face, using a glaze of cadmium red, cadmium yellow, and Payne's gray, working wet-in-wet with neutral tint. For an incremental push toward black I glazed two more layers over the blouse. Notice the appearance of the blouse, as it has a

LEANN, 2015
WATERCOLOR ON PAPER, 14 X 20 INCHES (35.5 X 51 CM)

more transparent look, due to the multiple thin glazes of color rather than a single thick opaque layer. And finally, I added a wash of burnt umber and French ultramarine to the background in order to unify the painting, as the contrast between the hair and background were too great. Then I added the darkest darks, as well as the fine details, which gave the painting a nuanced appearance.

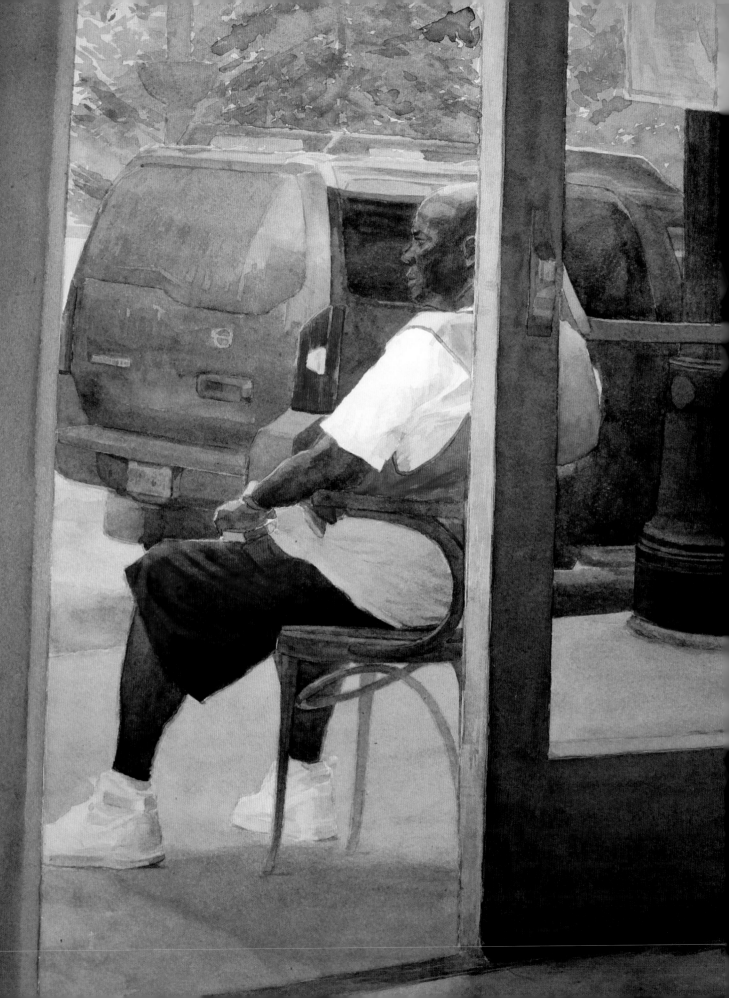

OVERCOMING WATERCOLOR CHALLENGES

"Make the best of an emergency."
—*John Singer Sargent*

Watercolor is both loved and revered by artists; therefore, the reviewers either celebrate the medium or dismiss it, due to a lack of understanding. Watercolor by its nature cannot be controlled, and your success will depend upon your willingness to accept that fact. The medium requires a more rapid pace than any other. The gradual building of layers of oil paint, pastel, or even acrylic offers an artist time to ruminate on each stroke of color applied. This luxury is not afforded to a watercolorist. From the second your brush touches the surface of the paper, you will be confronted with a series of decisions. The watercolor will glide across the paper, and you must react in a timely fashion.

In my experience with watercolor, I have found that mistakes are inevitable. The aim of this chapter is to discuss the medium's more common challenges and offer solutions to mitigate their effect on your work. It is essential to paint on a regular basis, in order to attain a set of problem-solving tools required to create realistic watercolors.

TARGET, 2013
WATERCOLOR ON PAPER, 24 X 18 INCHES (61 X 45.5 CM)

I generally avoid including modern references, such as automobiles, in my paintings. However, the location of the S.U.V. in the composition complements the figure here. I also made the decision to increase the chroma of the colors to give the painting a contemporary appearance.

BACK-FLOW BLOOMS

A bloom or bleed effect occurs when watercolor pigment moves across a wet surface, thereby creating a distracting deposit of paint. There are artists who paint florals and others who paint in an experimental style that incorporates the bleeding of the watercolor as a technique. I am a proponent of creative individuals expressing themselves and using any medium or style they deem necessary. Personally, however, I work in a realistic manner; therefore, the parameters in which I create are more defined.

Watercolor is unpredictable and there are instances, such as a bloom, when the medium will throw you a curveball. This occurrence usually takes place when you're painting wet-in-wet and the surface is confronted with an excess amount of pigment. The moist surface will not be able to effectively dilute the paint, resulting in a bleeding effect. To avoid this situation, be sure that your pigment-to-water ratio is equal when mixing multiple washes in a wet-in-wet technique.

The stained area at the top of the paper is the result of water flowing to an edge without an outlet. The water pools and bleeds back into the painting. Removing excess water from the surface of the paper will minimize the potential of blooms.

Another cause of blooming is when the watercolor reaches the edge of the paper and reverses its course. The flow of the water pushes the paint back into the painting, resulting in staining. My remedy for this situation is to twist the edge of a paper towel to approximately 2 inches (5 cm) and place it into the excess water to absorb it. I am mindful to hold the paper towel above the surface of the painting in order to avoid disturbing the wet paint. Restricting your brushstrokes to one direction while painting can prevent hard watermarks from forming, as well. If you push the water back and forth, the water will pool and eventually settle in many different areas.

HARD EDGES

When a stroke is made with a brush on a dry sheet of watercolor paper, the stroke will have hard edges on both sides. Certain objects in your paintings, such as clapboards on a house or a pole on a street sign, will require the use of straight edges. It is important to vary the degree of hardness of the edges to capture the various textures in your painting. When you look at the sky, you won't notice any hard edges and the transitions from light to dark are smooth. The best way to insure your edges remain soft is to wet the paper prior to applying color. Applying clean water over each dry layer is necessary to maintain the appearance of softness. Prior to applying water, however, make sure the existing layer is dry; this will prevent the possibility of lifting the color.

Applying clean water to the edge of a brushstroke and pulling it outward can soften an edge as well. To achieve a softer edge, load the brush with more water; to achieve a harder edge, decrease the water on the brush. Water should not be applied to both sides of a brushstroke on the paper, as the pigment will be pushed to the center and leave an unwanted watermark.

Paying attention to *edges* in your paintings is essential to achieving a high level of realism. The variation of hard and soft edges leads the eye through the painting. The accentuation of certain hard edges draws the eye, while objects with blurred edges recede. In the illustration above I used

Figure A Figure B

Using finesse when painting with watercolor is essential to raising the level of realism in your work. Just as oil painters use turpentine and other thinners to create glazing effects with oil paint, so should a watercolorist use water for various effects.

a single glaze for both squares. Figure A demonstrates the result of applying the paint directly to the paper without any attention paid to the sharpness of the edges. Figure B possesses a softer appearance, as I applied water to the surface of the paper prior to brushing in the color. The water created a barrier between the paper and the pigment; therefore, the intensity of the color was decreased. Notice how the value of the color was affected, as well.

STREAKING

Streaking occurs when you're painting a larger area with a flat brush and the paint begins to dry as you're painting. The result is unsightly lines that form a pattern that can be distracting to the viewer. Covering large areas in watercolor requires confidence and the ability to control a large brush. I prefer to use a round series 7, size 14 brush to wash in large areas. The brush holds loads of water and I can vary my brushstrokes more easily than I can with a flat brush. My advice is as soon as you notice streaking

LUNCH TIME IN HARLEM, 2012
WATERCOLOR ON PAPER, 18 X 24 INCHES (45.5 X 61 CM)

Each element of the background was painted using large amounts of water to keep the transitions soft. This places the attention solely upon the figure, which was created with thin layers of color over dry layers.

on the surface of your painting, wash the color off with clean water while the color is damp. Place a paper towel on the area and blot it, until the area is dry. Attempting to lift color from the paper's surface after it has dried will dig into the color and potentially ruin the painting.

OVERWORKING AREAS

I am frequently asked, "How do you know when you're finished with a painting?" There's no rule governing the exact moment you should stop working on a painting. I believe artists gain knowledge with each moment they spend in the creative zone. Managing your expectations for each completed work of art can give you permission to let go of the present set of challenges (in a painting) and reach for different challenges in a new painting. In an attempt to enhance a painting's visual merit, you run the risk of losing the energy of the initial concept.

One of the distinguishing characteristics of watercolor is its free-flowing nature; therefore, brushstrokes must be nuanced. Exerting a heavy-handed control over a watercolor can produce a rigid result. When I find the light diminishing in my work or the details jumping out in certain areas, I know it's time to stop and consider a painting finished. There's generally a point when you know in your subconscious that you're beating a dead horse.

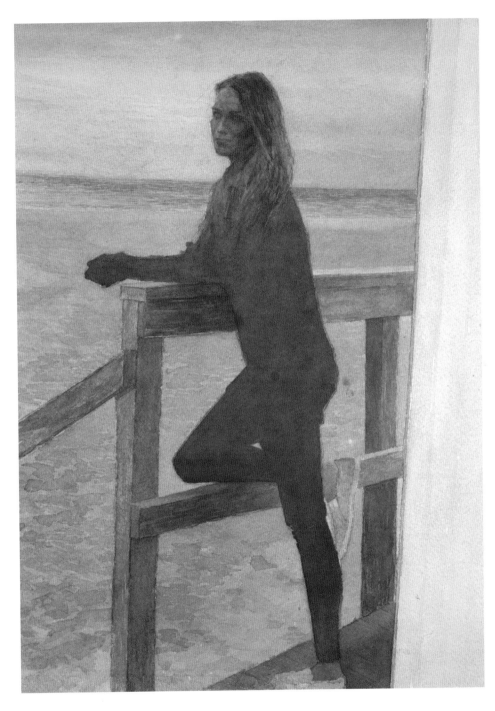

CHRISSY AT DUSK, 2015
WATERCOLOR ON PAPER, 16 X 12 INCHES (40.5 X 30.5 CM)

In an effort to capture the feeling of dusk, I worked with neutral colors and aggressively pushed the value range. The flesh tones were difficult to darken without changing the color of her skin. I took a risk and glazed a thin layer of neutral tint over her face, which resulted in an unrealistic appearance. It's best to take calculated risks in the early stages of a painting before investing a large amount of time and energy.

PAINTING LARGE AREAS

When I began using watercolor, I had difficulty painting large areas without watermarks forming on the paper. I discovered ox gall, which thins the watercolor and gave me more time to apply washes, whereby preventing unwanted watermarks. While ox gall slows the drying time, it also weakens the pigments, and my glazes never reached the intensity I desired. My view of ox gall is comparable to training wheels on a bicycle. Eventually, I had to lose the crutch and develop the requisite brush speed to manipulate the watercolor across an open sky or sandy beach before the water pooled.

Engaging the water to ensure that it is constantly moving in an expeditious manner is the key to avoiding disrupting marks on your painting. In order to apply an ample amount of color onto the paper use the largest brush with which you feel comfortable. A weak glaze of color will dry more quickly than a large, transient flood of water that meanders across the surface of the paper. Long, sweeping brushstrokes are better than short, digging strokes for massing in large areas of color.

OKLAHOMA WHEAT FIELD, 2011
DRYBRUSH WATERCOLOR ON PAPER, 30 X 40 INCHES
(76 X 101.5 CM)

Painting expansive areas in a large-scale watercolor requires the use of big brushes. It takes practice to become comfortable with applying the larger amounts of water to the paper's surface, as the pace of the water increases. I used a 2-inch (5-cm) flat brush for the sky area and the wheat field. The brush has a long handle that allowed for more flexibility in my wrist, as I worked rapidly to cover the large masses of the painting. The dimensions of this painting are 30 x 40 inches (76 x 101.5 cm). This size may not be considered a "large format" in other mediums; however, when you consider the high risk of ruining a painting in watercolor, size matters a great deal.

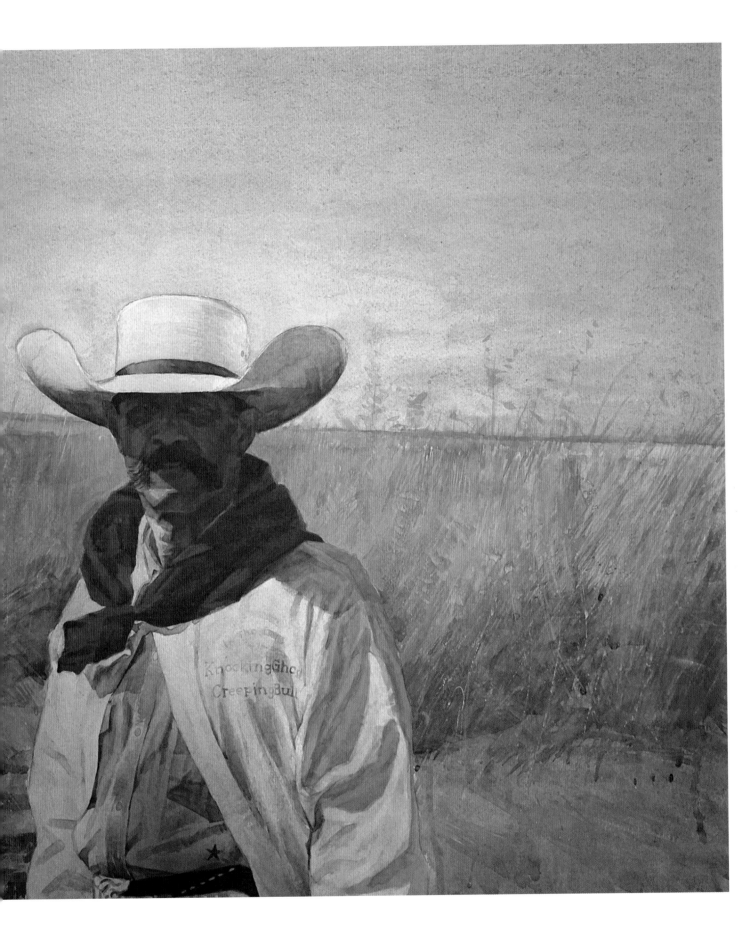

CHAPTER 9
AN ARTIST'S LIFE

"I don't really have studios. I wander around people's attics, out in fields, in cellars, anyplace I find that invites me."
—Andrew Wyeth

According to the National Endowment for the Arts, in 2013, 2.1 million workers held primary positions as artists. A primary job is defined as one at which the greatest number of hours were worked. In that same year, an estimated 271,000 workers also held second jobs as artists. Twelve percent of all artist jobs in 2013 were secondary employment. These figures reflect the difficulty of maintaining a career as a full-time artist. Fortunately, the lack of a full-time commitment to the arts doesn't prohibit creative individuals from carving out time to pursue their interests. The term "weekend warrior" refers to a person who participates in an activity only in his or her spare time.

As I teach watercolor workshops around the country, I find the classes populated with this subset of people.

There are participants from the most unlikely professions and backgrounds, who share the common goal of improving their painting skills. There is room at the table for everyone. Whether you are a professional fine artist or paint during your free time, the process of creating art is an invaluable gift. Artists of all levels are an integral part of the vibrancy of the art world.

THE INLET, 2015
WATERCOLOR ON PAPER, 14½ X 15 INCHES (37 X 38 CM)

The ocean is a dominant aspect of life where I reside. I am in endless pursuit of properly communicating its beauty through my watercolors.

CLAIMING A SPACE TO WORK

I read a book once that featured the studios of one hundred famous artists. It was intriguing to view the creative spaces of the most influential artists of our time. From the spare, whitewashed appearance of Georgia O'Keeffe's New Mexico sanctuary to Francis Bacon's paint-splashed walls and cluttered floors, the studios reflected the temperament and individual style of each artist. The paintings produced in these environments were merely by-products of the lives the artists led, and their studios were integral to their existence.

As a young artist, I would draw on the dresser drawer in my bedroom, or on the coffee table or family card table in the living room. Anyone who visited our home would find me hunched over any flat area of our house, working feverishly on a drawing. After college, I began painting with soft pastels and the dust became too extreme for tabletops, especially ones that other people used from time to time; therefore, the collapsible card table became the most viable option for my "portable studio." I can remember, however, a few instances where the legs of the card table gave way and my pastels and various materials crashed to the floor.

Eventually, the son of my mother's friend passed away and I inherited his drafting table. I had never been more grateful. Sitting in a task chair, turning on the desk lamp, and painting in an allocated space in my bedroom changed my perspective on the creative process. I felt like a professional artist, one who had just turned the key to a brand new studio.

A studio does not have to be elaborate or expansive in order to be effective. I have been working professionally as an artist for more than twenty years, and I have always set up my studio in a room in my home. The convenience of

Filling my studio with artifacts I collect when I'm out and about brings me joy throughout my day. I enjoy walking the beach to clear my mind and collecting miniature seashells is one of my favorite activities.

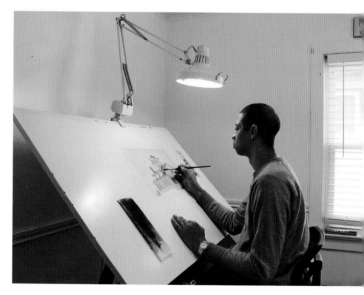

My studio is a place where I can be alone with my thoughts and free of technology and the multitude of distractions that inundate modern life.

having my work-in-progress readily available gives me the opportunity to analyze my mistakes at any time.

Whether you set up in a corner of your dining room, basement, or attic, set clear boundaries with your family members or roommates. Your painting time is precious and requires long periods of concentration; therefore, interruptions need to be kept to a minimum. If possible, pick an area that has the least amount of traffic. Painting is a meditative act and should be exercised in solitude. Watercolor does not require an exorbitant amount of space. In fact, Leonardo da Vinci once said, "An artist's studio should be a small space because small rooms discipline the mind and large ones distract it." My studio setup consists of a taboret (on wheels), drafting table, and closet to store supplies. I only work on one painting at a time; therefore, I don't need multiple easels.

Your studio should be properly lit. Creating art for long periods of time can put a strain on your eyes; therefore, it's important to have sufficient lighting to reduce the wear and tear on them. This is vital for artists who paint after work and whose studios are, therefore, devoid of natural sunlight. I paint during daylight hours; therefore, a combination lamp, containing fluorescent and incandescent bulbs, is sufficient.

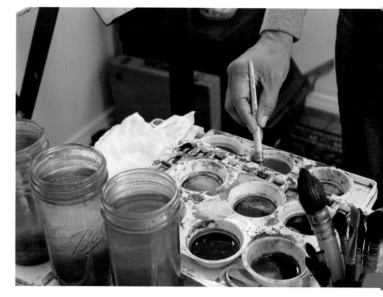

Working wet-in-wet requires me to have a few colors mixed simultaneously and ready for application. Watercolor painting is interactive; therefore, I find it to be more prudent to stand while I work.

TIP

• When working in a common area, be sure to remove objects that can be damaged by water. Nothing is worse than having an enjoyable painting experience, then spilling water on an important document.

KEEPING SUCCESS IN PERSPECTIVE

Striking the correct balance is important when socializing with fellow artists on the Internet. It may seem as if the careers of others are on a constant upward trajectory toward success, while you are experiencing ebbs and flows in your own. Keep in mind: You're only receiving good news from a multitude of sources every day. The barrage of celebratory posts from numerous sources can create unhealthy paranoia, and unwarranted skepticism about the progress you're making in your career.

To counteract this, try to use the success of others as inspiration. Setting the focus on your craft and committing to expanding your knowledge of art will open doors.

The creation of your art should always be the priority. The only variables you can control are your passion toward the work you create and the intensity with which you act upon that passion. It is futile to predict the public's reaction to your art. The moment you begin to seek approval from external forces, your vision becomes theirs.

Fame is an elusive concept, so there's no reason to chase it. We all desire to be appreciated for our contributions; however, in a world of celebrity where much value is placed upon athletes and entertainers, the visual artist is an outlier. Promoting oneself is a necessary evil in order to sustain a career in the arts. Each of us possesses a moral code, and as we are confronted with various opportunities, we must decide what is appropriate. Art is a visual diary, being written by the artist. The moment someone else begins to write in your diary, it's no longer your story.

NAVIGATING SOCIAL MEDIA

The Internet has changed how we shop, receive information, communicate, and even date. It has revolutionized the way business is conducted all over the world. Artists use it as a marketing tool to promote their work as well as advertise activities, such as workshops and exhibitions. It can be a wonderful tool. The challenge, however, is managing the amount of time we spend on the various social websites. The expression "time dump" comes to mind. The World Wide Web is so expansive, you can have pure intentions simply to check the notifications on your Facebook page and then find yourself clicking a link to funny cat videos. Before you know it, an hour has passed while you're surfing the Web and you can no longer recall what your original intention was for logging on to it.

Connecting with an online community can expose you to a broader audience. I performed a live demonstration on Periscope (a Twitter application) and answered questions from viewers during the two-hour painting session. The conversation was lively and engaging. Demonstrations such as this allow me to move expeditiously through my painting process without overthinking every detail. The immediacy of the process is likened to a sprint (as opposed to a marathon, which is more akin to how I normally paint).

LEXIE, 2015
WATERCOLOR ON PAPER, 20 X 20 INCHES (51 X 51 CM)

This demonstration piece was painted from a live model in approximately one hour and thirty minutes, while answering questions from an online audience. When I paint in an atmosphere where time is limited and I'm required to multitask, it's necessary for me to rely largely upon muscle memory I've attained from years of painting.

I am always seeking to include the element of spontaneity in my finished work, and demo sessions assist me in trusting my initial thoughts on the paper.

STAYING FOCUSED

Over my twenty-year career, I've evolved as the times have changed. In the mid-1990s the popular form of communication was writing and receiving letters in the mail. If your correspondence was urgent, you could mark it as Priority, and it would arrive one day earlier than usual. Those days are distant memories, however, in light of the present forms of communication. The instant gratification that comes along with sending and receiving messages via text, Facebook in-boxes, Twitter, and e-mail have become commonplace. The level of accessibility that currently prevails in our culture must be met with a strong will and determination to devote quality time to your art.

I work much harder to ward off distraction now than I did before the advent of smart phones and social media. My work day begins at 8 a.m. and ends at 4:30 p.m. I take one hour for lunch, and during that time I catch up on my e-mails and correspondences. At 3 p.m., I take a coffee break, which allows me to step away from my work and rest my brain. This routine keeps me grounded and gives me a sense of normalcy. I am not a believer in sitting around and waiting for inspiration to strike. If I remain consistent with my routine, inevitably a good idea will find me in my studio.

I believe an artist must exercise the following four ideals in order to thrive:

Passion is a burning desire to pursue a goal. It is the fuel by which your actions are ignited. Your level of passion cannot be measured; however, the manifestation of your efforts will be a visual indication. People usually form strong interests in particular activities early on, before the baggage of life weighs us down and diverts our focus toward fear and doubt. Listen to your inner voice, and fight for what brings you the most joy.

Vision in this sense does not refer to an artist's eyesight. Rather, it speaks to what an artist seeks to convey to the world. In essence, it is the infrastructure of your body of work. It is also important to note that your vision encompasses *what* you say, as well as *how* you say it. You may have a vision to paint beautiful landscapes; however, if you deliver the message in an abstract manner, it will be perceived differently than a classical realist's version of the same scene. Your vision for your artistic expression is highly personal and should be decided solely by you. This is vitally important if you desire to maintain a career as a professional artist. Your collectors want to hear a clear and concise message from you.

Discipline works hand in hand with your creativity. The artistic journey is all-encompassing in terms of joy and pain. You will experience triumphant moments when you are rewarded or acknowledged for your work; you will also have times when nothing is happening and you feel invisible. Working diligently through every situation life throws at you increases your resilience and cements your resolve. Looking back at the early years of my career, I painted in my friends' basements, a church office, and small bedrooms with terrible lighting. My discipline kept me focused, regardless of the circumstances in which I found myself. I worked vigorously and committed myself to a schedule, despite the fact that there was no great demand for what I was creating—at the time.

Perseverance is the will to thrive in the face of adversity. In 2009, I experienced the loss of three important people in my life. In addition, my mother had an aneurysm. A darkness lingered for several months. I gradually returned to painting and found a place of solace in the realm of creativity that I couldn't experience anywhere else. It was difficult

at first to fully invest my emotions into my paintings; however, as time passed I began to work with a renewed sense of urgency. As Andrew Wyeth wrote, "One's art goes as far and as deep as one's love goes." Once you face a challenge head on and conquer it, you will be surprised to discover the inner strength you possess.

FINDING INSPIRATION

Edward Hopper once said, "Great art is the outward expression of an inner life in the artist, and this inner life will result in his personal vision of the world. . . . The inner life of a human being is a vast and varied realm." As recent as two decades ago, libraries were valuable resources for artists who were eager to gain knowledge of historic works and of contemporary artists. But we are currently living in the Information Age, where access to world events, culture, history, and anything we can possibly think of are one Google search away.

Studying the work of great masters throughout art history can inspire you to raise the level of your artistry. Several major museums in the United States have made their collections available on the Internet. The high-resolution format allows users to zoom in and see the rich detail of the masterworks. In many cases, experiencing work online can be more useful than visiting a museum, due to the fact that many works are often not on view. The digitized archive allows users to access the complete collection of an institution.

With the advent of the Internet, art is consumed primarily on a computer screen. While these visual aids offer a spark of inspiration, there's no replacement for standing in front of an original work of art. Taking a break from the demands of your work can offer a renewed focus as well as open new doors of creativity. Visiting art museums is an excellent way to observe historic works of art from the vantage point of the creator. Social media websites allow artists to connect with one another and receive updates on activities as well as new works being produced. Attending exhibition openings or scheduling a studio visit with a fellow artist is an opportunity to socialize with your peers and recharge your creative battery. Taking walks in nature can relax your mind and invigorate your senses. One of my favorite activities is walking on the beach along the Atlantic Ocean during the morning hours. The roar of the waves, as they crash onto the shore, and the expansive sky allows me to prioritize my daily concerns.

Changing the environment in which you paint can be invigorating and has the potential to birth new ideas. Watercolor is excellent for plein air painting, as it requires a minimal amount of gear and accessories. I live a few minutes from the Atlantic Ocean, and when I feel the need for a change of pace, I pack a small tote and ride my Cruiser to the beach and paint in nature. Working outdoors awakens my senses and connects me to the world I inhabit. My studio is a place of solace and offers me a private place to explore my ideas; however, a change of scenery is beneficial from time to time.

Whether you're a professional artist or a weekend warrior, be sure to take the opportunity to slow down and "smell the roses" from time to time. It's understandable to devote a lion's share of your time and attention to the technical aspects of painting; however, your creative journey is a gift for you to relish.

PHOTOGRAPHING YOUR ARTWORK

Most people who will experience your work will do so through a photographic image. The most prevalent form is on the Internet, whether it's your personal website, gallery's website, social media channels, or a random Web search. It is important to control the integrity of your work by utilizing professional photographic services or purchasing a quality camera that shoots high-resolution images. Depending on the quantity you are producing, it can become expensive to rely upon a professional to photograph your work. Keep in mind, however, that if a work of art is photographed badly, once it has sold, you will be left with a useless visual representation of your art. If you are uncomfortable with the DIY method, it may be worth spending the money to use a professional. A few of my early works will never be shared with the public, due to the fact that I did not properly document my art at that time.

To help get you started with this process, I recommend that you visit www.artistsnetwork.com and type "How to Photograph a Painting, Step by Step" in the search bar. There are tips and recommendations offered by professional photographer Ric Deliantoni, who shoots paintings, crafts, and woodworking projects for *The Artist's Magazine*.

I hope this book serves as a resource, as well as an inspiration to you. Remember to enjoy your journey!

POINT PLEASANT SEAGULL, 2012
WATERCOLOR ON PAPER, 10 X 19¾ INCHES (25.5 X 50 CM)

I was painting in plein air while sitting on the beach when a seagull wandered into my view. He seemed to be inspecting my activities for an extended period of time. I felt compelled to amend my painting and quickly implanted the gull into the scene. Painting in nature can be unpredictable and is an important way for me to balance the controlled atmosphere of my studio.

DISCARD